Page 3: Test site: Optician's sign, UK, c.1942
Page 5: Koishi Kiyoshi, from *Early Summer Nerves*, Japan, 1933
Pages 6-7: Chino Otsuka, from the series *Tokyo 4-3-4-506*, Japan, 1997-9

Published by Square Peg 2011

2 4 6 8 10 9 7 5 3 1

Copyright © Julian Rothenstein and Mel Gooding 2011
Introduction © David Shrigley 2011

The Authors have asserted their rights under the Copyright, Designs
and Patents Act 1988 to be identified as the authors of this work

First published in Great Britain in 2011 by
Square Peg, Random House, 20 Vauxhall Bridge Road,
London SW1V 2SA

www.randomhouse.co.uk

Addresses for companies within The Random House Group Limited can be found at: www.randomhouse.co.uk/offices.htm

The Random House Group Limited Reg. No. 954009

A CIP catalogue record for this book
is available from the British Library

ISBN 9780224086868

The Random House Group Limited supports The Forest Stewardship
Council (FSC), the leading international forest certification organisation. All our titles that are printed on Greenpeace
approved FSC certified paper carry the FSC logo. Our paper procurement policy can be found at
www.randomhouse.co.uk/environment

Printed and bound in China by C & C Printing Co Ltd.

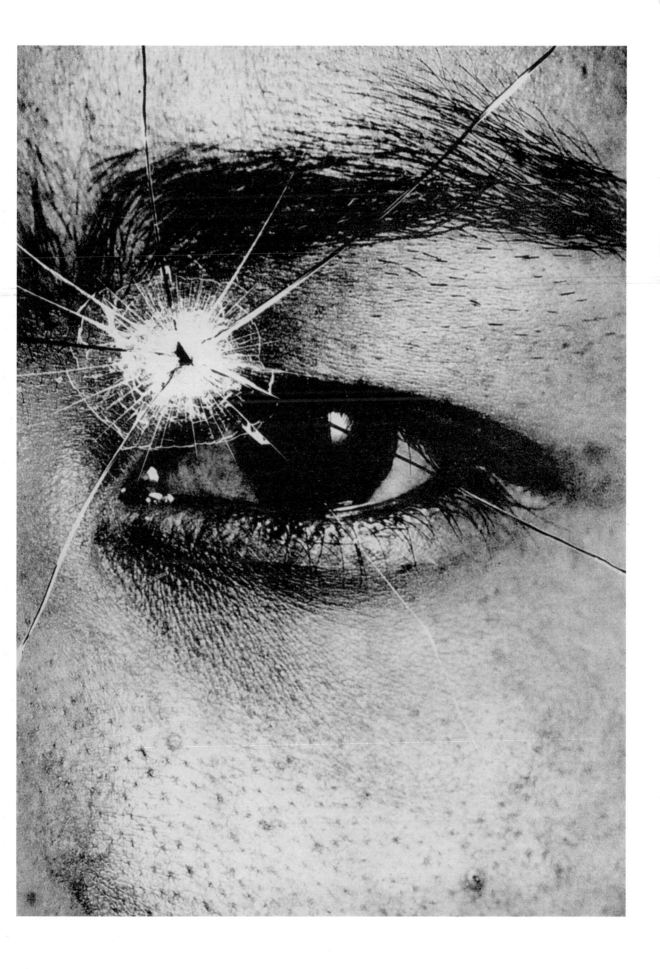

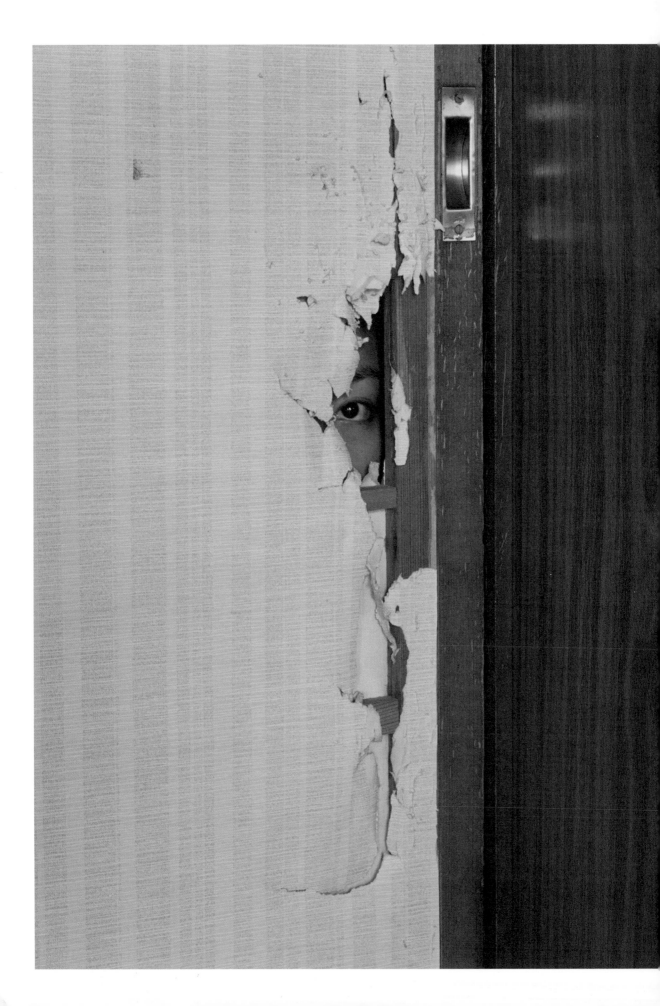

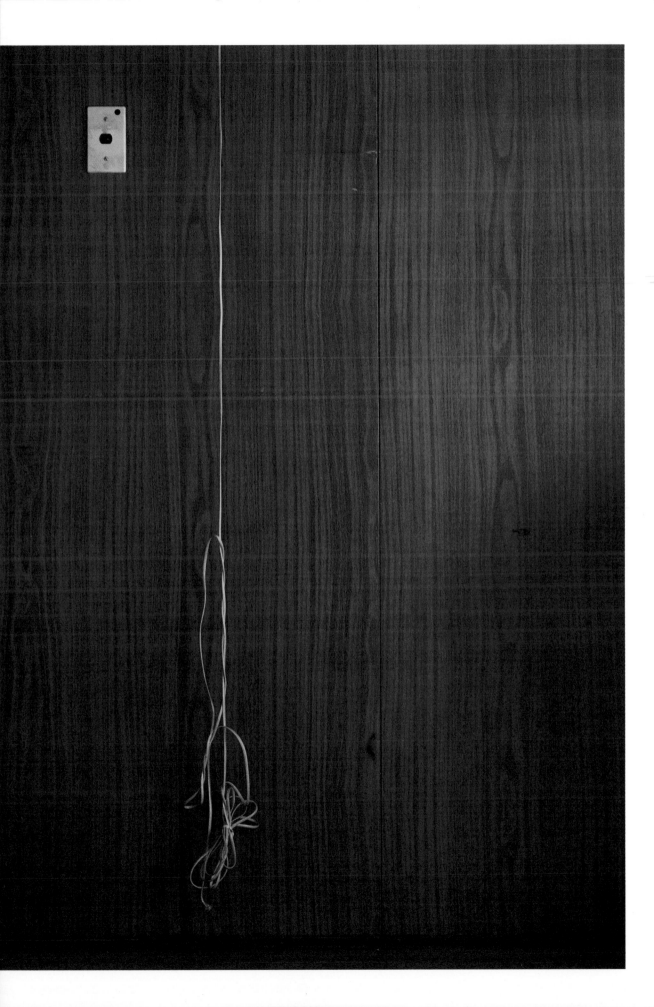

A COMPENDIUM OF VISUAL SURPRISE

EDITED BY JULIAN ROTHENSTEIN

WITH AN INTRODUCTION BY DAVID SHRIGLEY
AND TEXTS BY MEL GOODING

THE REDSTONE BOOK OF THE

EYE

◧ SQUARE PEG

THE REDSTONE BOOK OF THE

EYE

SQUARE PEG

FOR HIANG, LUCIEN AND ELLA

CONTENTS

INTRODUCTION 14 EYE MUSIC 19 ALL EYES 33

WHAT DO YOU SEE? 45 EYE TESTS 69

THE ARTIST'S EYE 82 AN EYE ON THE STREET 100

THE COMIC EYE 121 THE MIND'S EYE 143

THE UNSEEING EYE 163 FOR THE CHILD'S EYE 183

THE EROTIC EYE 197 TRICKS OF THE EYE 212

THE CHILD'S EYE 229 THE SATIRICAL EYE 242

THE CAMERA EYE 255 WORK FOR THE EYE 269

ACKNOWLEDGEMENTS / SOURCES OF ILLUSTRATIONS 284

THE SEEING EYE

EYES ARE MORE THAN JUST DECORATIONS ON YOUR FACE, PRETTY THOUGH THEY CAN BE.

EYES ARE PRINCIPALLY USED FOR SEEING WITH. THE IMAGES THAT YOU SEE THROUGH YOUR EYES ARE CHANNELLED INTO YOU BRAIN WHERE THEY ARE PROCESSED.

IF WE SEE A HANDSOME BABY THROUGH OUR EYES THEN WE ARE PLEASED AND ARE PRONE TO SMILING.

IF WE SEE A HORRIBLE RAT FROM THE SEWER THEN WE ARE DISPLEASED AND ARE PRONE TO GRIMACING AND PROTEST.

HOWEVER, LOOKING AT THINGS CAN BE MORE COMPLICATED THAN THIS. SOMETIMES WE LOOK AT THINGS AND IT IS UNCLEAR WHETHER WE ARE LOOKING AT A NICE THING OR A HORRIBLE THING. SOMETIMES WE DO NOT KNOW WHAT WE ARE LOOKING AT AT ALL AND WE ARE CONFUSED. SOME PEOPLE LIKE BEING CONFUSED IN THIS WAY WHILE OTHERS HATE IT AND GET ANGRY ABOUT IT. PERSONALLY, I AM DRAWN TO CONFUSING IMAGES AND THEY DO NOT MAKE ME ANGRY IN THE SLIGHTEST.

THE CREATORS OF CONFUSING IMAGES KNOW THAT WHILST ALL NORMAL EYES SEE THE SAME THING, OUR BRAINS ARE STUPIDLY UNRELIABLE. THESE PEOPLE CREATE AND SELECT THEIR IMAGES WITH THIS IN MIND IN THE HOPE THAT WE WILL FIND IT INTERESTING AND WILL REWARD THEM FOR IT. THIS BOOK IS A KIND OF REWARD FOR THE PEOPLE WHO MAKE THESE KINDS OF IMAGES. IT IS ALSO A TREAT FOR THOSE OF US WHO LIKE THESE KINDS OF IMAGES.

ANIMALS ALSO HAVE EYES, THOUGH WE HAVE NO REAL WAY OF KNOWING WHETHER THEY SEE THE SAME THINGS AS US. IT IS SUSPECTED THAT THEY ACTUALLY SEE DIFFERENT THINGS. IT IS ALSO SUSPECTED THAT MANY OF THEM PREFER SMELLING AND LISTENING TO ACTUALLY SEEING. IT IS NOT POSSIBLE TO SEE THE WORLD THROUGH AN ANIMAL'S EYES. SCIENTISTS HAVE TRIED IT AND THIS PROVED TO BE THE CASE.

PEOPLE SOMETIMES SAY 'OPEN YOUR EYES' BUT WHAT THEY REALLY MEAN IS 'STOP BEING AN IDIOT'.

BLIND PEOPLE ARE UNABLE TO SEE THINGS THROUGH THEIR EYES. THEY SEE THINGS IN THEIR MIND'S EYE. EVERYONE CAN SEE THINGS THROUGH THEIR MIND'S EYE BUT IT ISN'T UNTIL PEOPLE GO ~~XXXX~~ BLIND THAT THEY START TO DO IT PROPERLY.

CHILDREN SEE THINGS DIFFERENTLY TO ADULTS BECAUSE THEIR EYES ARE SMALLER. THE WORLD APPEARS TO BE ENORMOUS TO THEM. WHEN THEY BECOME ADULTS THE WORLD STARTS TO APPEAR TO BE A MORE ~~XXXX~~ MANAGEABLE SIZE.

IN RELIGION IT IS SAID THAT GOD SEES EVERYTHING. THIS MAY OR MAY NOT BE TRUE. MOST RELIGIOUS PEOPLE ASSUME IT IS TRUE JUST TO BE ON THE SAFE SIDE. IN OLDEN TIMES IT WAS SUGGESTED THAT GOD HAD ONE BIG EYE THAT SAW EVERYTHING. NOWADAYS GOD HAS TWO EYES.

THE SIZE AND LOCATION OF THE EYES ON THE FACE IS SEEN TO BE QUITE IMPORTANT.

IF YOU HAVE HUGE BULBOUS EYES OR TINY BEADY EYES THEN THIS IS SEEN TO BE A BAD THING. SIMILARLY IF YOUR EYES ARE A NORMAL SIZE BUT ARE TOO FAR APART OR TOO CLOSE TOGETHER THEN THIS IS ALSO BAD. YOUR EYES MUST BE OF NORMAL SIZE AND THE PERFECT DISTANCE APART OR ELSE YOUR LIFE WILL BE MISERABLE. WEARING GLASSES THOUGH, IS NOW SEEN TO BE ACCEPTABLE IN MOST COUNTRIES.

WHEN SOMEONE SAYS 'I'VE GOT MY EYE ON YOU' IT DOES NOT MEAN THAT THEY ARE IN LOVE WITH YOU. UNFORTUNATELY, IT MEANS THAT THEY DON'T TRUST YOU AND THAT THEY FEEL THE NEED TO MONITOR YOUR ACTIVITIES.

SOME PEOPLE ARE AFRAID OF PEOPLE LOOKING AT THEM AND TRY TO HIDE FROM VIEW. SOME PEOPLE LIKE OTHER PEOPLE LOOKING AT THEM AND ACTIVELY ENCOURAGE IT. SOME PEOPLE LIKE LOOKING AT OTHER PEOPLE IN SECRET THROUGH BINOCULARS OR TELESCOPES. SOME PEOPLE THINK THAT OTHER PEOPLE ARE LOOKING AT THEM IN SECRET THROUGH BINOCULARS OR TELESCOPES, EVEN THOUGH THEY ARE NOT.

SOME PEOPLE SEE THINGS THAT AREN'T REALLY THERE BUT THEY ARE ABLE TO CONVINCE LARGE NUMBERS OF OTHER PEOPLE THAT THESE THINGS ARE REAL AND THEY BECOME FAMOUS AND SUCCESSFUL AS A RESULT. HOWEVER THIS DOESN'T HAPPEN VERY OFTEN, AND IN GENERAL IF YOU FREQUENTLY SEE THINGS THAT ARE NOT REALLY THERE THEN IT IS PROBABLY A GOOD IDEA TO KEEP QUIET ABOUT IT.

STARING AT INANIMATE OBJECTS (LIKE
ARTWORKS FOR EXAMPLE) IS USUALLY SEEN
AS A GOOD THING AND IS OFTEN
CONSIDERED TO BE A SIGN OF INTELLIGENCE.
STARING AT PEOPLE THOUGH, IS USUALLY SEEN
AS A BAD THING AND IS OFTEN CONSIDERED
RUDE OR A SIGN OF BEING MENTALLY
DEFECTIVE.

LOOKING AT THE SUN CAN MAKE YOU GO
BLIND. LOOKING AT EROTIC IMAGES CAN
ALSO DAMAGE YOUR EYES IF THE LIGHTING
CONDITIONS ARE POOR OR IF THE ACCOMPANYING
TEXT IS VERY SMALL.

IN ADDITION TO PEOPLE AND ANIMALS; POTATOES,
STORMS, NEEDLES AND ROBOTS ALSO HAVE EYES.

DAVID SHRIGLEY
10 MAY, 2011.

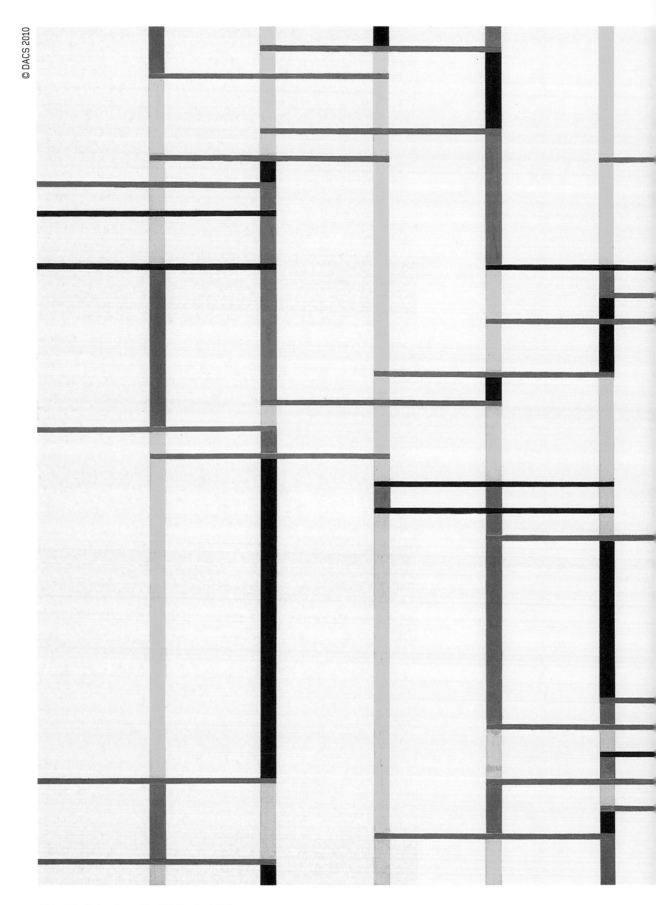

Richard Paul Lohse, *Koncretion III*, Switzerland, 1947

EYE MUSIC

Music brings pictures to the eye. Pictures may bring music to the mind. Such reminders and correspondences, evocations of the heard and seen, may bring joy to the heart or a smile to the lips. A dynamic or harmonious arrangement of shapes and colours: visual music! A vivid picture on the floral wallpaper, a printed cloth thrown across a baby grand piano; a red cello at rest: silent music rooms. Stravinsky and the boy violinist: unheard music behind the eyes. The conductor conducts; the listener is drunk on sound; the skittish cats frolic on the stave: the playful eye loves to perform music.

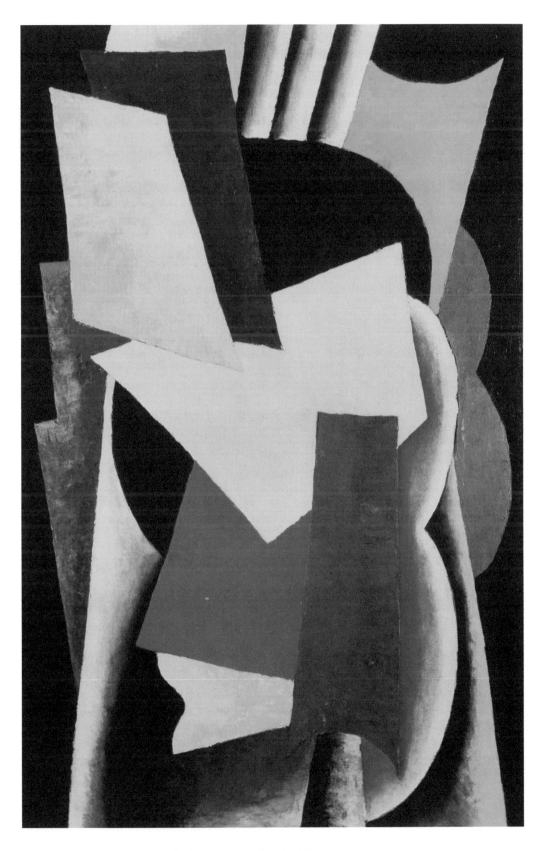

Liubov Popova, *Painterly Architectronic (Still Life, Instruments)*, Russia, 1916

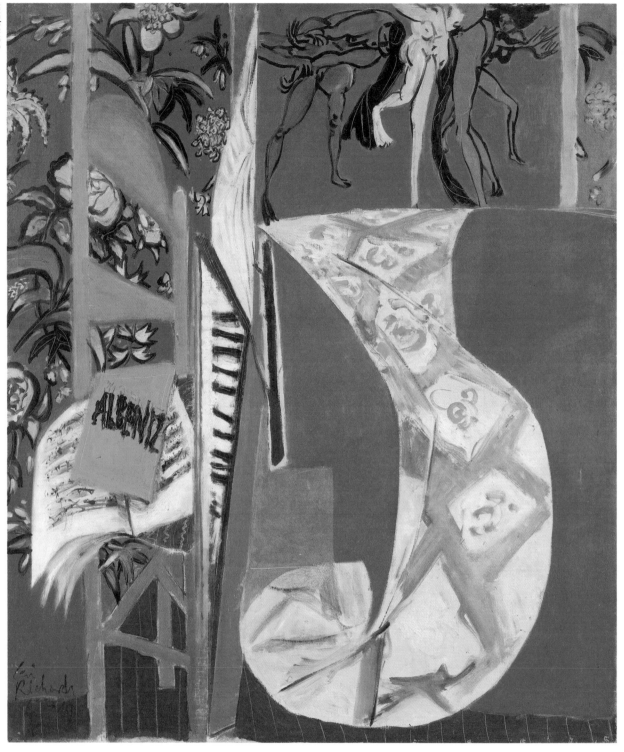

Ceri Richards, *Red Interior with Music by Albeniz*, UK, 1949

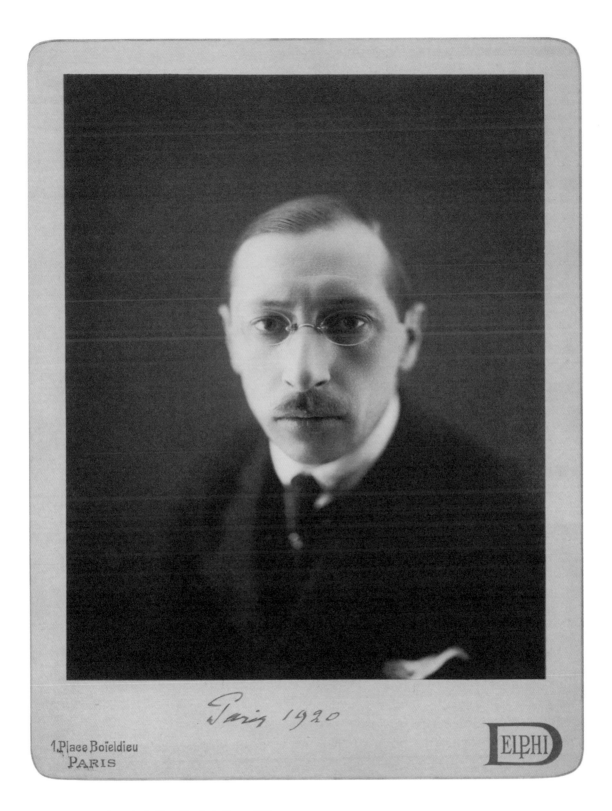

Paris 1920

1 Place Boïeldieu
PARIS

DELPHI

Piercing vision: studio portrait of Igor Stravinsky, France, 1920

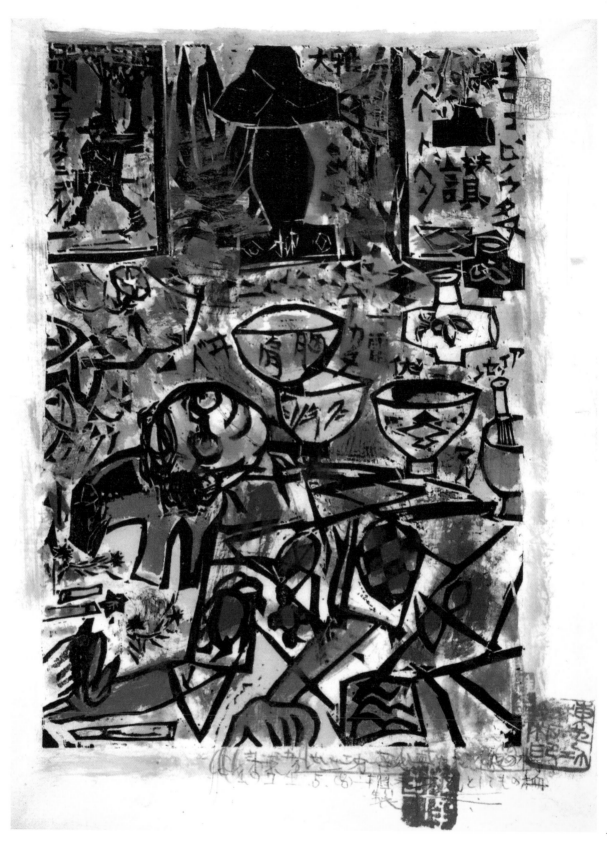

Shiko Munakata, *Joyful Self-portrait: Listening to Beethoven's 'Ninth'*, Japan, 1963

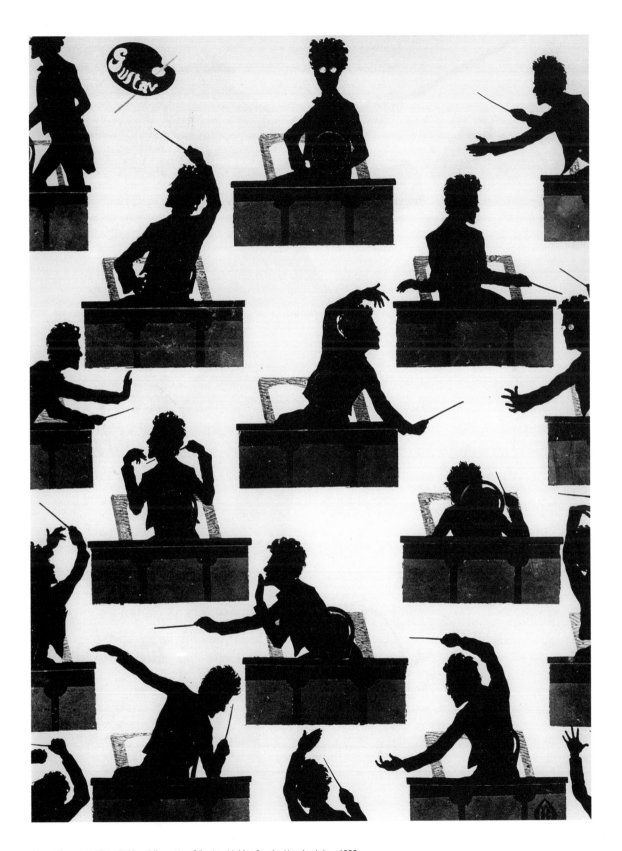

Living the music: Otto Buhler, *Silhouette of Gustav Mahler Conducting*, Austria, c.1900

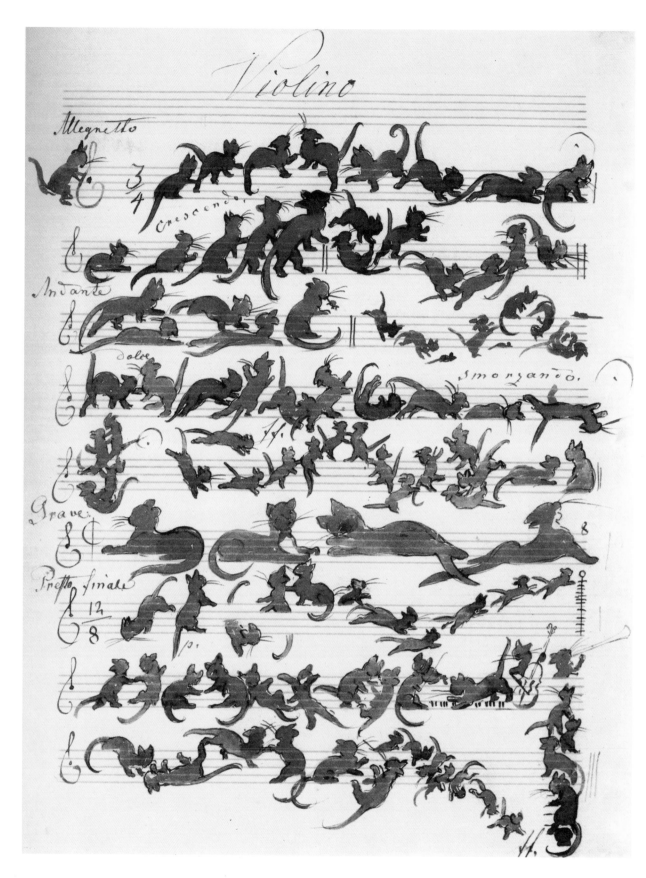

Moritz von Schwind, *Cat Symphony*, Germany, 1869

Ата Евгеньевна
ИВАНИЦКАЯ

МЕЛОДИИ　MÉLODIES
НАРОДОВ　DES PEUPLES

для голоса с фортепиано　　　　pour 1 voix et Piano

ВЫПУСК I SÉRIE

International: Pavel Kuznetzov, *Melodies of the Nations*, sheet music cover, USSR, 1925

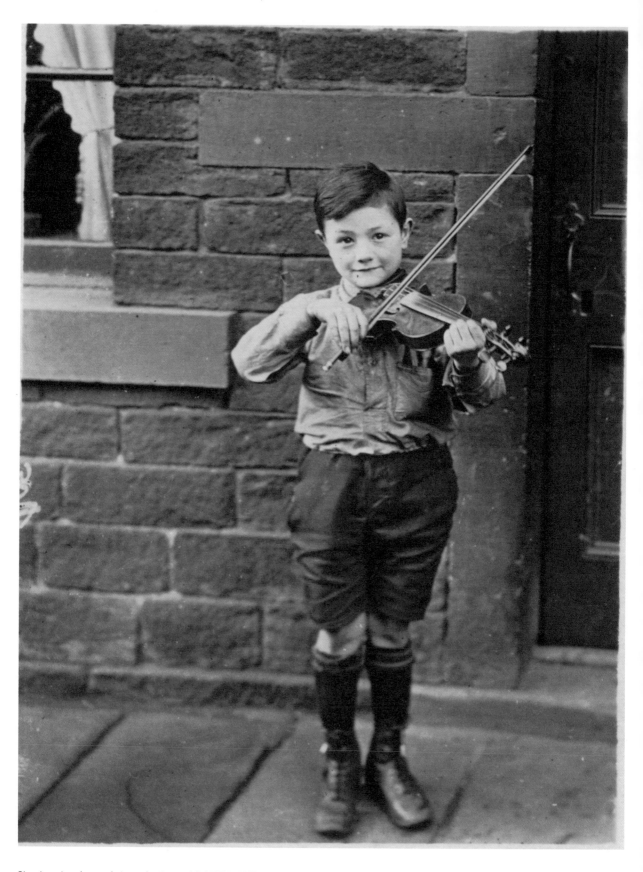

Street music: unknown photographer 'young violinist', UK, *c*.1937

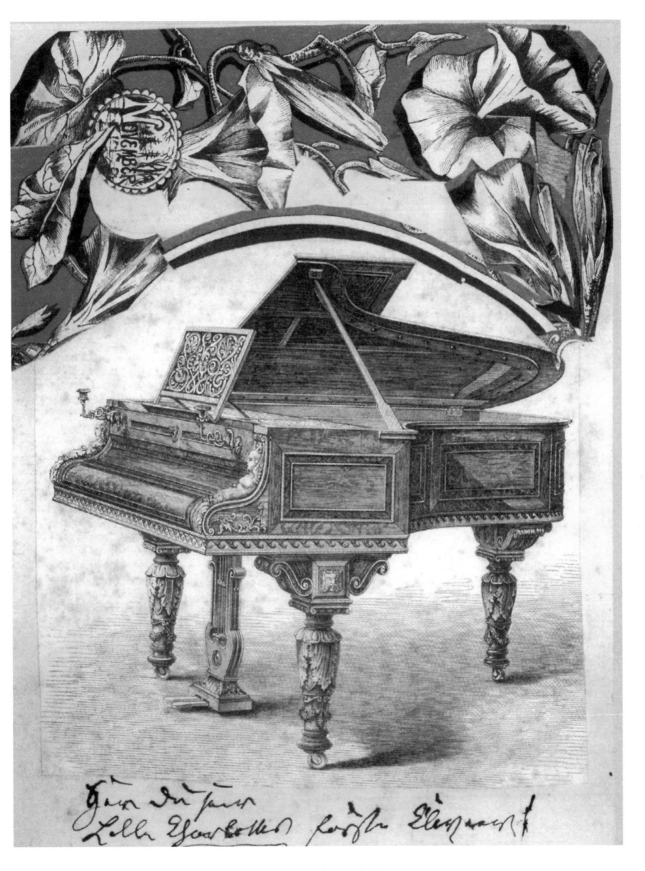

Playful grandeur: Hans Christian Andersen, from *Charlotte Melchior's Picture Book*, Denmark, 1874

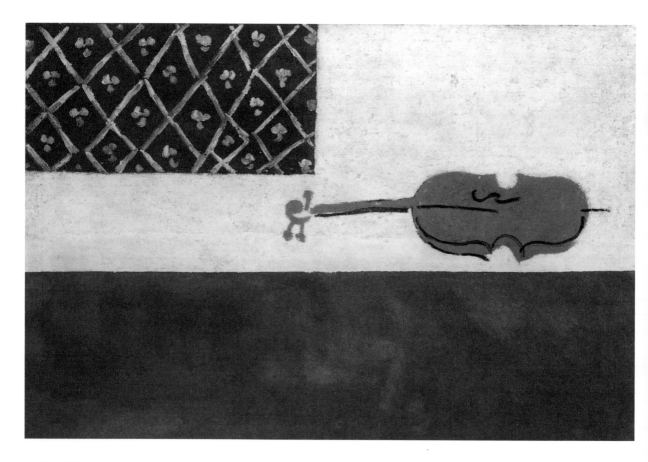

Ivan Puni, *Violin*, Russia, 1919

'An eye can threaten like a loaded and levelled gun,' said Ralph Waldo Emerson. And indeed the eye is active. A glance or gaze can convulse us, hurt or caress. The eye responds to the eye: we cannot take our eyes off those eyes that catch our own as if to compel response. Animals and birds know this if only as instinct. So do those who design film posters. To compel, eyes do not even need a face: caught in the beam of an eye, we are transfixed. Eyes! So powerful and yet so vulnerable, as Gerard Manley Hopkins observed: *'...this sleek and seeing ball/ But a prick will make no eye at all...'* A razor will also do the trick. Our eyes look away.

ALL EYES

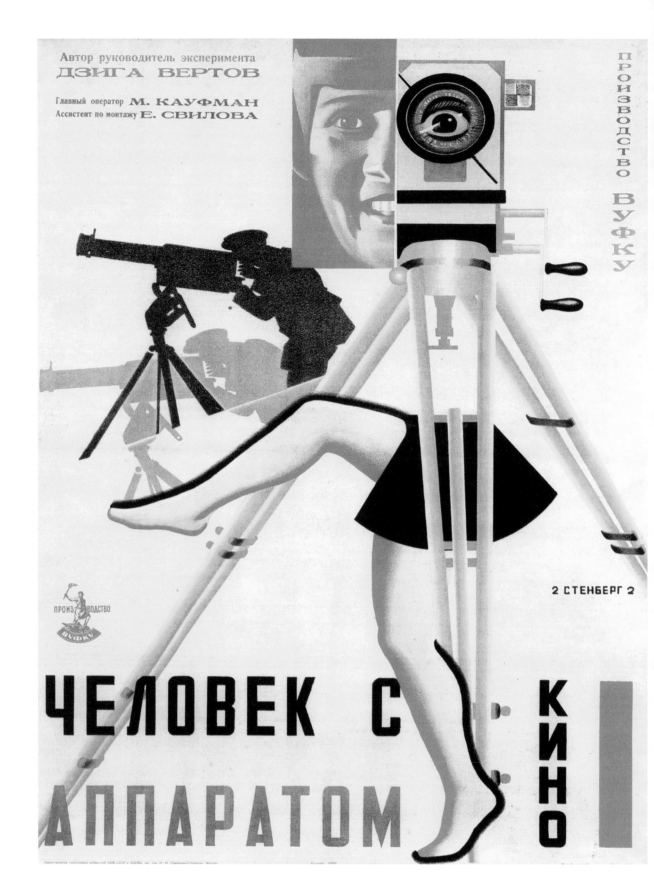

Georgii & Vladimir Stenberg, film poster for *The Man With a Movie Camera*, directed by Dziga Vertov, USSR, 1929

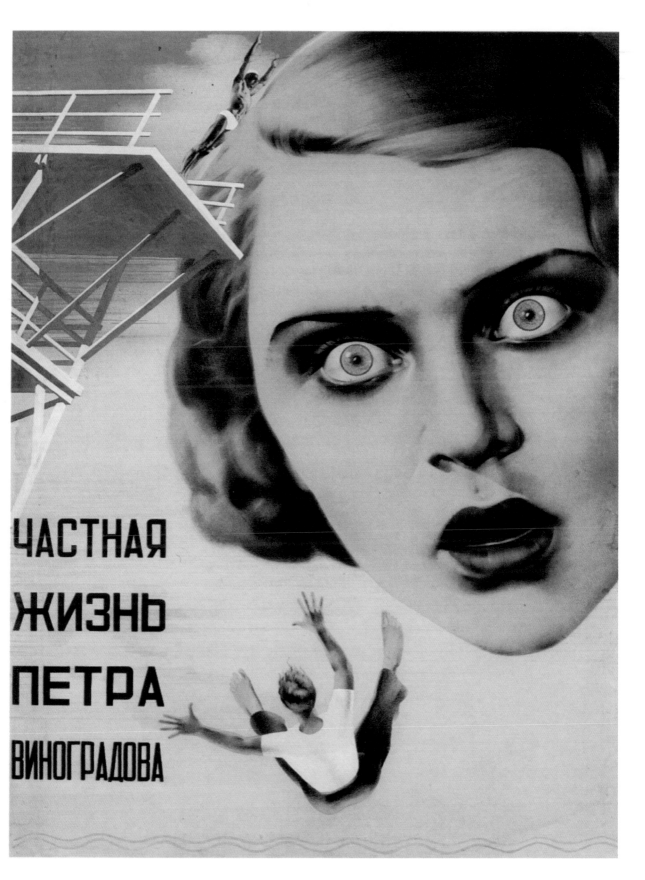

Anatoly Belsky, film poster for *The Private Life of Peter Vinograd*, directed by Alexander Macheret, USSR, 1934

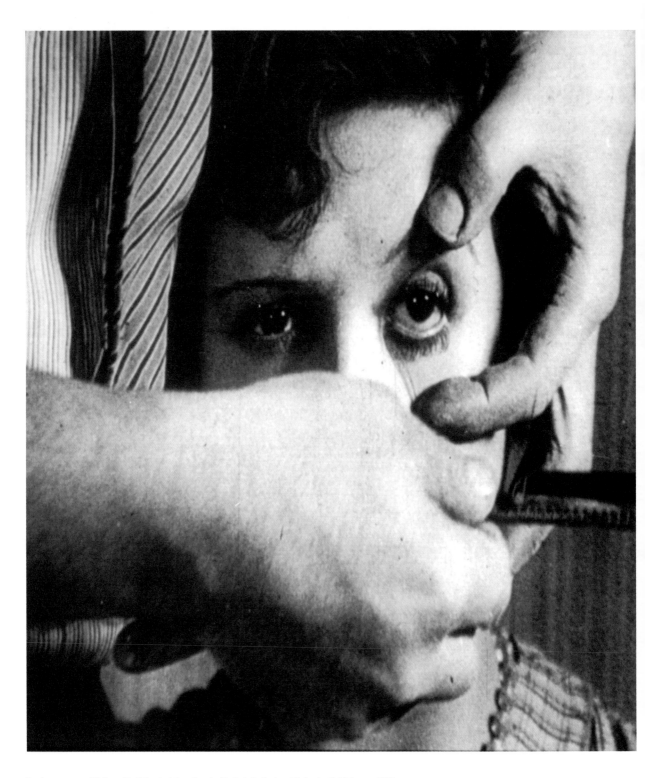

Look away now: still from *Un Chien Andalou*, directed by Luis Buñuel and Salvador Dalí, France, 1929

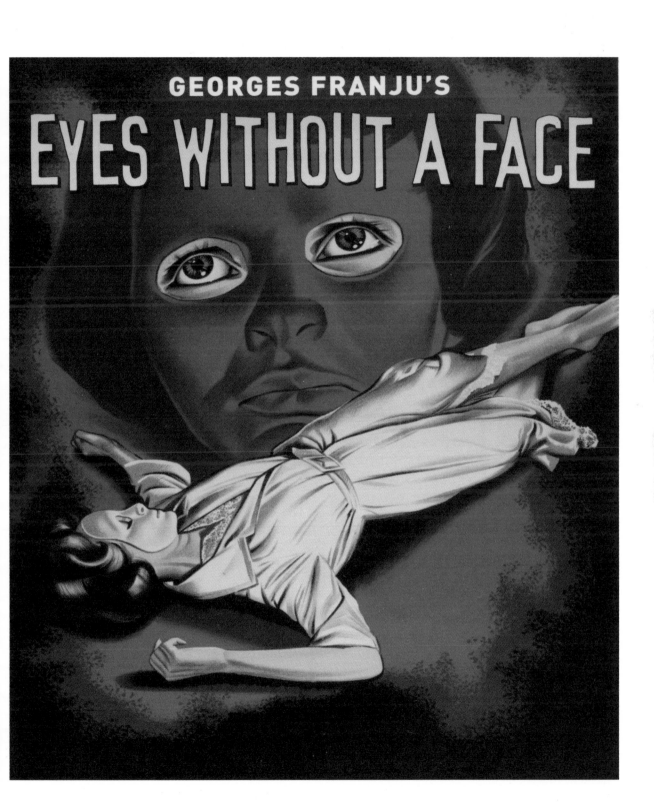

Georges Franju, poster for his own film *Eyes Without a Face*, France, 1960

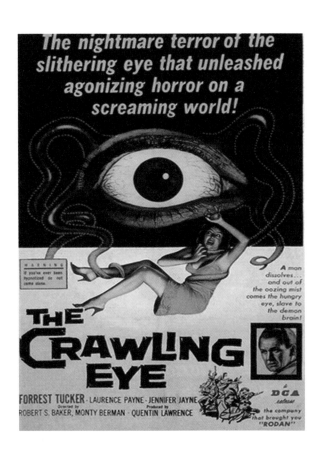

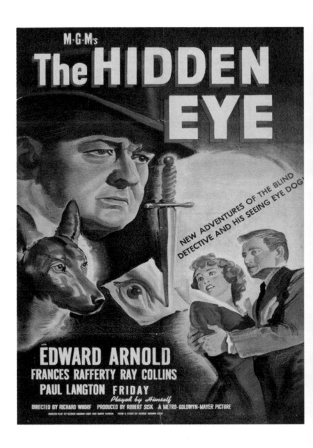

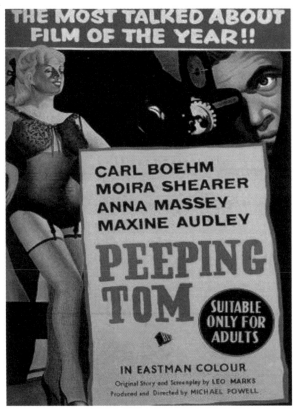

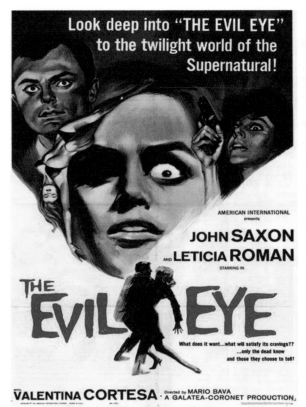

The slithering eye, the hungry eye, the crawling eye, the hidden eye, the seeing eye, the evil eye, the peeping eye: clockwise from above left, posters for films directed by Quentin Lawrence, USA, 1958; Richard Whorf, USA, 1945; Blano Bava, USA, 1962; Michael Powell, UK, 1959

STEPHEN KING'S
CAT'S EYE

DIRECTED BY STARRING
LEWIS TEAGUE DREW BARRYMORE JAMES WOODS WITH ALAN KING KENNETH MICMILLAN
SCREENPLAY BY PRODUCED BY MUSIC BY
STEPHEN KING MARTHA J. SCHUMACHER ALAN SILVESTRI

A cat's eye caught in bright light: Nick Tassone, from the Stephen King poster series, USA, 2010

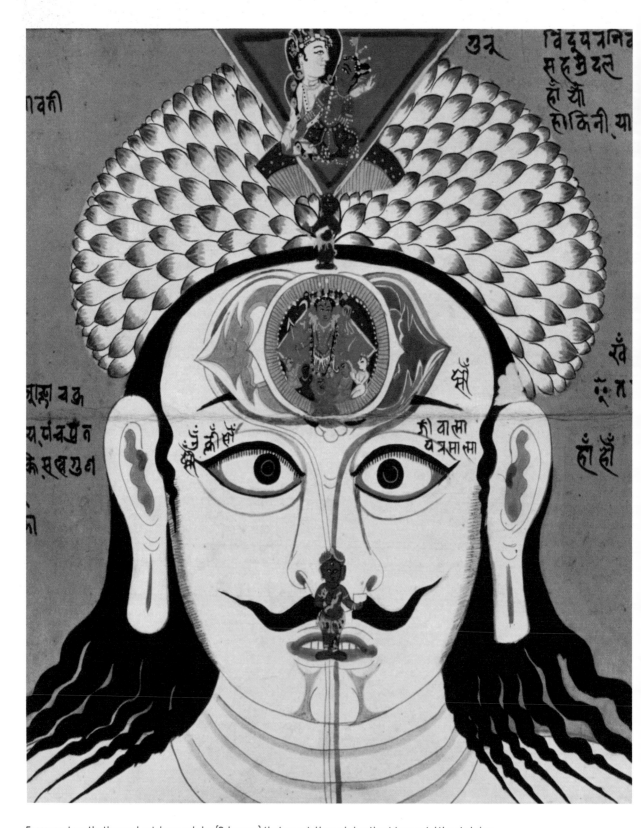

Energy centres: the thousand-petal crown chakra (Sahasrara), the two-petal brow chakra, the sixteen-petal throat chakra, tantric scroll painting, 17th century, Nepal, India

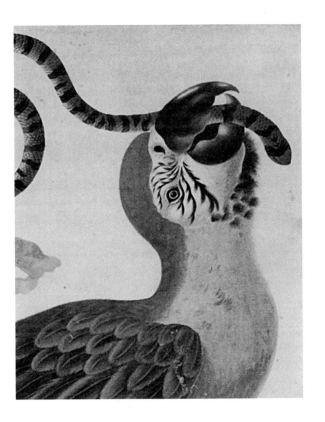

Fatal eyes: Maria Sibylla Merian and daughters, details of hand-coloured etchings, Germany, *c.*1700

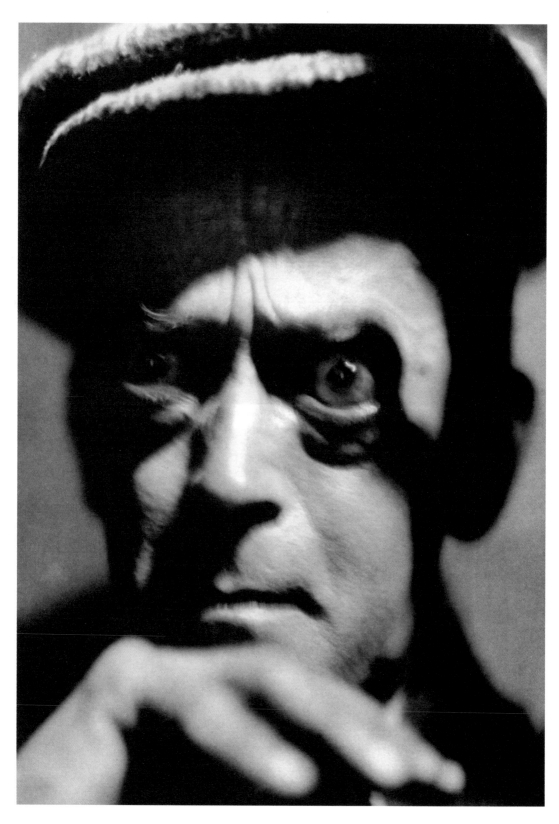

Heinrich Gotho, *Angst*, Germany, *c.*1929

WHAT DO YOU SEE?

The mind loves the eye to be deceived. It is the pleasure of surprise: the excitement of seeing something where we did not expect it. For as long as there has been mark-making there have been images hidden within images, visual paradoxes and secret signs. Such puzzles and jokes may be put to diverse purposes: comical, political, philosophical, celebratory, mystical, etc.

Thus, upside-down faces offer opportunities to play visually with the perennial fascinations of opposites: beautiful/ugly, good/bad, old/young (which can be useful to satirists); the memento mori skull can contain graphic reminders of just what will be lost; multiple figures will remind us of the common identity that occurs in joint enterprise, and of the paradox of the one-in-many, many-in-one.

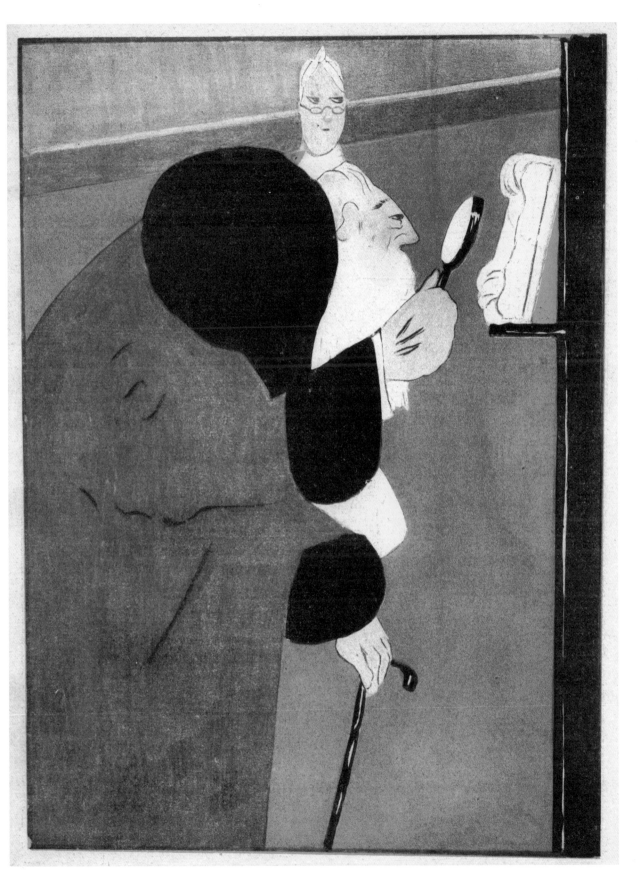

Paul Iribe, from radical magazine *L'Assiette au Beurre*, No. 108, France, 1903

Mind, inspiration and nature: *The Spirit of Byron*, a popular print, UK, 1830

Lilies of France, hidden profiles of the French royal family, popular print, France, 1815

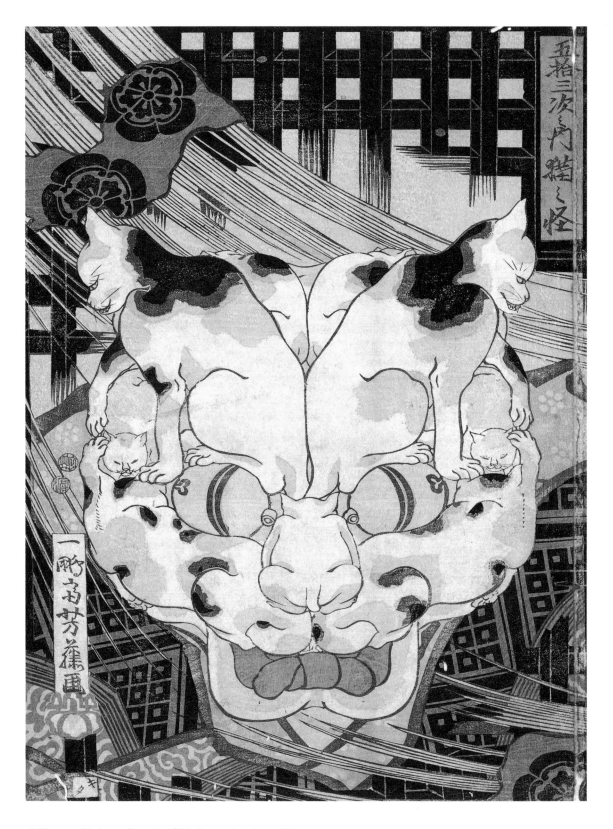

Evil Cats, woodblock print illustration of Kabuki ghost story, Japan, 1847

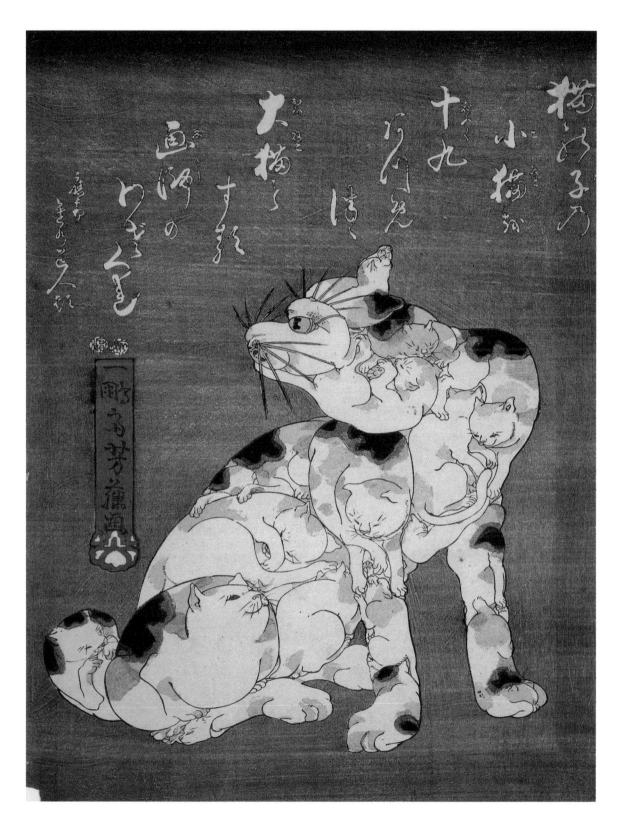

Fecundity: *Cat and Kittens*, woodblock print of composite image, Japan, *c.*1850

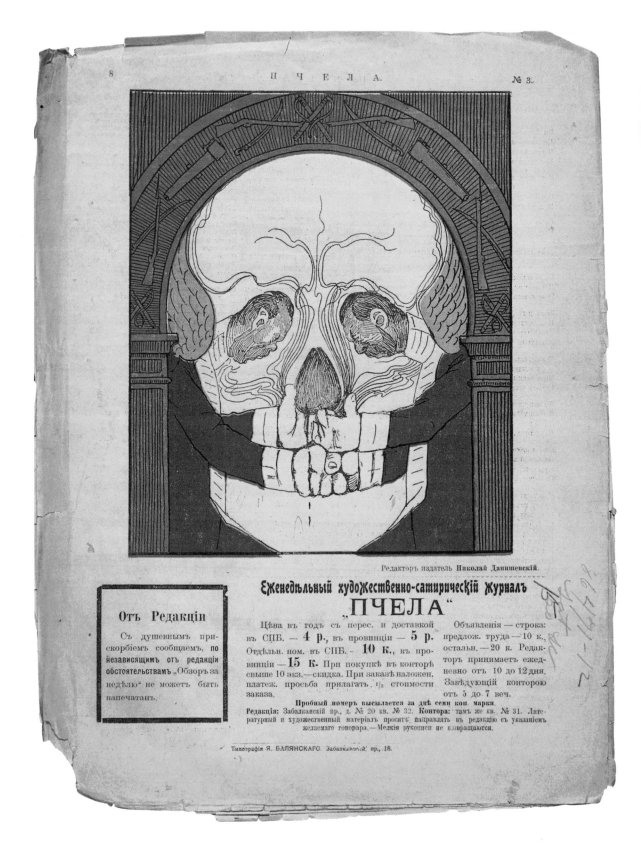

Редакторъ издатель Николай Данишевскій.

Еженедѣльный художественно-сатирическій журналъ
„ПЧЕЛА"

Цѣна въ годъ съ перес. и доставкой
въ СПБ. — **4 р.**, въ провинціи — **5 р.**
Отдѣльн. ном. въ СПБ. — **10 к.**, въ про-
винціи — **15 к.** При покупкѣ въ конторѣ
свыше 10 экз.—скидка. При заказѣ наложен.
платеж. просьба прилагать . 1/3 стоимости
заказа.

Объявленія — строка:
предлож. труда — 10 к.,
остальн. — 20 к. Редак-
торъ принимаетъ ежед-
невно отъ 10 до 12 дня.
Завѣдующій конторою
отъ 5 до 7 веч.

Пробный номеръ высылается за двѣ семи коп. марки.
Редакція: Забалканскій пр., д. № 20 кв. № 32. **Контора:** тамъ же кв. № 31. Лите-
ратурный и художественный матеріалъ просятъ направлять въ редакцію съ указаніемъ
желаемаго гонорара.—Мелкія рукописи не возвращаются.

Типографія Я. БАЛЯНСКАГО. Забалканскій пр., 18.

Pchela, the bee that stings: back cover of satirical magazine *The Bee*, Russia, 1906

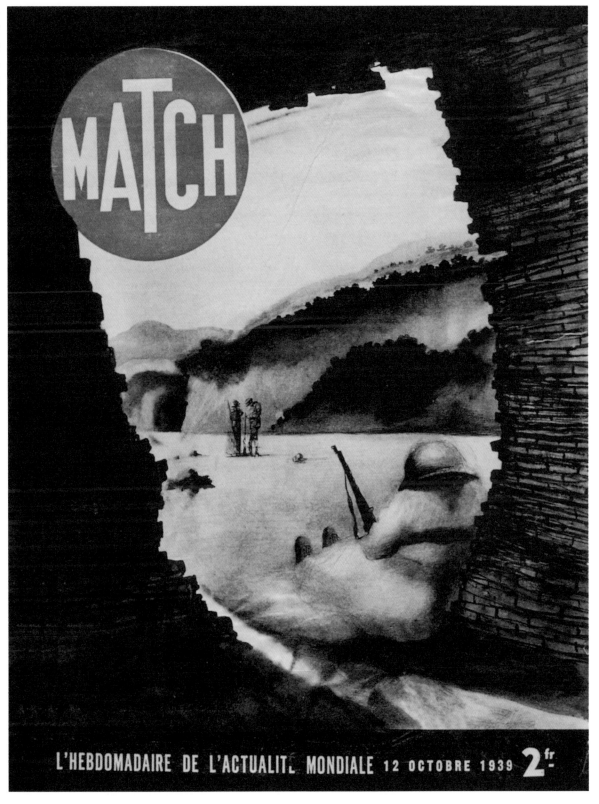

'Paranoiac-critical' hallucination of sleeping French military: Salvador Dalí, cover for *Match* magazine, France, 1939

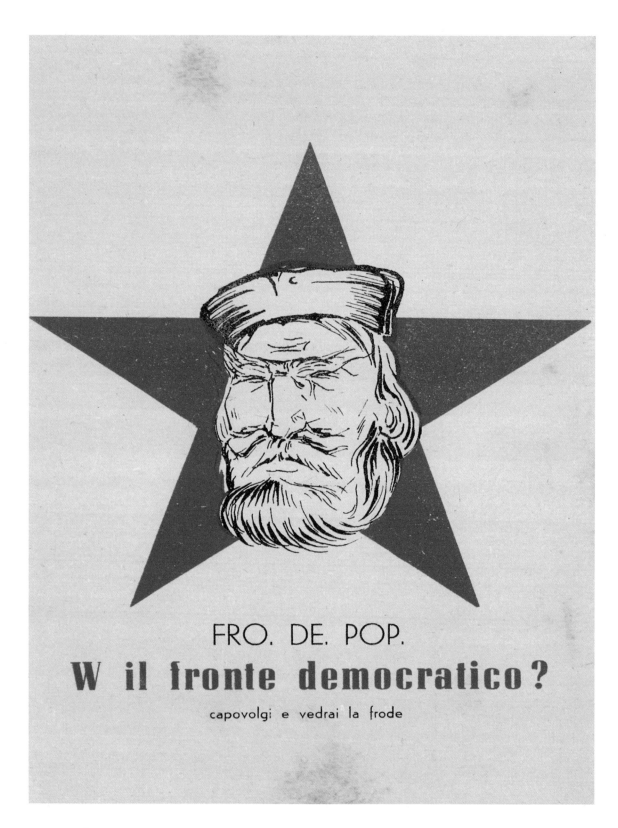

Anti-Socialist/Communist Popular Front satirical poster, Italy, 1946

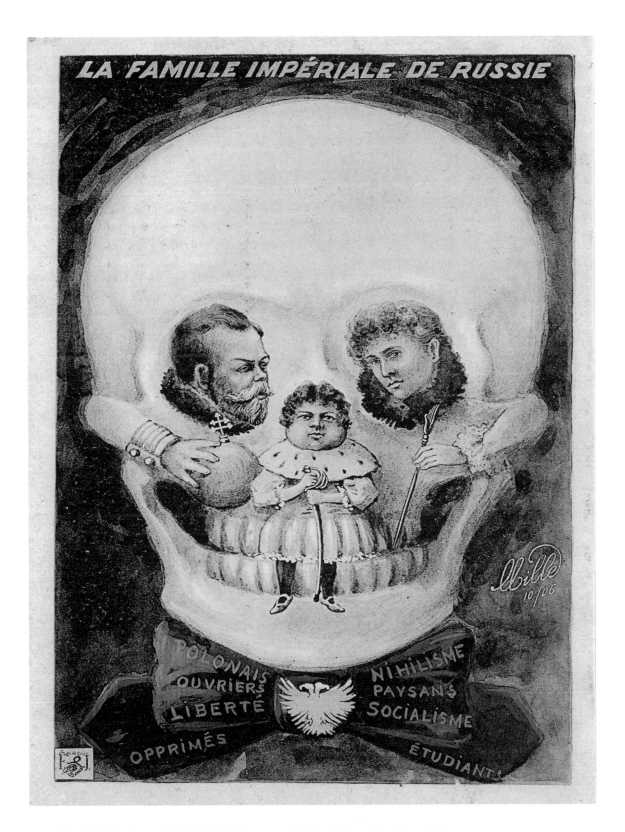

Imperial death's head: royal oppression in Russia after the suppressed 1905 revolution, postcard, France, 1906

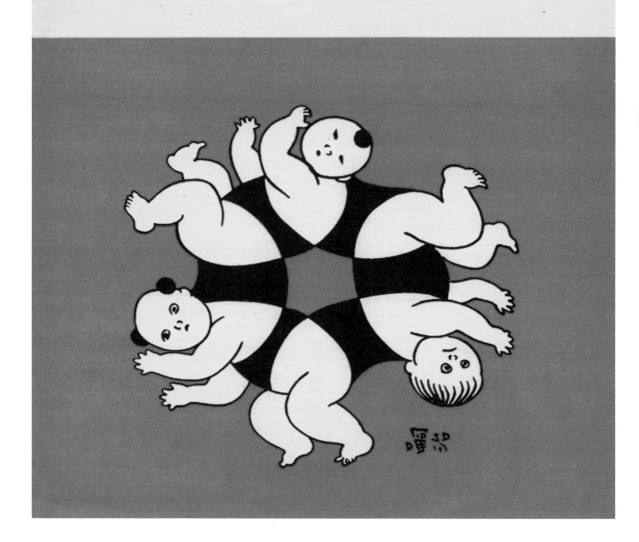

Three heads, four bodies: multiple figure on song sheet cover, France, c.1910

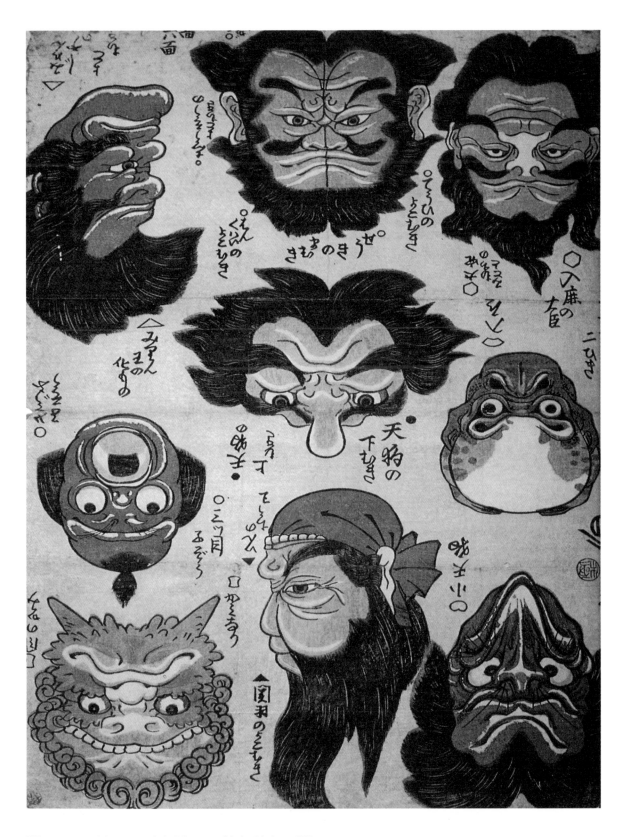

Of fearsome aspect, however you look at them: woodblock print, Japan, 1830

'And despite storms or vermin it upward springs': find the profiles of William IV and of the Lords Grey, Brougham, Russell and Durham, patriotic popular engraving, UK, 1831

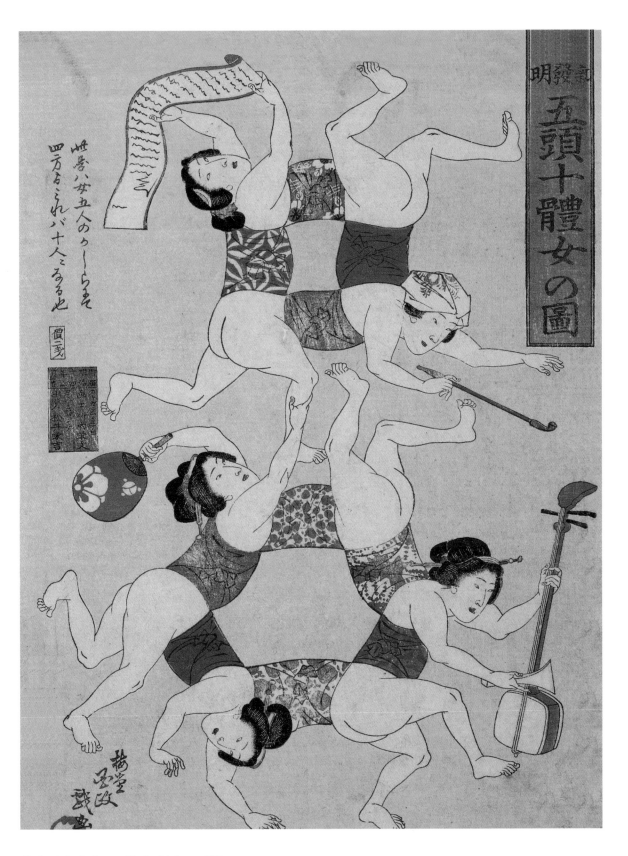

Five heads, ten bodies: woodblock print, Japan *c.*1890

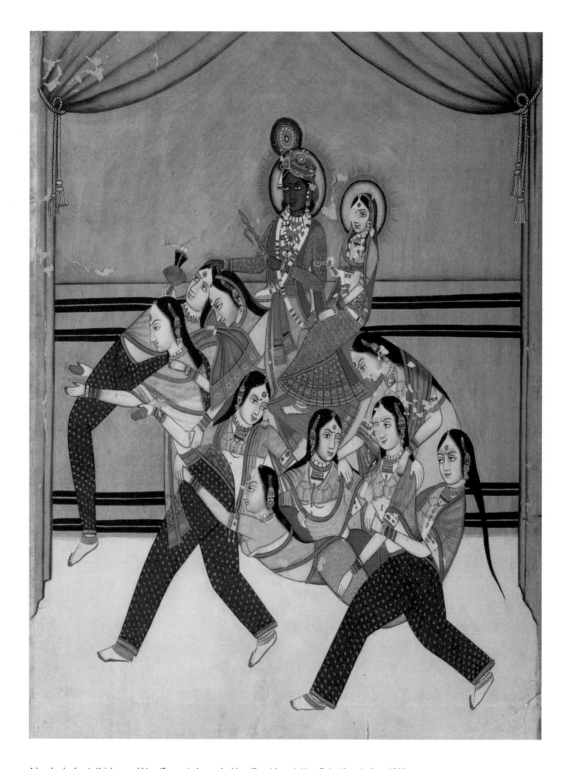

A lovely elephant: Krishna and his wife carried away by his milkmaids, painting, Rajasthan, India, *c.*1830

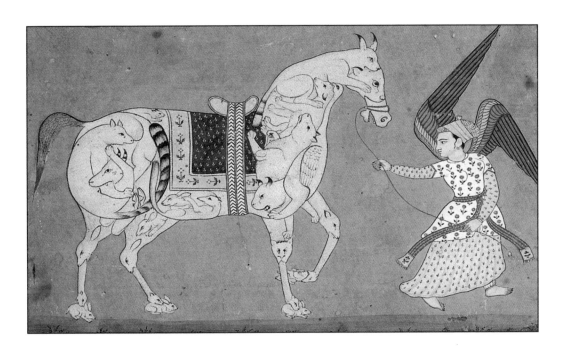

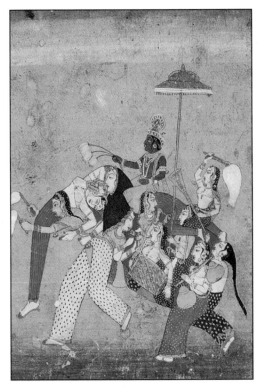
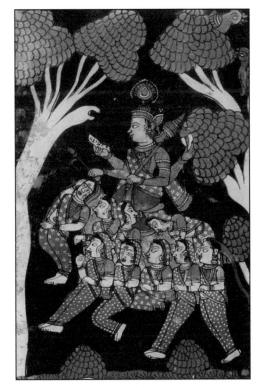

ABOVE: composite horse with spirit groom, Mogul painting, c.1780; BELOW: more lovely elephants, Rajasthan, India, 19th century

Find the polar bear!: Tatiana Glebova, from *Where Am I?*, children's book, Russia, 1928

Find the driver!

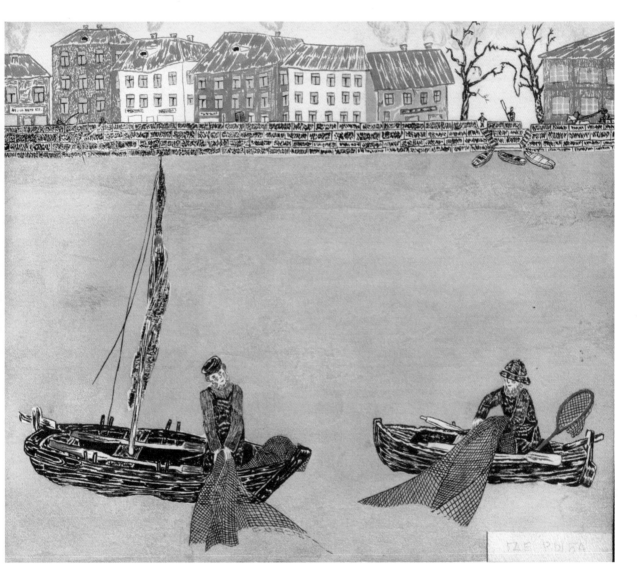

Find the fish!

Virtuoso exercise: two bodies, one head; three bodies, one head, woodblock print, Japan, mid-19th century

EYE TESTS

Eye test charts using letters of the alphabet were not introduced until the 1830s. In 1862 the Dutch ophthalmologist Herman Snellen designed the first reliable charts for testing vision-distance, using carefully size-adjusted letters. Sans serif letters, having less visual distraction, were introduced soon after. In recent times, Gill Sans Bold has been especially popular. Snellen also introduced charts with calibrated lines and abstract figures for young or illiterate patients. Eye test chart designs all over the world are still based on Snellen's pioneering 'Optotypes'. The economy and clarity demanded by its function gave the eye test chart a formal typographic elegance that looked modern long before modern times. Charts to test the selective colour vision of so-called 'colour blindness' also date from the nineteenth century. They have their own charming aesthetic: the look of garden designs or floral displays.

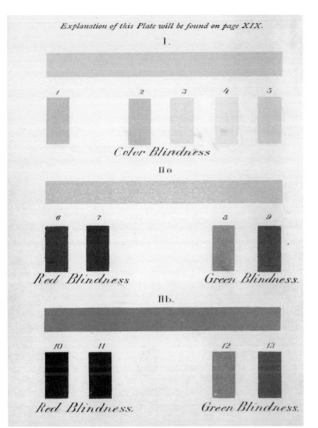

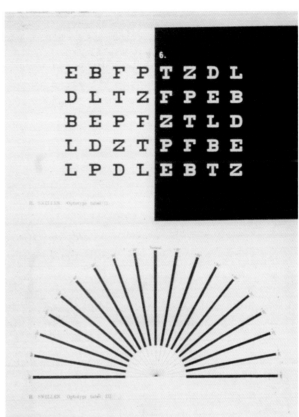

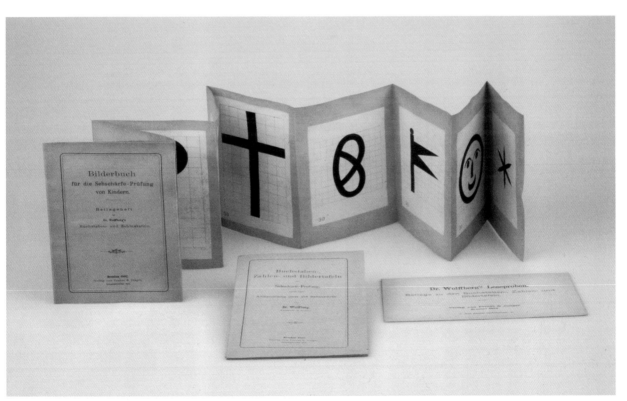

Early colour blindness and eye test charts, mid-19th century

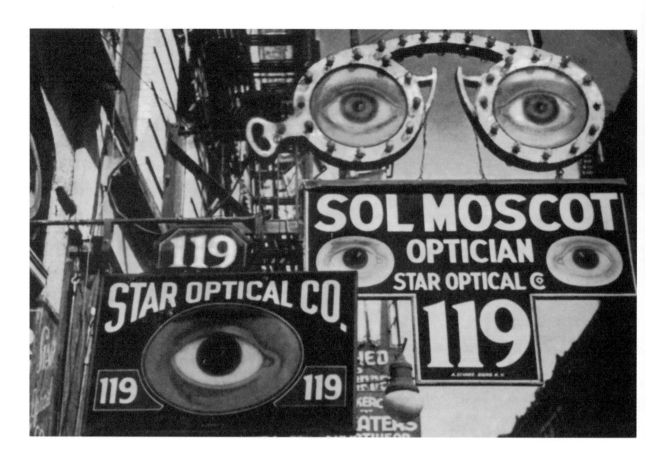

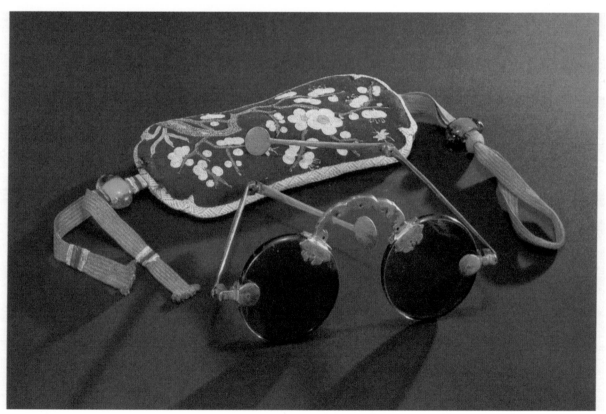

ABOVE: '[The optician's eyes] are blue and gigantic ...They look out of no face, but, instead, from a pair of enormous yellow spectacles which pass over a non-existent nose' (F. Scott Fitzgerald, *The Great Gatsby*, 1926). Optician's shop signs, Orchard Street, New York, USA, 1935; BELOW: spectacles with embroidered case, China, 19th century

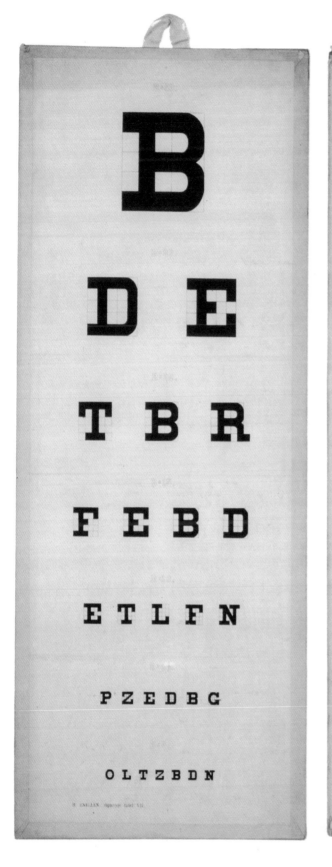
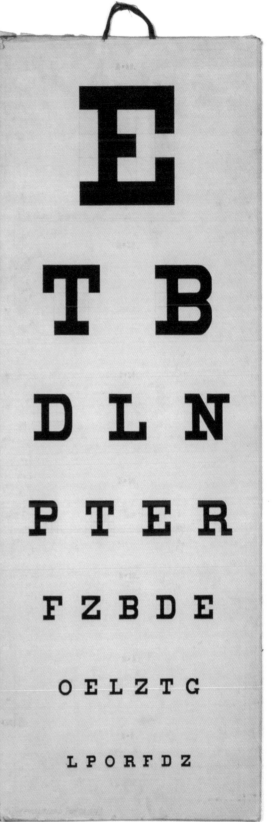

Can read: alphabetic eye test chart, Netherlands, 19th century

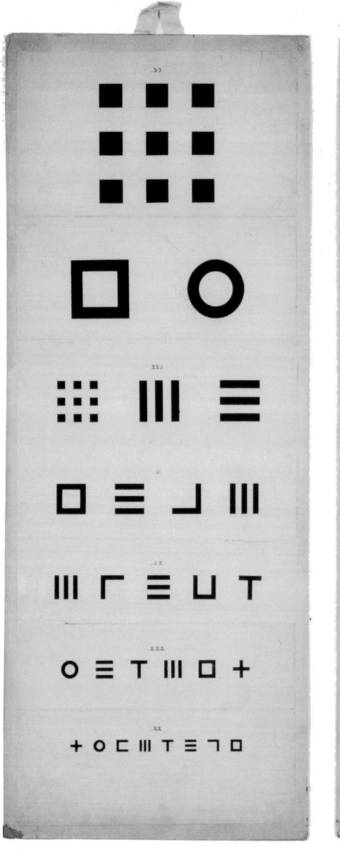
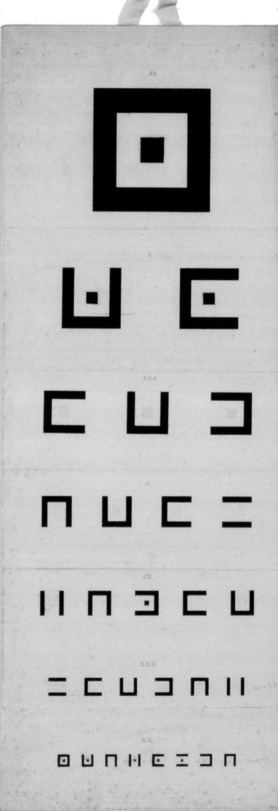

Can't read: abstract eye test chart, Netherlands, 19th century

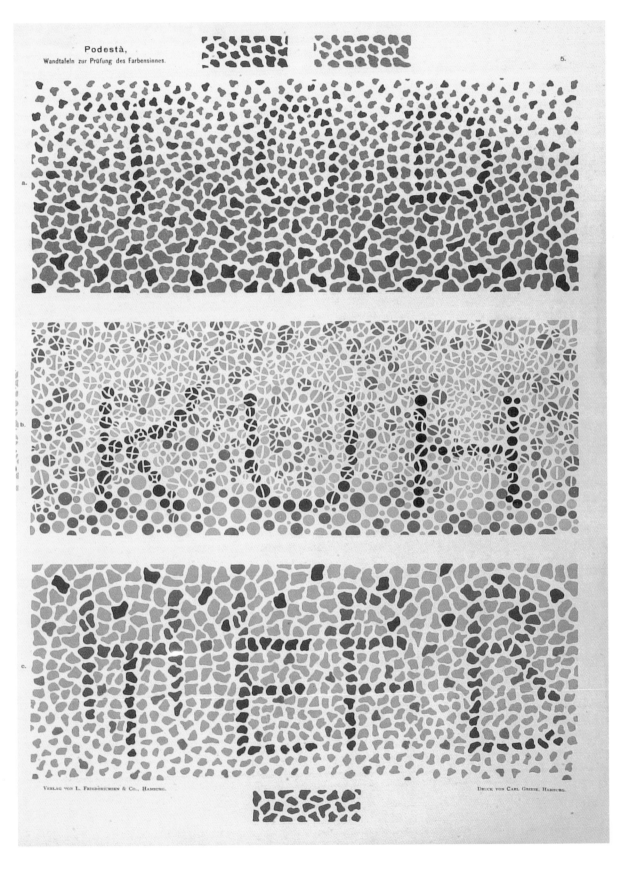

H. Podesta, colour blindness test, Germany, 1916

Joan Brossa, *Visual Poem*, Spain, 1978

Saul Steinberg, from *All In Line*, USA, 1945

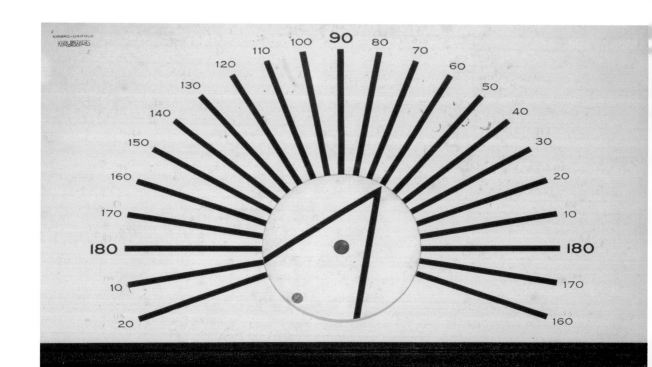

Inventive: eye test chart, UK, 19th century

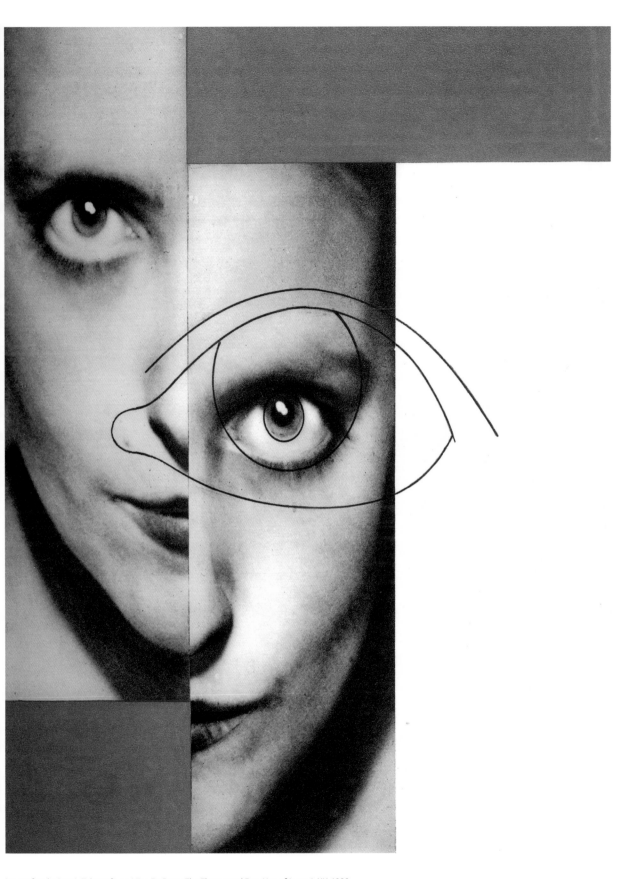

An eye for design: A. Tolmer, from *Mise En Page: The Theory and Practice of Layout*, UK, 1932

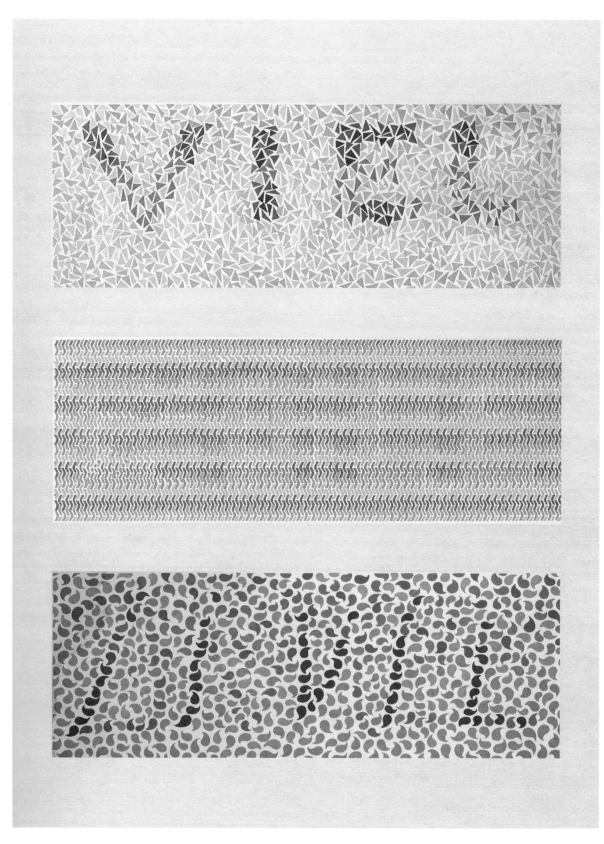

H. Podesta, colour blindness test, Germany, 1916

Cézanne once said, *'Monet is just an eye. But, God, what an eye!'* But of course no artist is just an eye, however extraordinary. Both Cézanne and Monet were in their different ways obsessed with the process of seeing, and there is no seeing without thought. *'Appearances reach us through the eye,'* wrote Leo Steinberg, the great American art critic and historian, *'and the eye – whether we speak with the psychologist or the embryologist – is part of the brain and therefore hopelessly involved in mysterious cerebral operations.'* There is no such thing as pure vision: 'outsight' requires insight to make it work; every experience brings an unprecedented visual composition of the world we look at. This makes creative seers of us all as soon as we pay attention to what we see. Colour is complex, paint is texture, photography discovers strangeness in the everyday. Anything can bring focus to the artistic eye: a posing model, postcards and old cuttings, a mountainside, a horse indoors, seashells, a bathroom sink, the idea of a film. The thoughtful eye is a doorway to art, and art is a portal to the as-yet-unseen.

THE ARTIST'S EYE

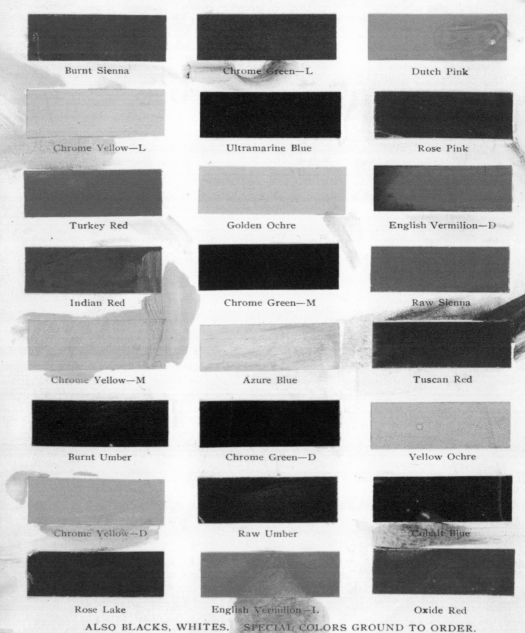

W. P. FULLER & COMPANY.

SAMPLE SHADES OF
DISTEMPER COLORS.
For Fresco Painting and Interior Decorating.

Burnt Sienna	Chrome Green—L	Dutch Pink
Chrome Yellow—L	Ultramarine Blue	Rose Pink
Turkey Red	Golden Ochre	English Vermilion—D
Indian Red	Chrome Green—M	Raw Sienna
Chrome Yellow—M	Azure Blue	Tuscan Red
Burnt Umber	Chrome Green—D	Yellow Ochre
Chrome Yellow—D	Raw Umber	Cobalt Blue
Rose Lake	English Vermilion—L	Oxide Red

ALSO BLACKS, WHITES. SPECIAL COLORS GROUND TO ORDER.

An unknown painter tests out a colour-man's sample chart, USA, late 19th century

Collage of source material from Picasso's studio, France, early 20th century

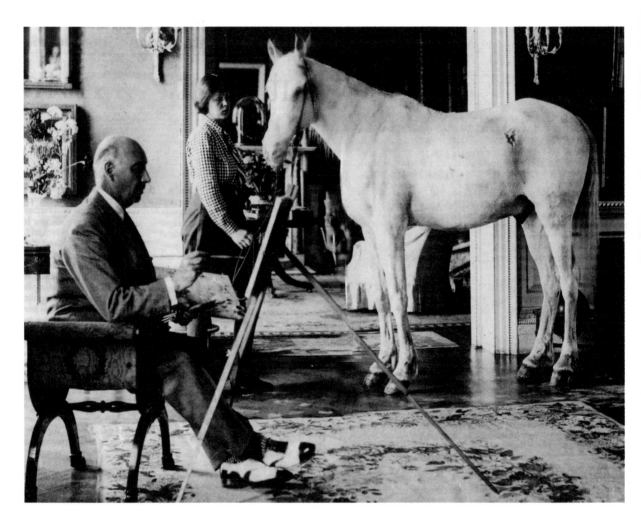

Artist at work: unknown photographer, *Lord Berners paints a horse*, UK, *c.*1940

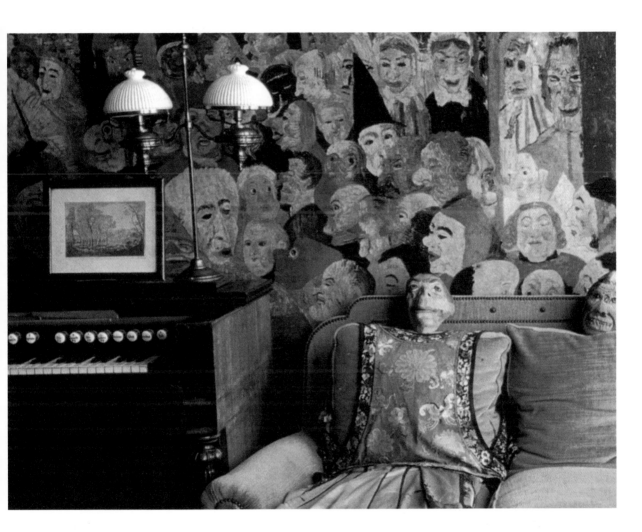

Jean-Claude Amiel, *James Ensor's Harmonium*, France, 2004

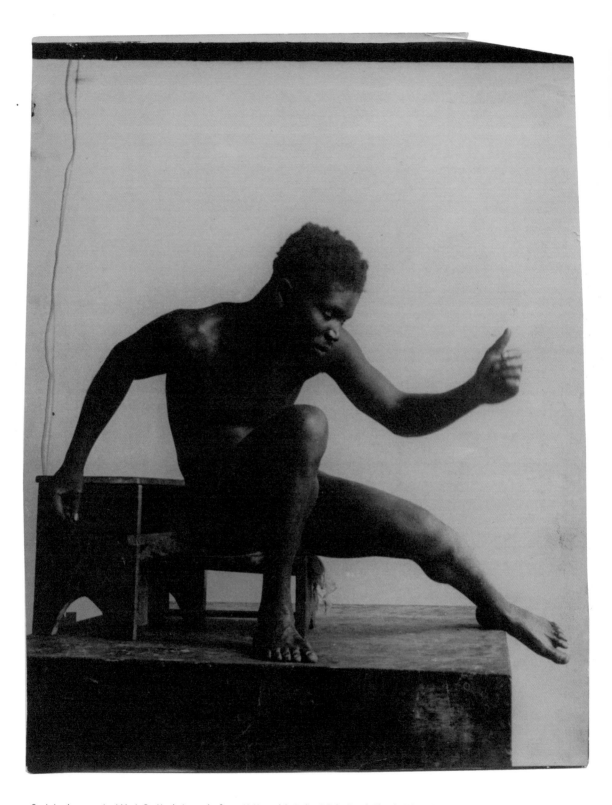

Contained energy: José Maria Sert's photograph of an artist's model, studio at Palm Beach, Florida, USA, 1924

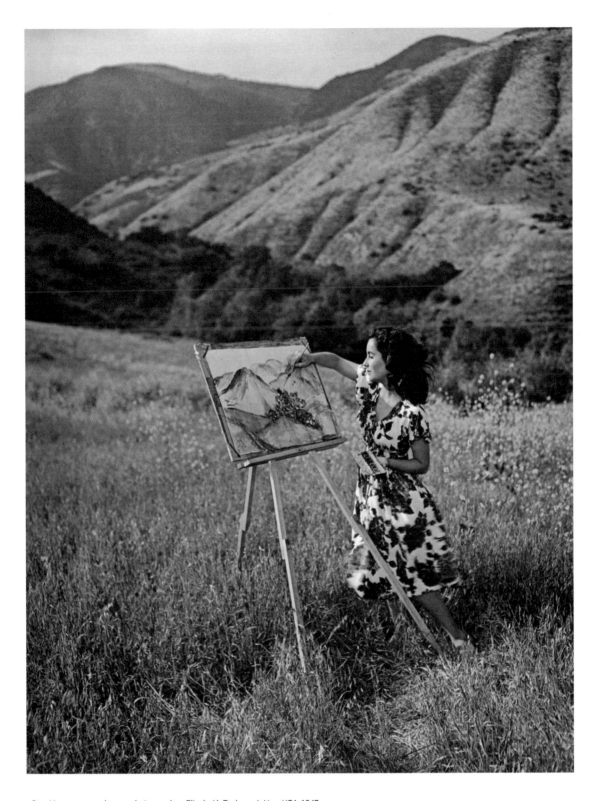

Creative energy: unknown photographer, Elizabeth Taylor painting, USA, 1947

L'OEIL

300 FRANCS · DOUZE PAGES EN COULEURS

REVUE D'ART

SUISSE FRANCS 3.80 · BELGIQUE 54 FRANCS · NUMÉRO 7.8 · JUILLET/AOUT 1955

Cover of art magazine, France, July-August, 1955

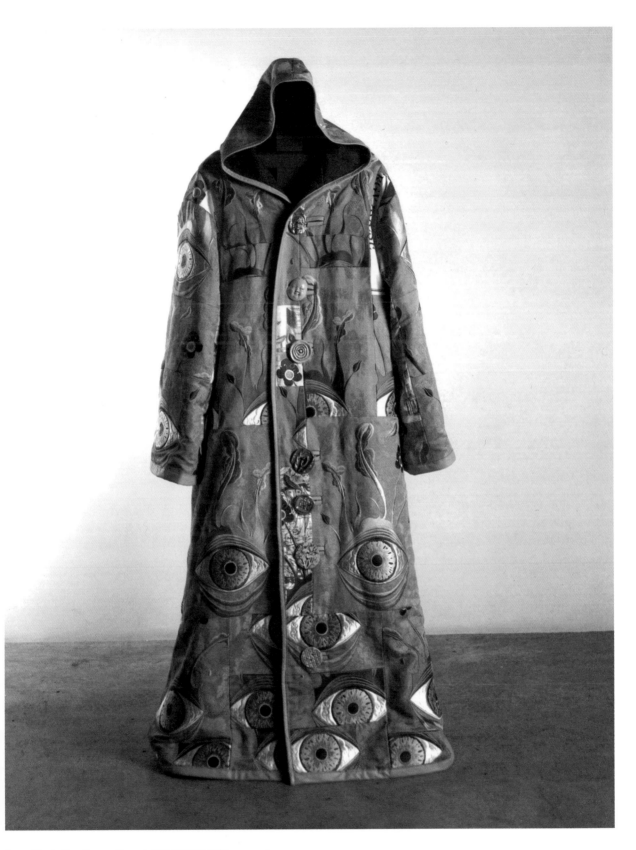

Eyes without a face: Grayson Perry, *Artist's Robe*, UK, 2004

A great artist's marginalia, UK

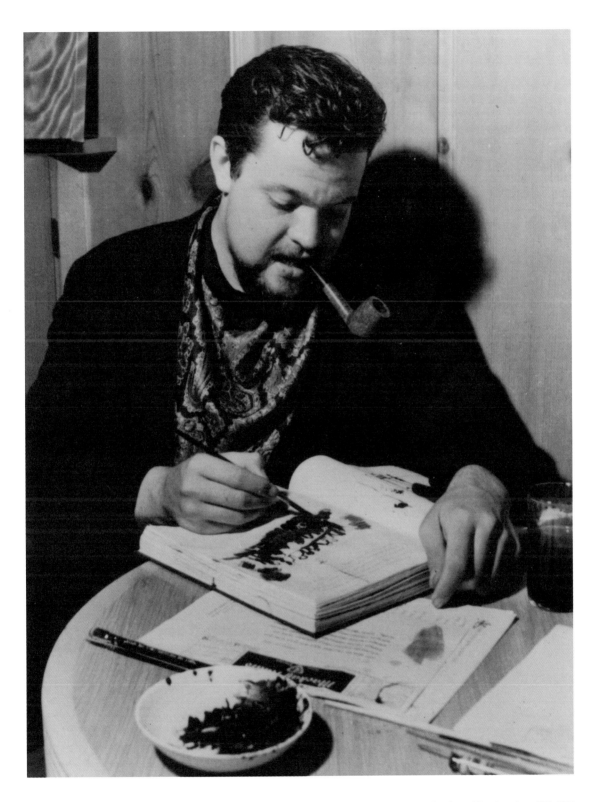

Concentrated energy: Peter Stackpole, photograph of Orson Welles, who once dreamed of being a painter, sketching with watercolours, USA, 1940s

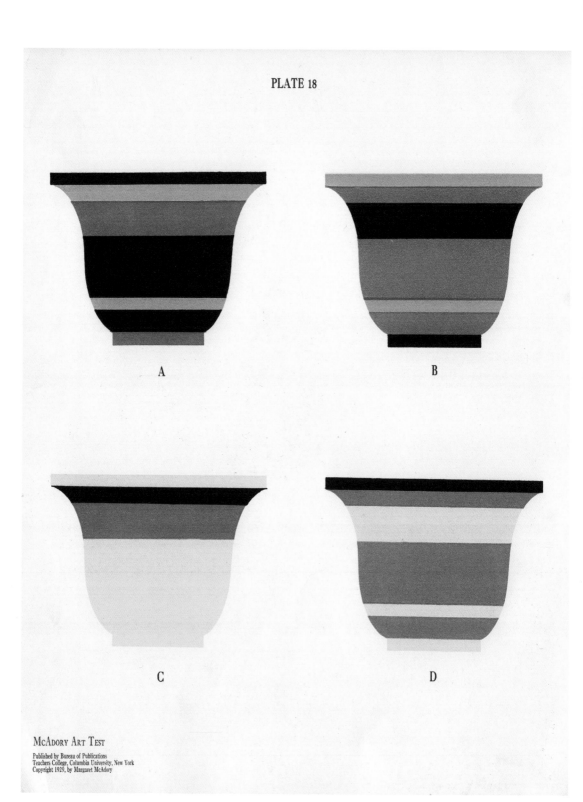

PLATE 18

A

B

C

D

McAdory Art Test

Published by Bureau of Publications
Teachers College, Columbia University, New York
Copyright 1929, by Margaret McAdory

Which design is best?: aesthetic judgment indicator, from McAdory Design Test, USA, 1929

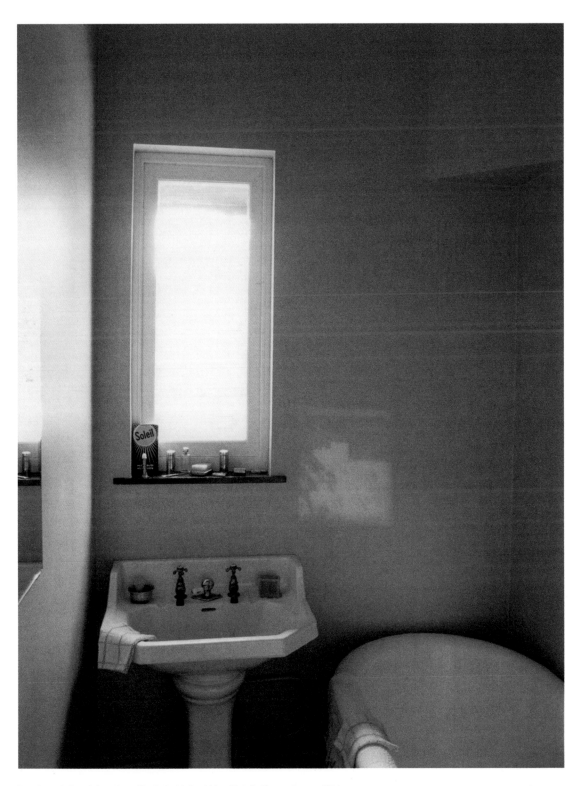

Boxed sun at the window: Jean-Claude Amiel, *René Magritte's Bathroom*, France, 2004

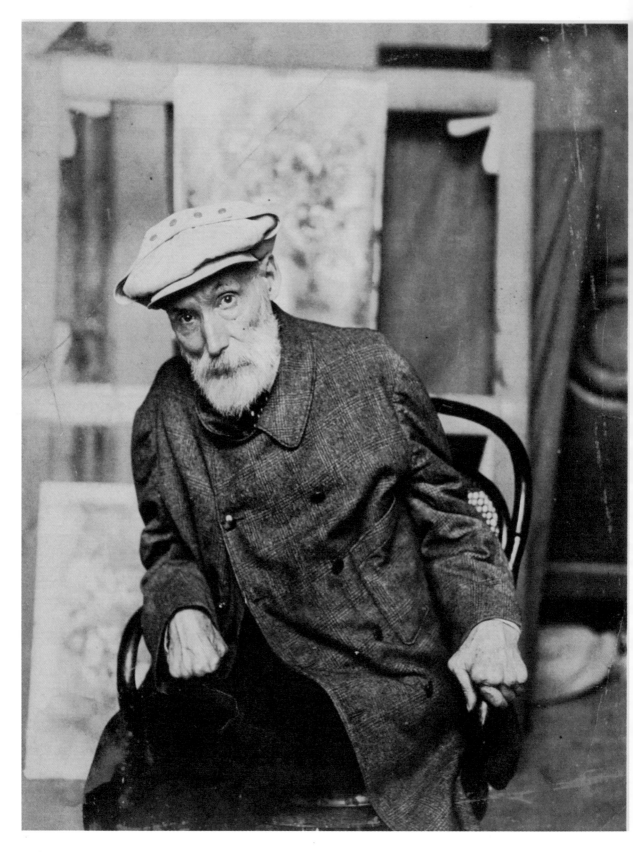

Indefatigable visionary: Pierre-Auguste Renoir at 72, Vollard Gallery photograph, France, 1913

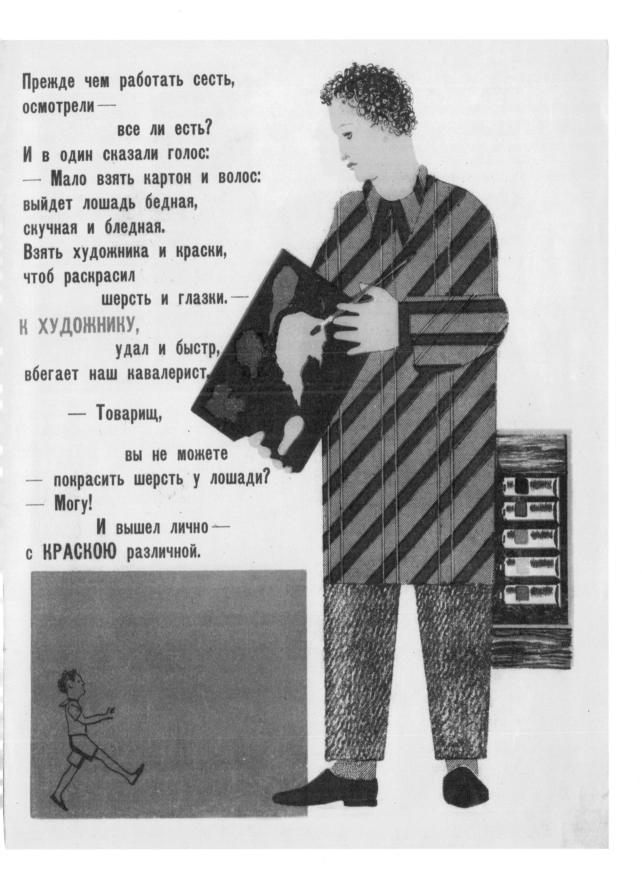

Прежде чем работать сесть,
осмотрели—
 все ли есть?
И в один сказали голос:
— Мало взять картон и волос:
выйдет лошадь бедная,
скучная и бледная.
Взять художника и краски,
чтоб раскрасил
 шерсть и глазки.—
К ХУДОЖНИКУ,
 удал и быстр,
вбегает наш кавалерист.

 — Товарищ,

 вы не можете
— покрасить шерсть у лошади?
— Могу!
 И вышел лично—
с КРАСКОЮ различной.

Portrait of the artist: Lidia Popova, illustration for Mayakovsky's children's book, *The Fire Horse*, USSR, 1928

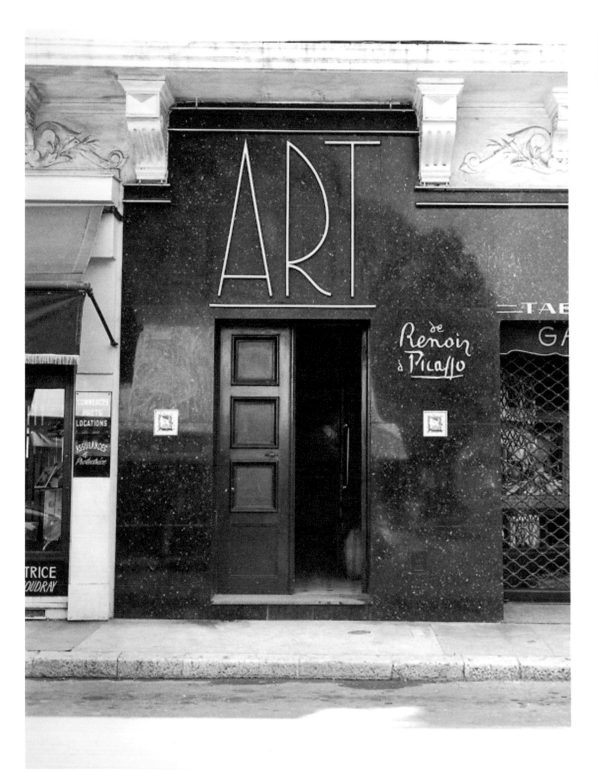

Ed Ruscha, *Cannes, France*, USA, 1961

'Outside, the street prepared a thousand more real enchantments for me.'

André Breton was writing about the difference between the pleasures and problems of traditional art in museums and the ever-changing, perpetually marvellous reality of the street, a reality that, even as it unfolds, acquires the quality of the surreal. Nothing has opened our eyes to the super-real enchantments, intrigues and enigmas of the street more than the sudden chemical enlightenments of photography.

From Baudelaire to Benjamin, from Caillebotte to Léger, from Aragon to Warhol, the street, its adornments and defacements, its strange and familiar objects, its human drama and political spectacle, has provided a major focus for modern painting, photography and film. Breton's *'more real enchantments'* have paradoxically entered art itself. Now, expecting to be surprised, we all keep an eye on the street.

AN EYE

ON THE STREET

Keep an eye out! unknown artist, street scene illustration from *The Blue Point*, USSR, c.1930

юрий владимиров

синяя точка

3 коп.

ГИЗ
1930

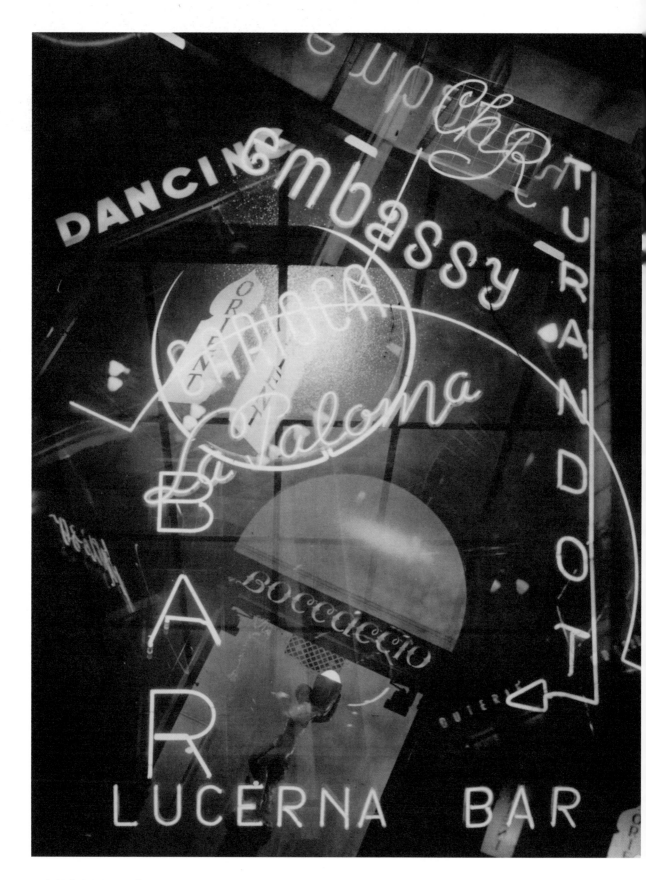

Night life/night lights: Josef Ehm, *Untitled*, Czechoslovakia, 1935

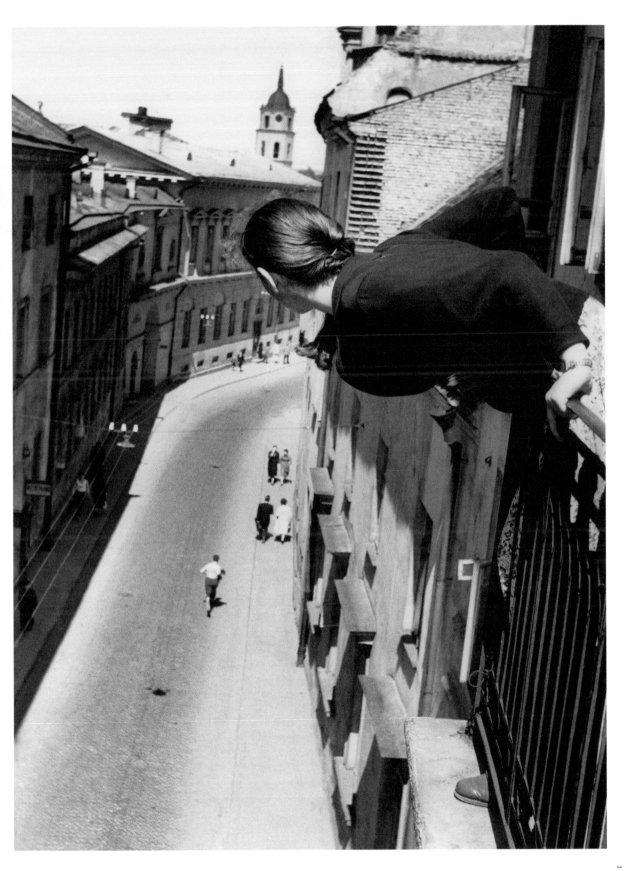

Antanas Sutkus, from *The Daily Life Archives 1959-1993*, Lithuania, late 20th century

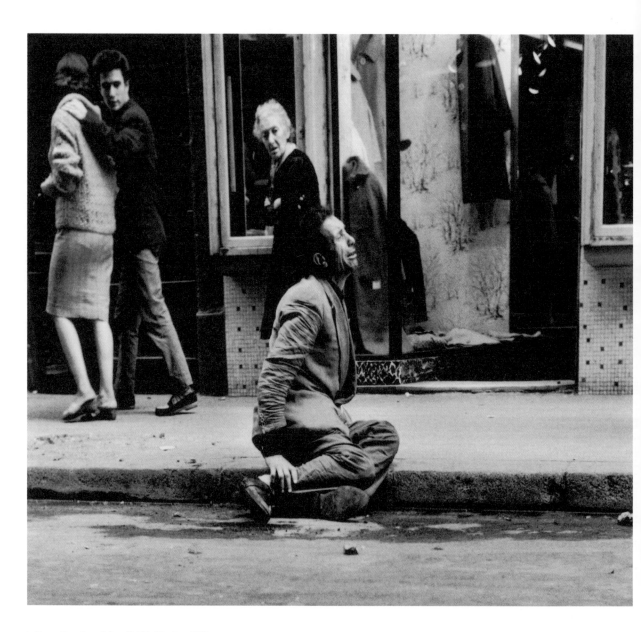

In the gutter: Joan Colom, *Untitled*, Spain, *c.*1965

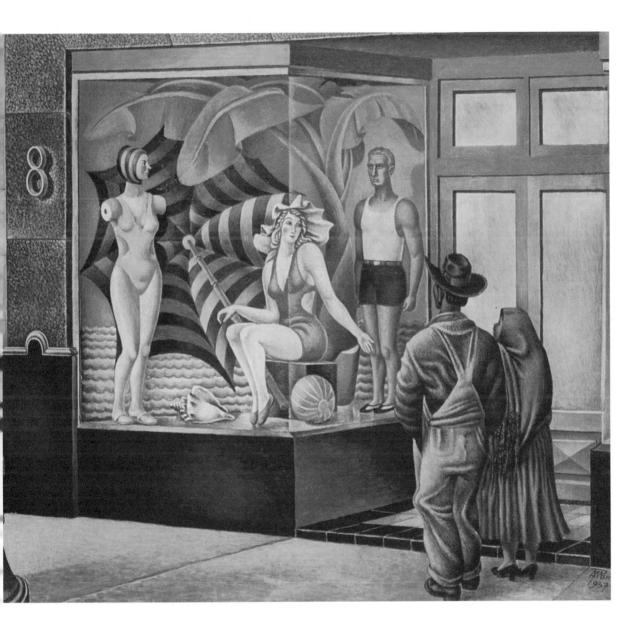

Street dreams: Antonio Ruiz, *Summer,* Mexico, 1937

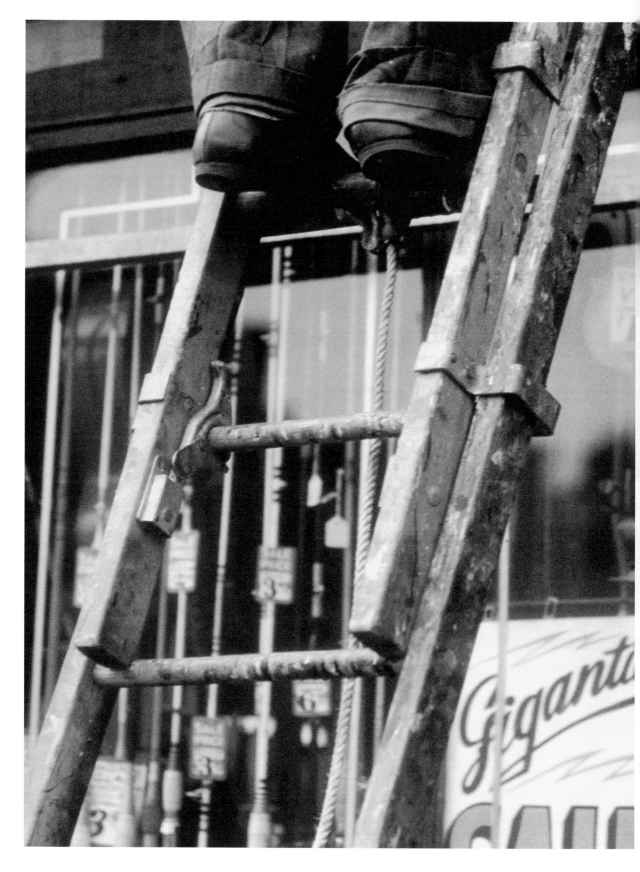

Saul Leiter, *Man on Ladder*, USA, 1954

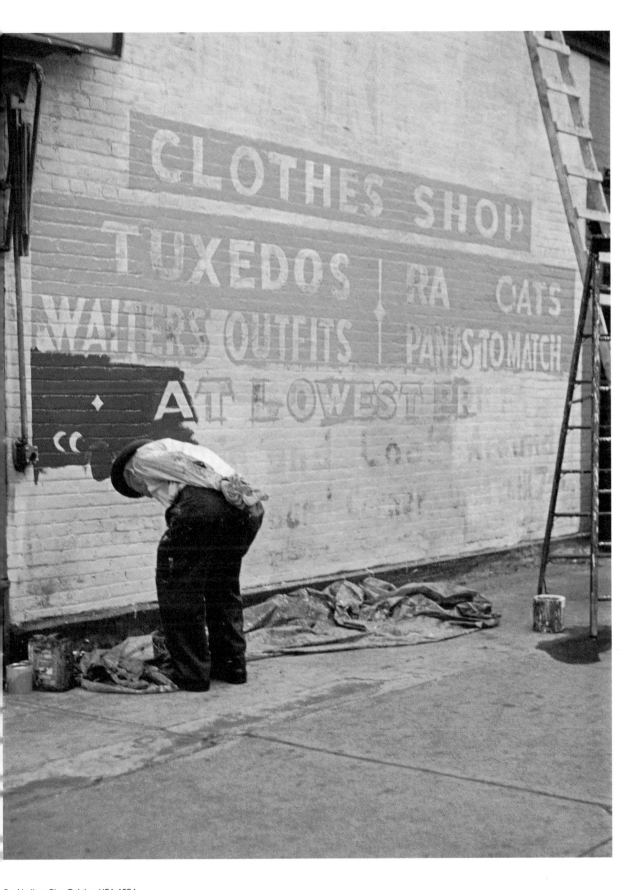

Saul Leiter, *Sign Painter*, USA, 1954

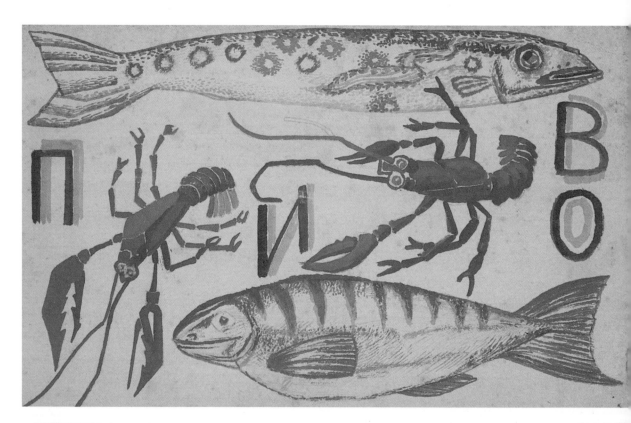

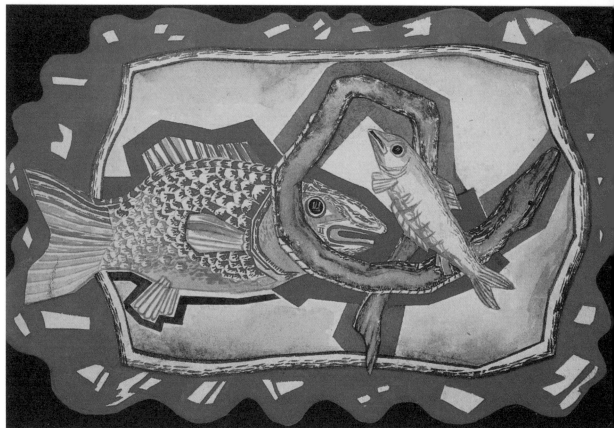

Eye-catching!: Nikolai Yevgrafov, sketches for shopfront panels, USSR, late 1920s

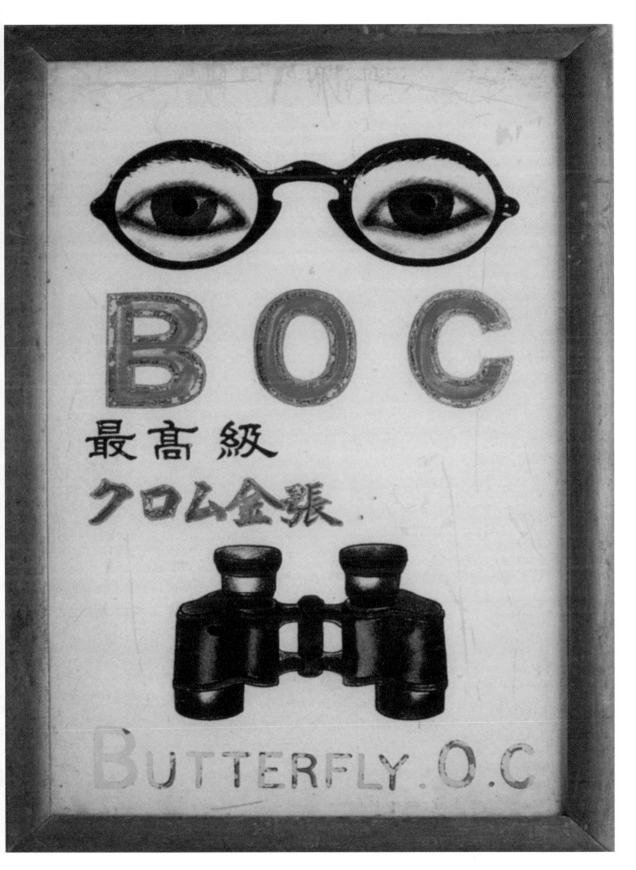

Binocular vision: spectacular shop sign, Japan, c.1930
OVERLEAF: Werner Heldt, *Parade of Zeros*, Germany, 1933–4

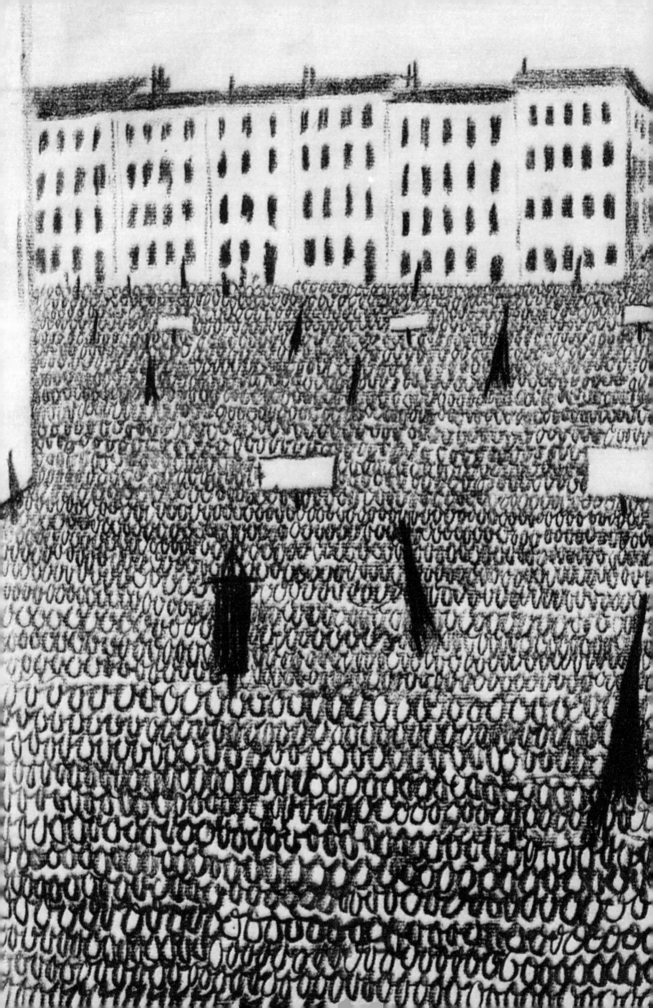

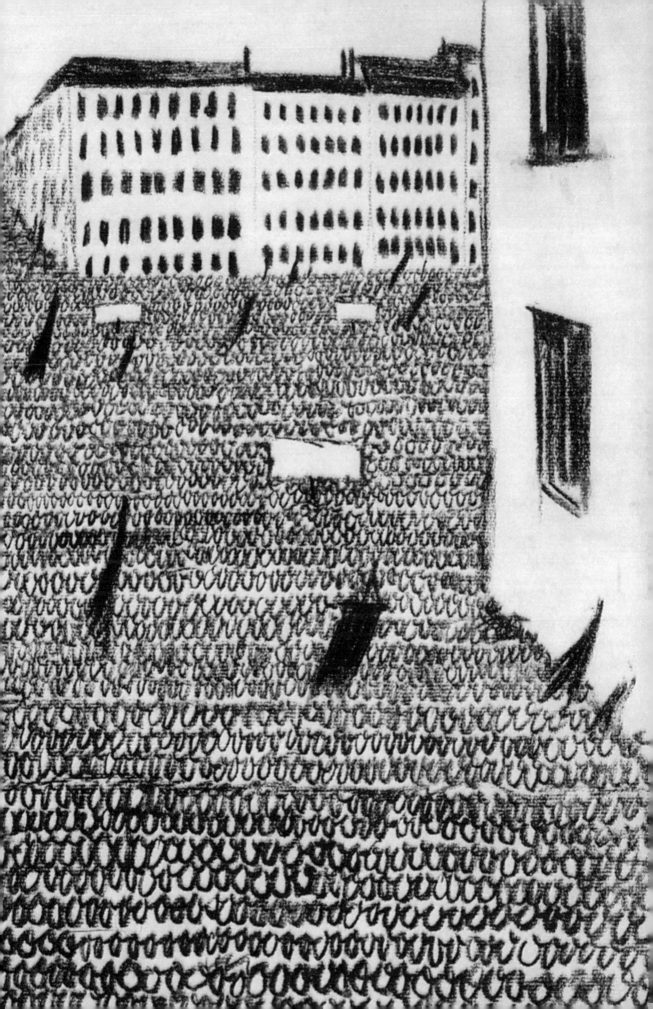

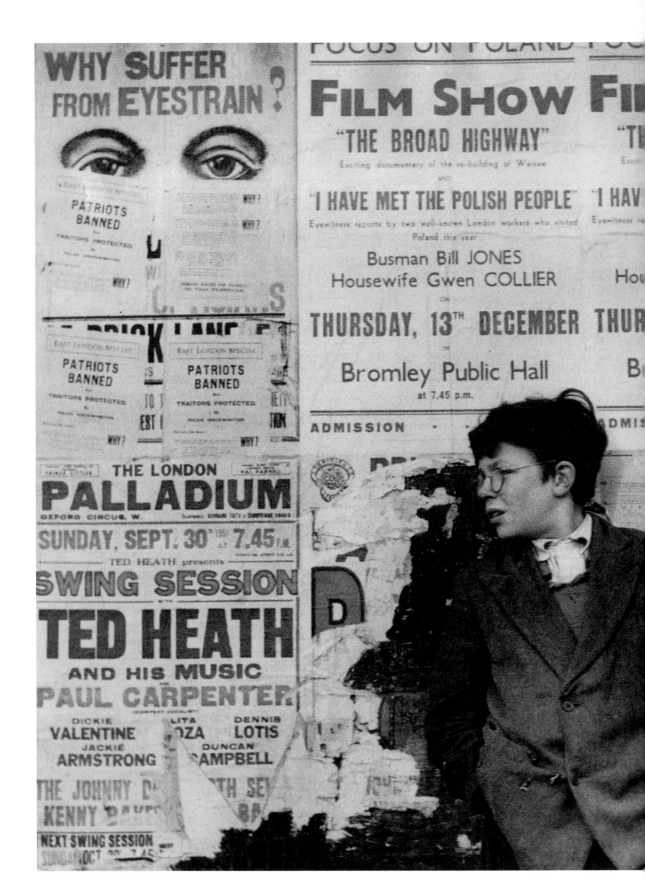

So much to see: Nigel Henderson, *Peter Samuels*, UK, 1951

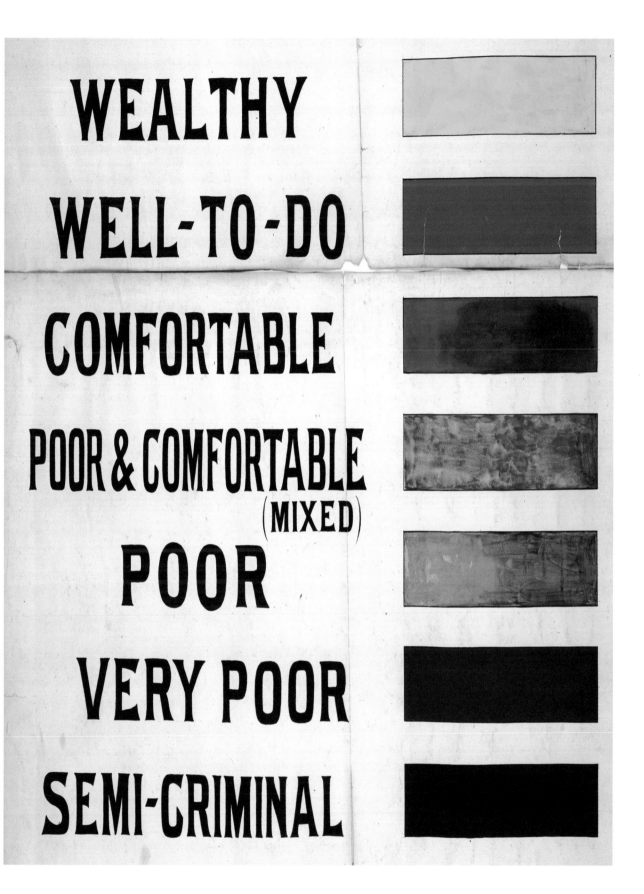

WEALTHY

WELL-TO-DO

COMFORTABLE

POOR & COMFORTABLE (MIXED)

POOR

VERY POOR

SEMI-CRIMINAL

Charles Booth, colour key to map of street demographics, in first *Maps Descriptive of London Poverty*, UK, 1889

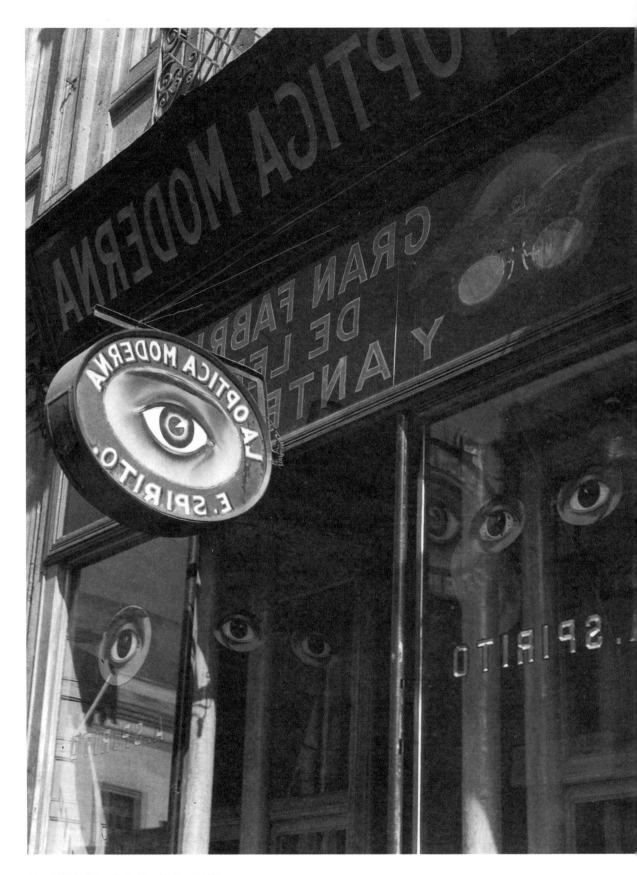

Manuel Alvarez Bravo, *Optical Parable*, Mexico, 1931

Legs without bodies: Martha Rosler, *Vienna*, 1987

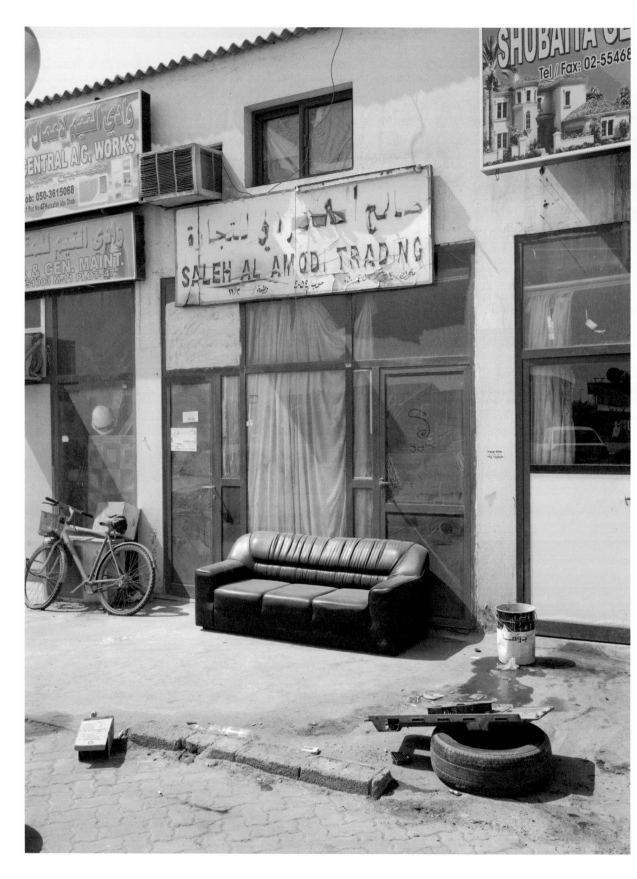

Not much trade: Stephen Shore, *Abu Dhabi, United Arab Emirates, October 23*, 2009

THE COMIC
EYE

To have a pure eye for the absurd, the ironic or the simply comic is a rare and special gift. The images here have the quality of the purely visual: beyond mere identification they require no captions. Each works by taking a visual correspondence, a simple idea, a parody or an inadvertence and presenting it with an absurd literalness. The penny drops: you smile.

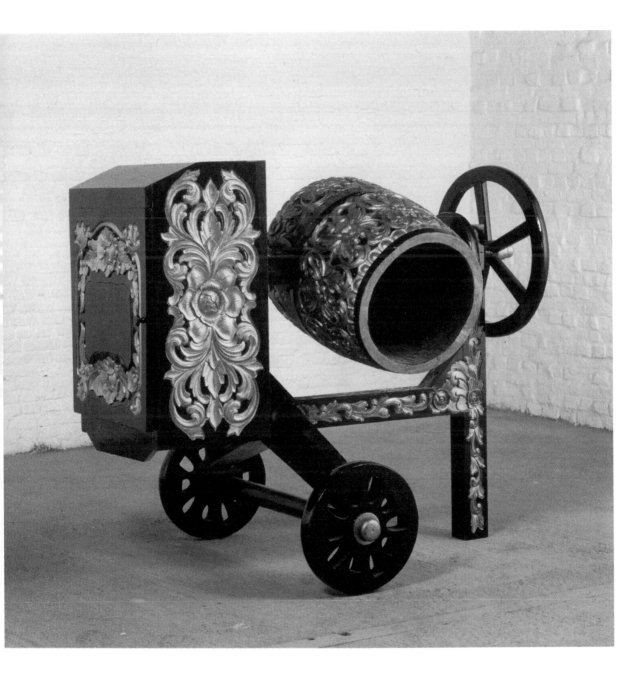

Wim Delvoye, *Cement Mixer*, Belgium, 1992

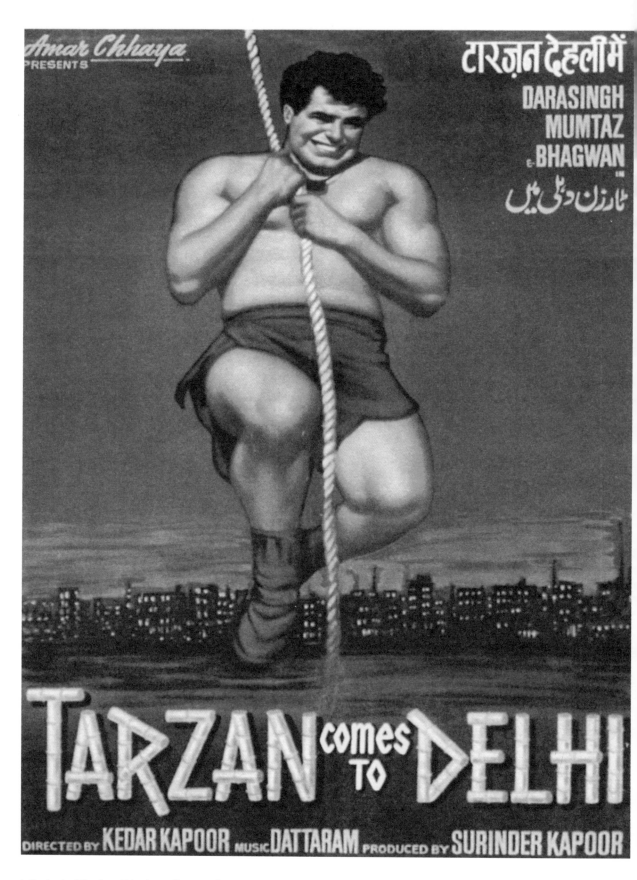

In the jungle of the city: artist unknown, film poster for *Tarzan Comes to Delhi*, India, 1965

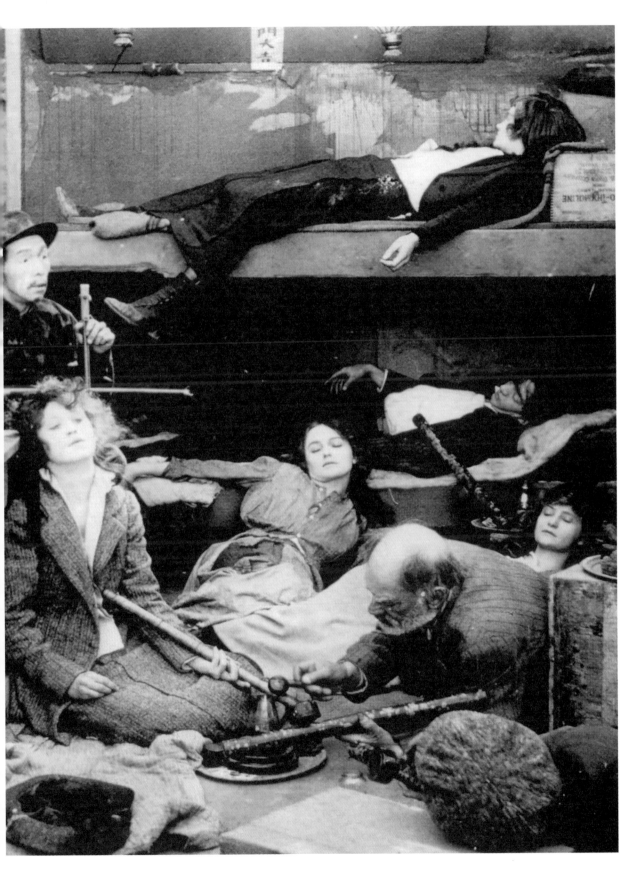

Out of it: film still from anti-drugs film *The Dividend*, USA, 1916

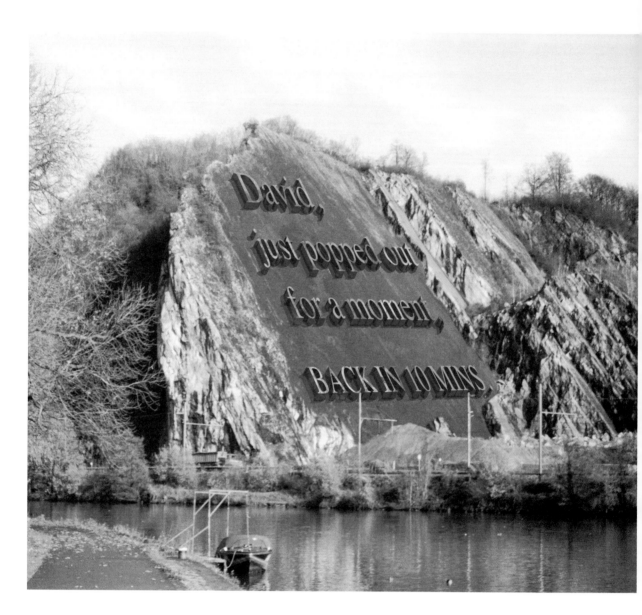

Wim Delvoye, *David, just popped out for a moment, back in 10 mins.*, Belgium, 1997

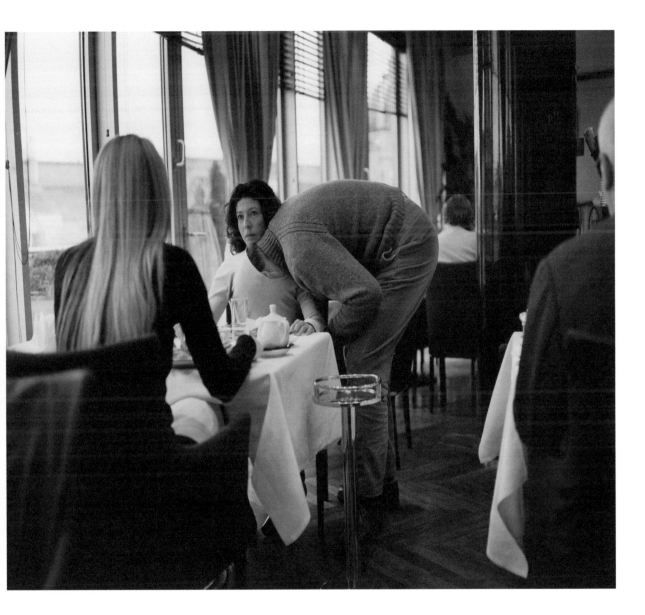

Erwin Wurm, *Inspection*, from the series *How to be Politically Incorrect*, Austria, 2002

David Shrigley, *Untitled,* from *Why We Got the Sack from the Museum,* UK, 1998

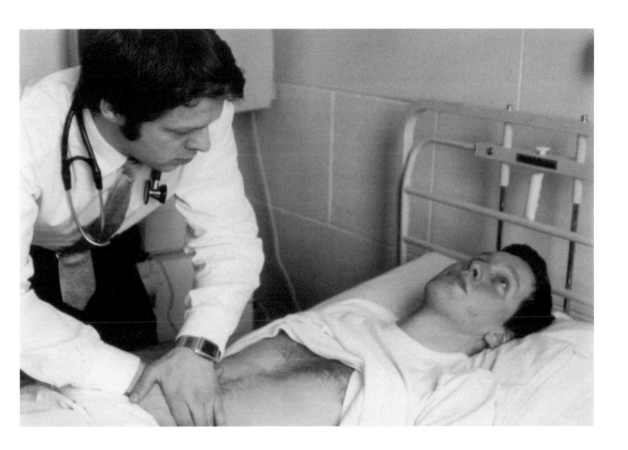

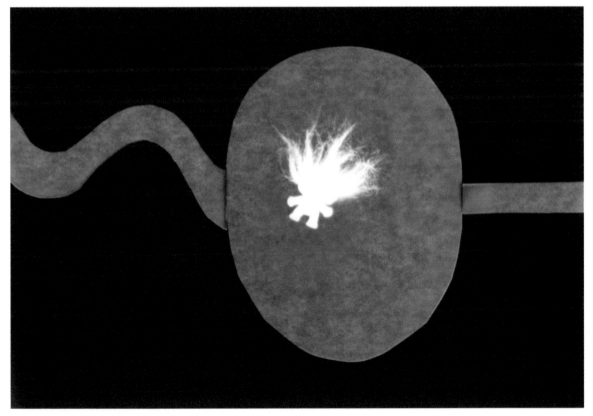

David Shrigley, *X-Ray*, UK, 2002

TAUCHNITZ EDITION

COLLECTION OF BRITISH AND AMERICAN AUTHORS

VOL. 5027

THE ENGLISH: ARE THEY HUMAN?

BY

G. J. RENIER

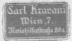

LEIPZIG: BERNHARD TAUCHNITZ

PARIS: LIBRAIRIE GAULON & FILS, 39, RUE MADAME

Not to be introduced into the British Empire and U.S.A.

Who wants to know?: *The English: Are they Human?* by G. J. Renier, Germany, 1932

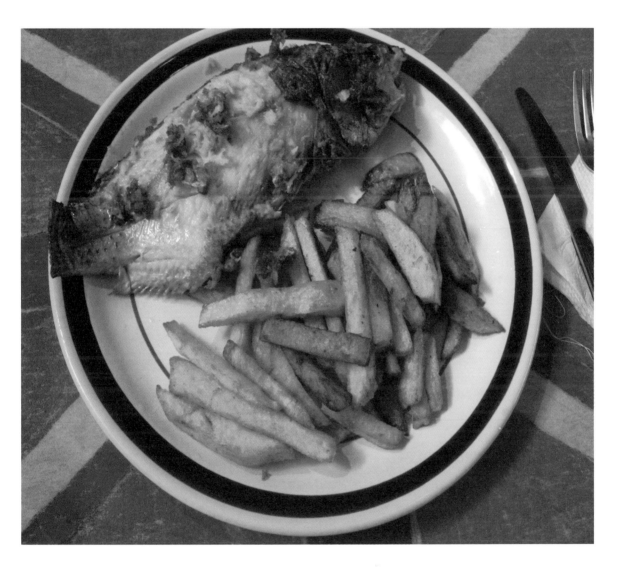

Mmm! Sea bream and chips! (Not *quite* right): Alicia Melendez, *Fish and Chips*, from a photo project to make an image of England, Mexico, 2000

Chema Madoz, *Untitled*, Spain, 1998

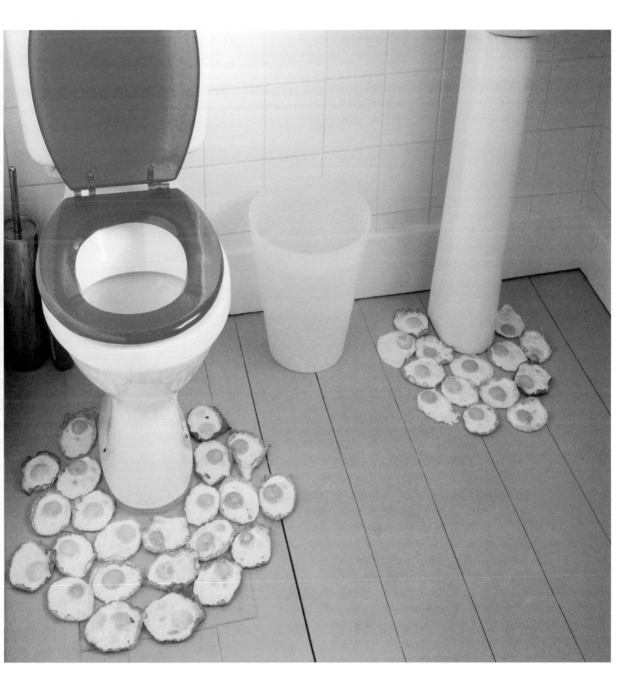

Sian Bonnell, from the series *House Beautiful*, UK, 2002-5

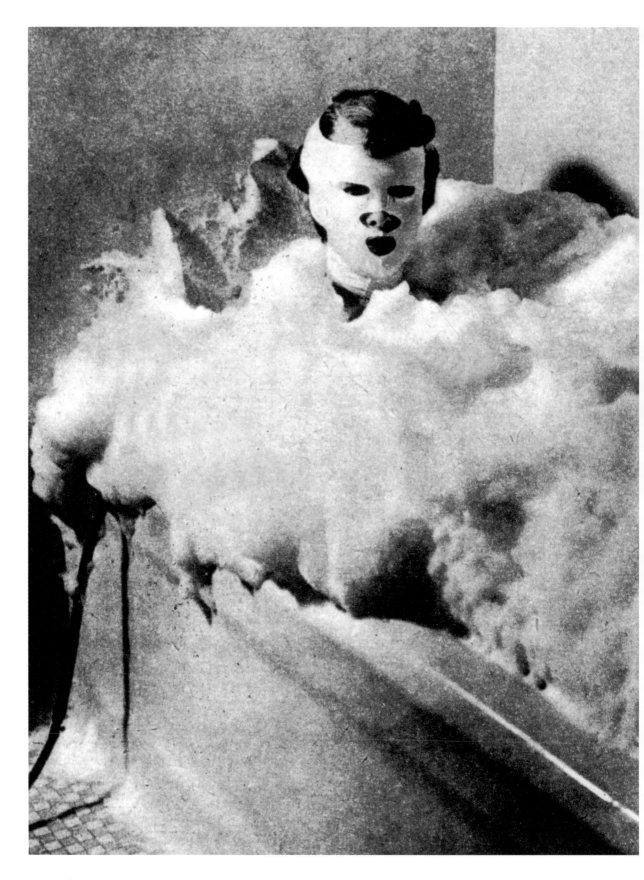

Beauty: unknown photographer, *The Beauty Bath*, UK, c.1938

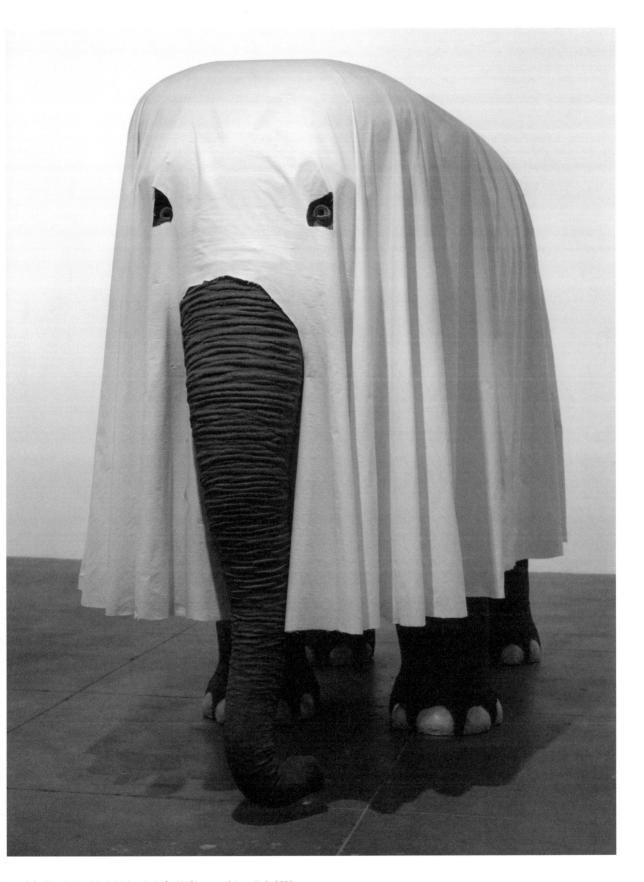

....and the Beast: Maurizio Cattelan, *Not Afraid of Love*, sculpture, Italy, 2000

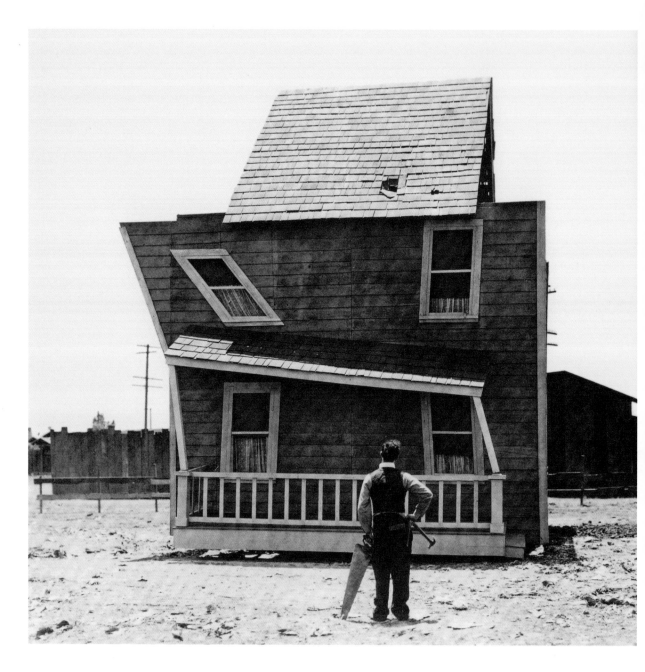

Wait for it: Buster Keaton in *One Week*, USA, 1920

Friedrich Kunath, *Untitled*, Germany, 2009

Sian Bonnell, from the series *Risk Assessment*, UK, 2009

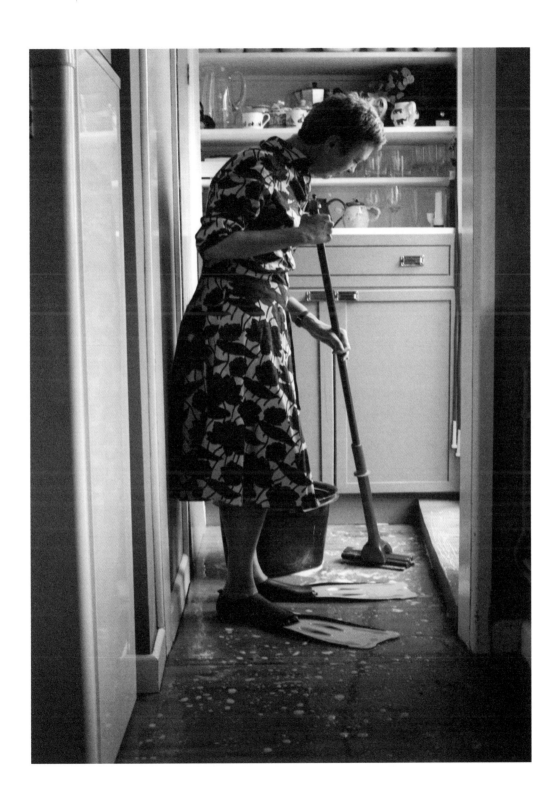

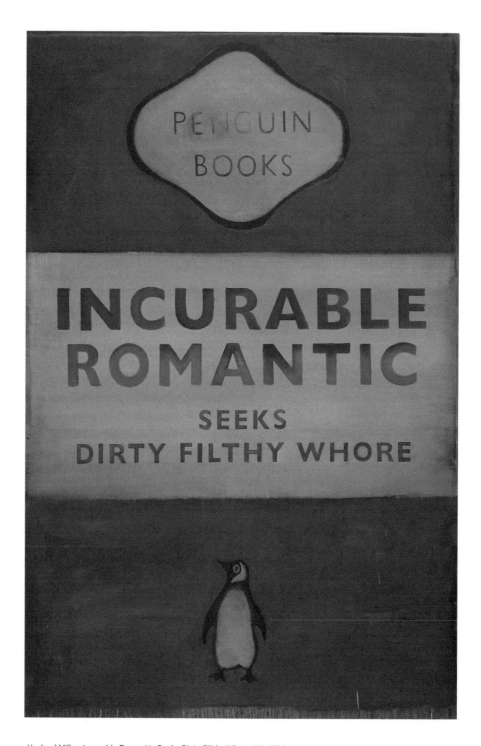

Harland Miller, *Incurable Romantic Seeks Dirty Filthy Whore*, UK, 2006

THE MIND'S EYE

When we imagine things or places, or recall our dreams when we are awake, or lie in that state between sleeping and waking, or see in a blot on the page landscapes or figures or creatures, or simply when we remember something visually, we speak of what we see as in the mind's eye. It is as if we cast images on a transparent screen. This inner vision can be vivid or vague, but it will quickly fade, as if in a dream. But the inventions of art can hold the image or project one that did not exist before. We measure our immediate visual actuality against these visions of the mind: they transfigure the ordinary.

William Blake knew that the mind's eye sees reality with great clarity: '*The tree which moves some to tears of joy is in the eyes of others only a Green thing which stands in the way. Some see Nature all Ridicule and Deformity, and by these I shall not regulate my proportions; and some scarce see Nature at all. But to the Eye of the Man of Imagination, Nature is Imagination itself. As a man is, so he sees. As the Eye is formed, such are its Powers. You certainly Mistake, when you say the Visions of Fancy are not to be found in This World. To Me This World is all One continued Vision of Fancy or Imagination, and I feel Flatter'd when I am told so.*'

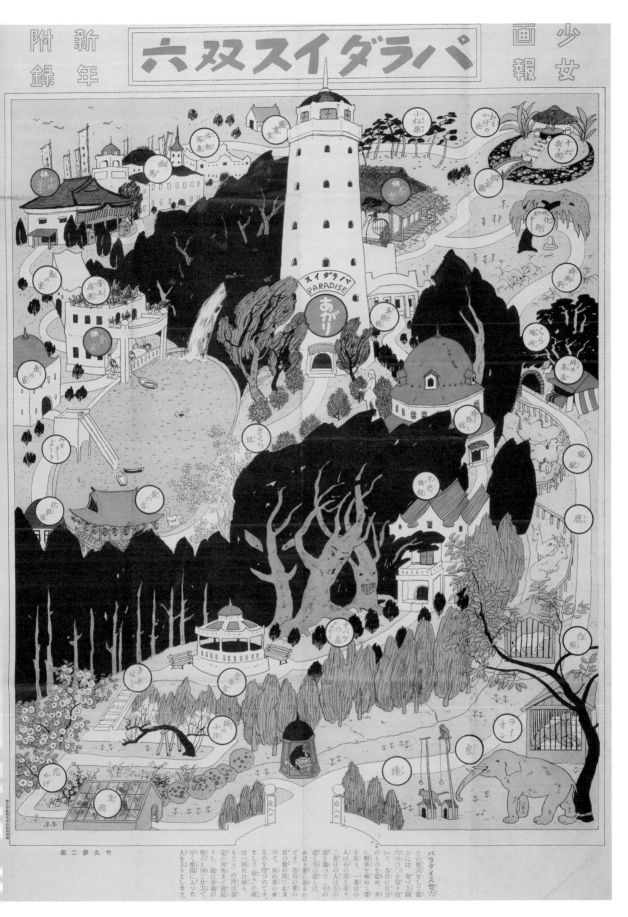

Children's board game: *The Road to Paradise*, Japan, 19th century

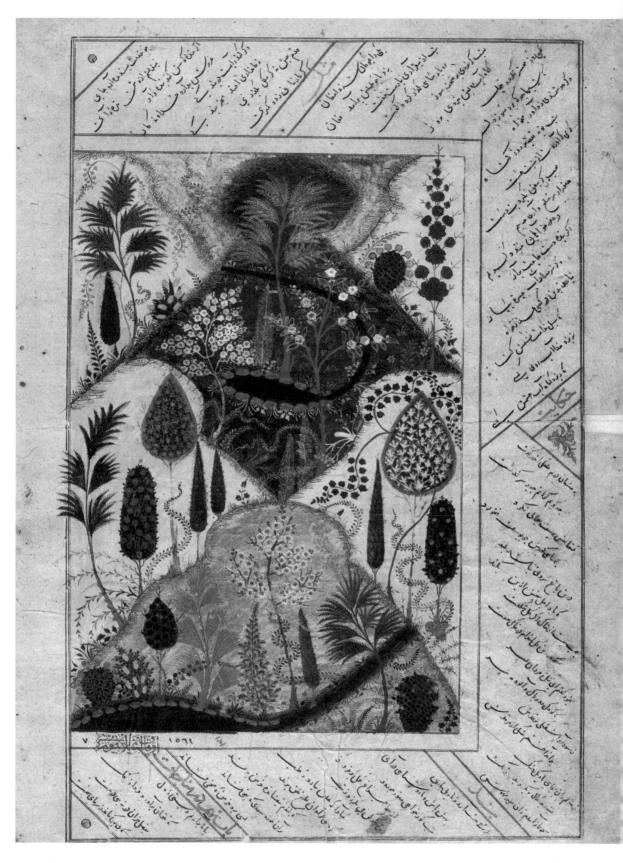

Paradise found!: Unknown artist and writer, Persia, 18th century

LES RÈVES.

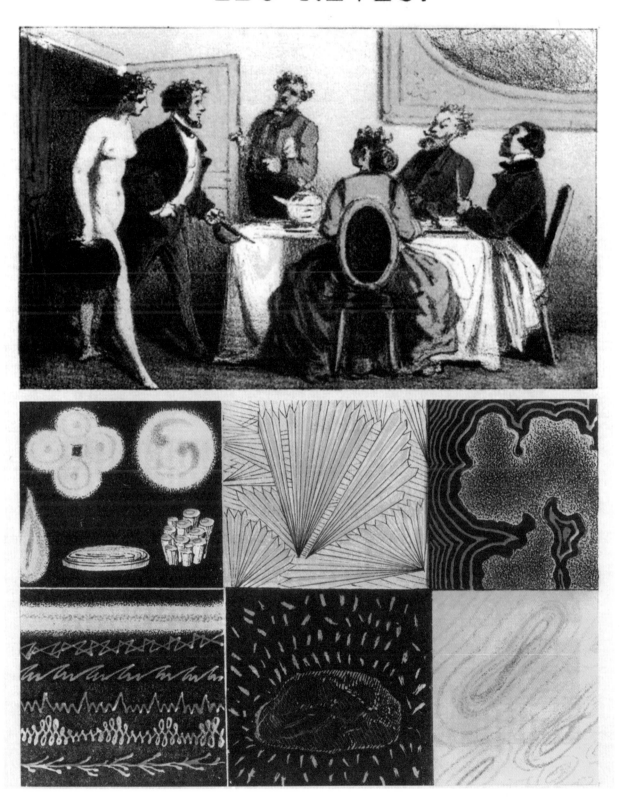

ABOVE: a common bourgeois dream, lithograph, France, 19th century; BELOW: between sleep and waking, anoetic images recorded by the Marquis Hervey de Saint-Denis, Paris, France, 1867

Holistic analysis: educational chart, India, 1995

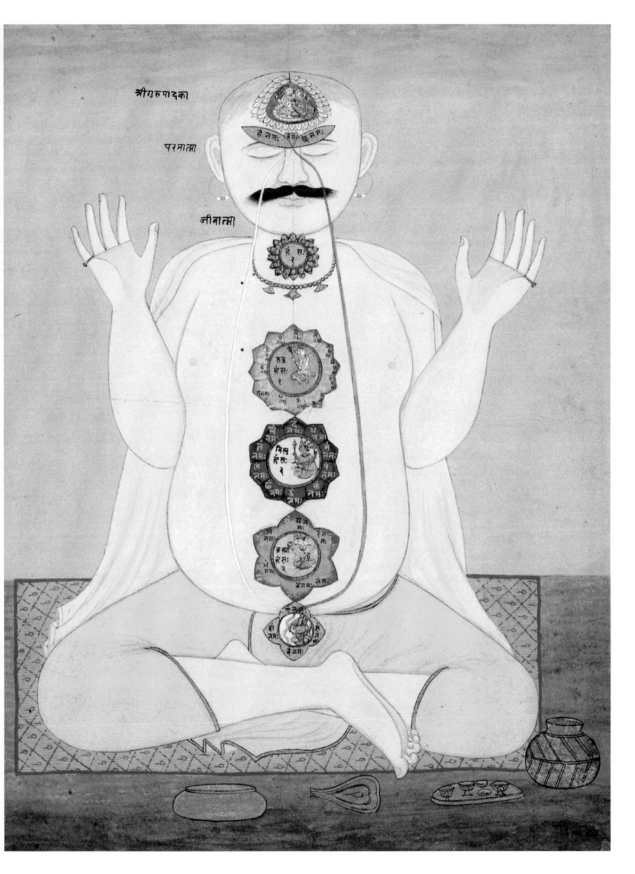

The chakras are the seven centres of spiritual energy of the body, often depicted as flowers or wheels; they are located at the crown of the head, the forehead, the throat, the heart, the solar plexus, the base of the spine, the prostate or ovaries: Hindu painting, India, 19th century

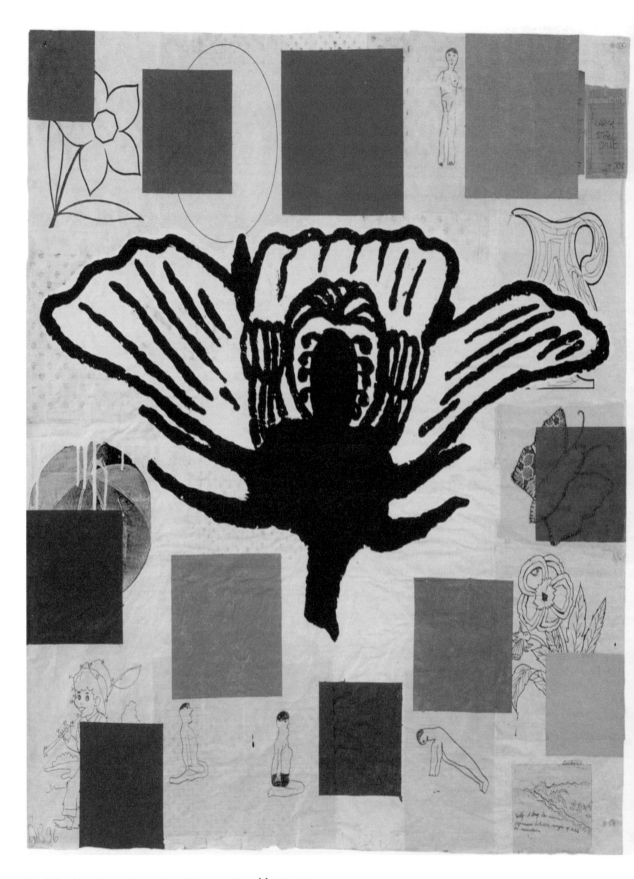

Donald Baechler, *Abstract Composition with Burmese Flower (4)*, USA, 1996

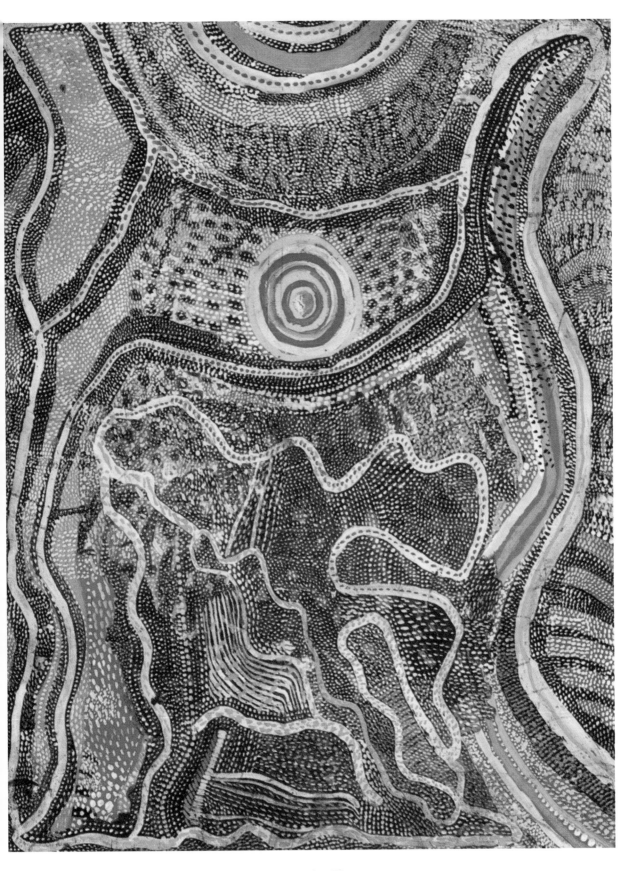

Johnny Warrangkula Tjupurrula, *Water Dreaming with Rain and Lightning*, Australia, 1972

2 And on the seventh day God ended his work which he had made; and he rested on the seventh day from all his work which he had made.

3 And God blessed the seventh day, and sanctified it: because that in it he had rested from all his work which God created and made.

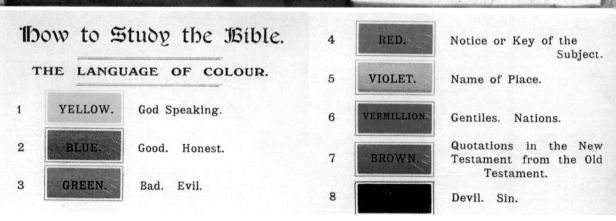

How to Study the Bible.

THE LANGUAGE OF COLOUR.

1	YELLOW.	God Speaking.
2	BLUE.	Good. Honest.
3	GREEN.	Bad. Evil.
4	RED.	Notice or Key of the Subject.
5	VIOLET.	Name of Place.
6	VERMILLION.	Gentiles. Nations.
7	BROWN.	Quotations in the New Testament from the Old Testament.
8		Devil. Sin.

Biblical exegesis made easy: from the Macklin Bible, with text colour-coded by Alfred Woods, UK, 1888-1900

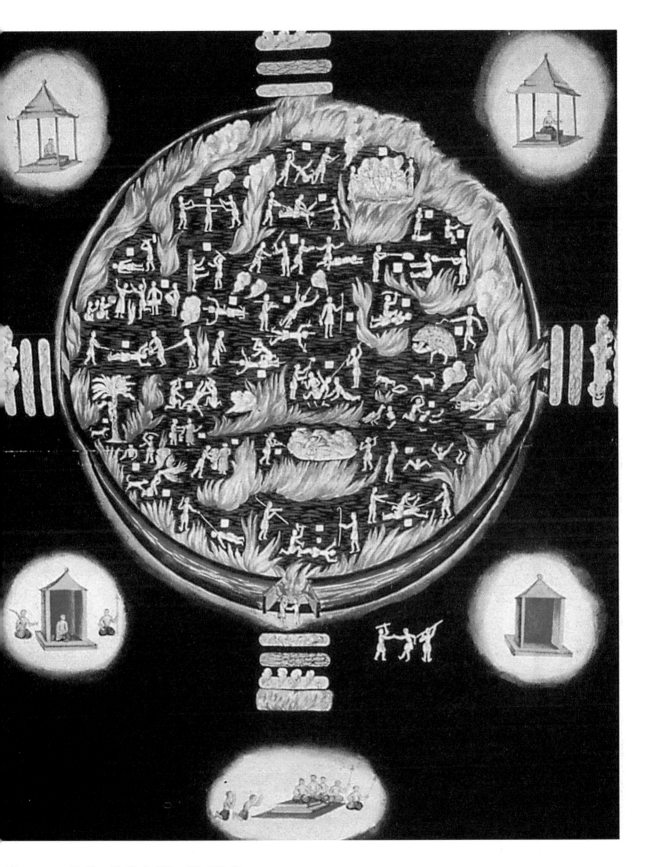

A Burmese map of hell from *The Wynford Album,* UK, c.1830–40

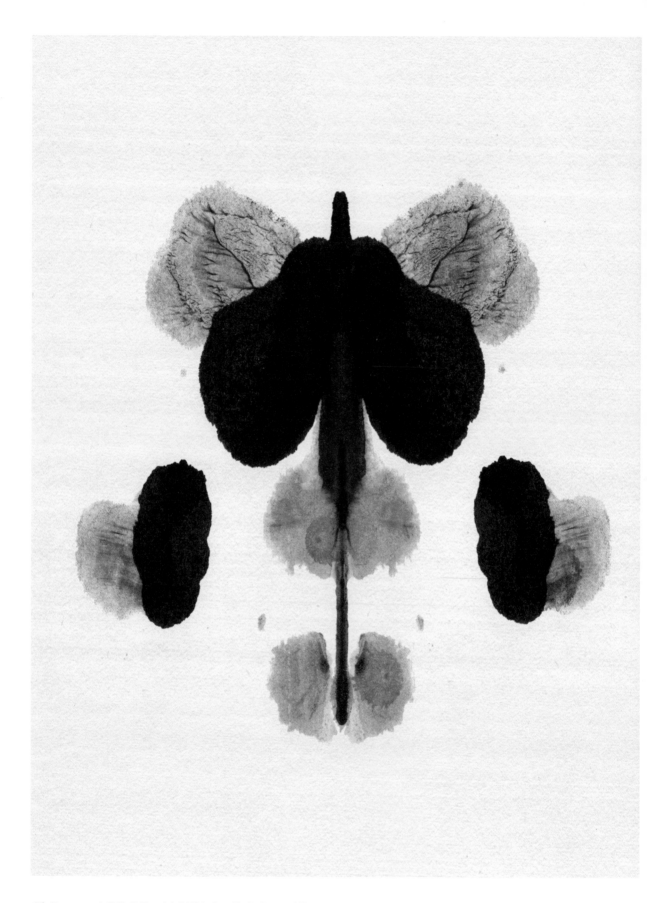

What's on your mind? Ella Rothenstein, inkblots from *The Redstone Inkblot Test*, UK, 2010

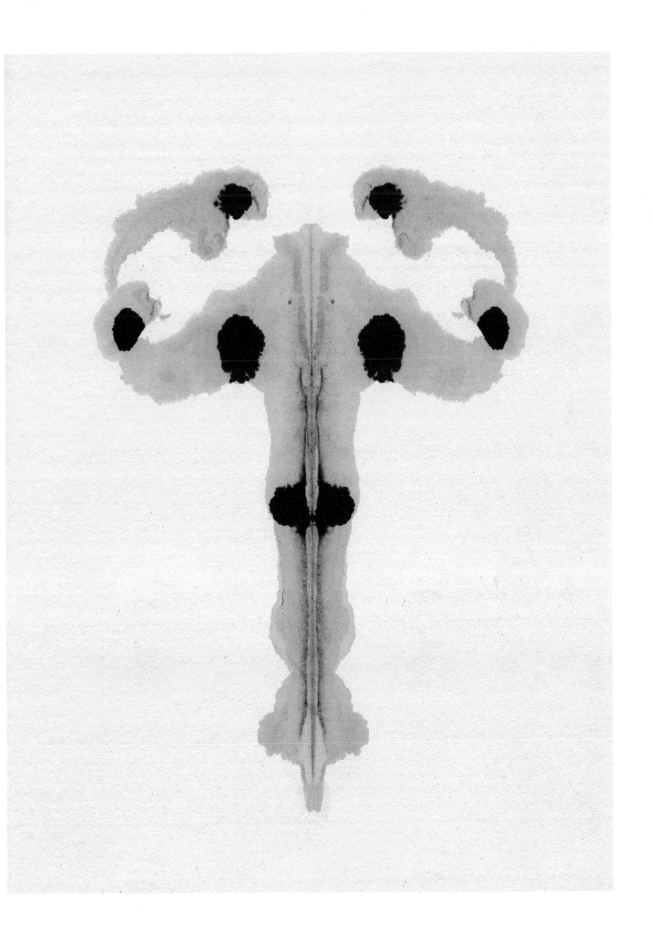

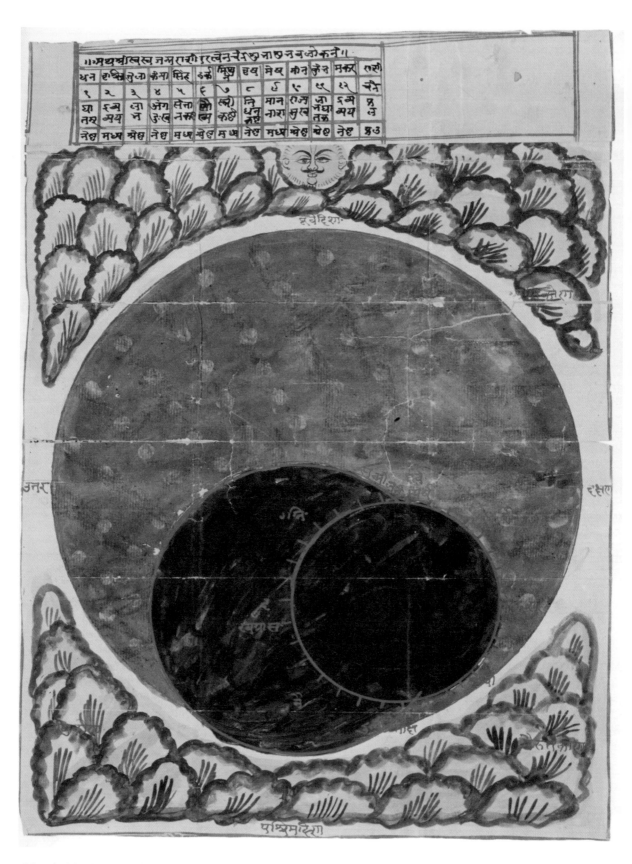

Eclipse: tantric painting, Rajasthan, 18th century

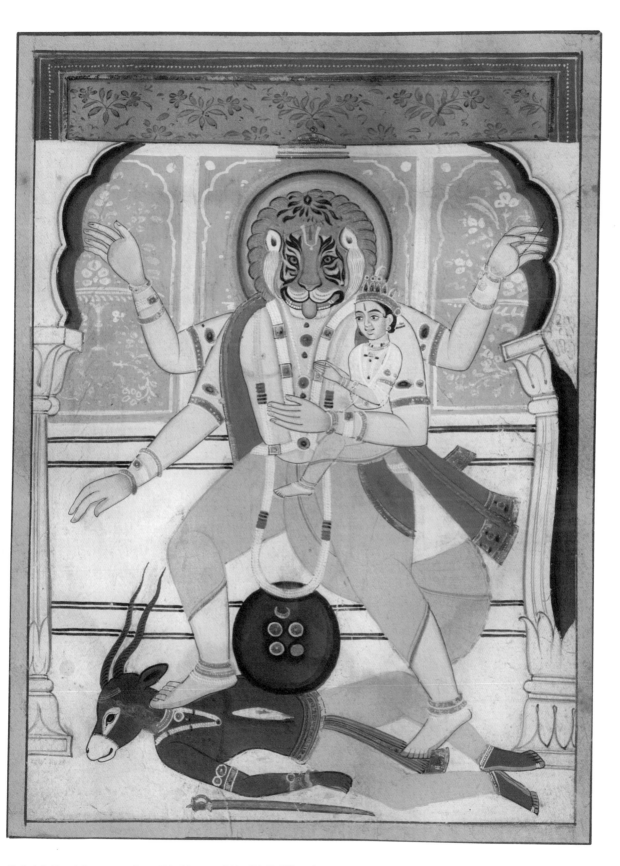

Hindu deity Narasimha conquers demon, Rajput kangra painting, N. India, 18th century

And showers of blood will fall from Heaven and rivers will turn to blood. And the fishes of the seas will perish; and fire will come up out of the midst of the deep.

Showers of Blood.

Rivers of Blood.

The Word delivered with elegant economy: Shaker 'gift drawings' from *The Book of Prophetic Signs* written by Prophet Isaiah, USA, 1843

The Sun clothed in Sackcloth and the Moon in Scarlet!!!
Heavy Judgements shall come on the Earth
I will avenge mine Anger upon Men!! Saith the Lord of Hosts.

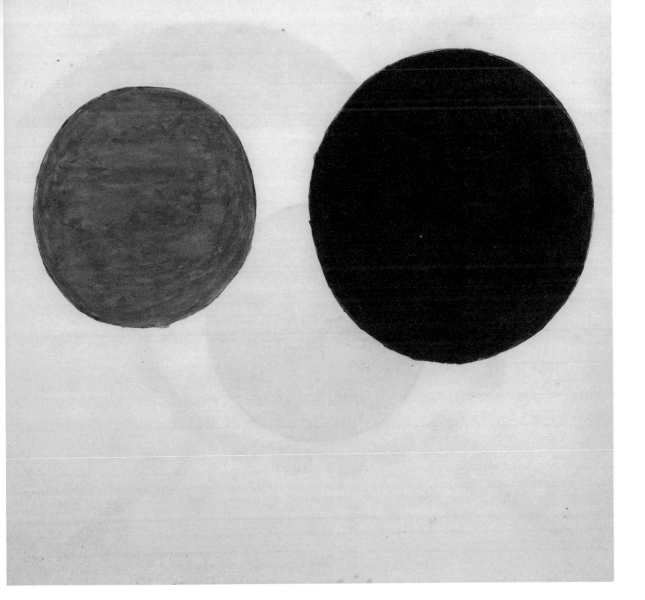

Feodor Stepanovich Rojanovsky (known as Rojan), illustration for *Plouf, The Little Wild Duck*, France, 1936

THE UNSEEING EYE

The eye, it is said, is the window to the soul. But what if blinds have been drawn across that window? In a darkened room, the mind thinks, the imagination constructs and shapes reality, and the spirit lives, each in its characteristic forms with its necessary vigour. For the blind person all is in 'the mind's eye'. Here are the words of the blind Slovenian photographer Evgen Bavčar: *"Even a blind person has visual equipment, optical needs, as someone who is longing for light in a dark room. From this desire, I photograph."* With the obvious exceptions, each photograph in this section was taken by a blind photographer. We are used to the idea that the loss of one faculty enhances the acuity of those that remain. In these photographs we encounter the paradox that it is sight itself that seems sharpened by blindness.

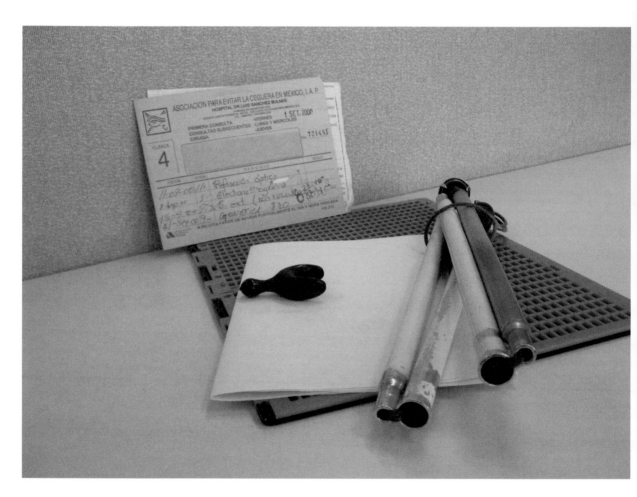

Registered blind, she has a Braille printing set and collapsible white stick: Verenice Hernandez, *Cruelty*, Mexico, *c.*2005

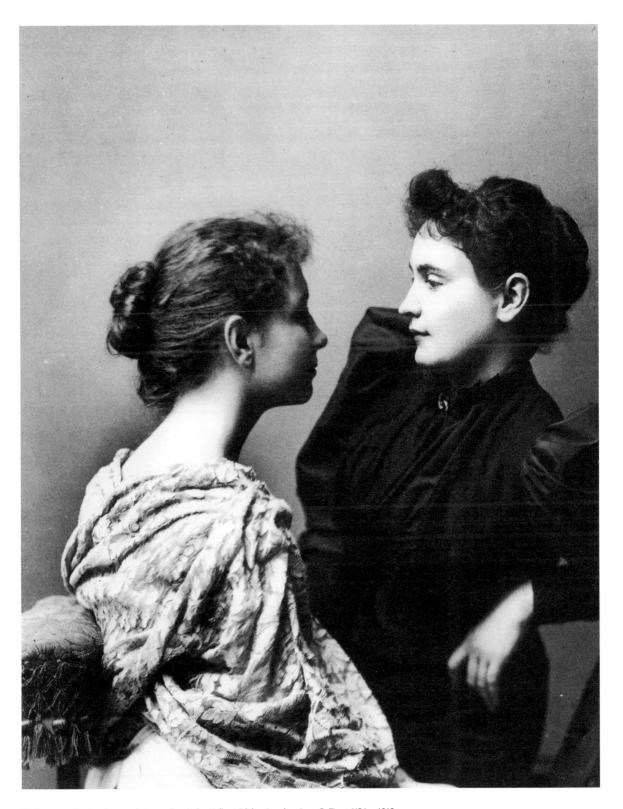

Eye to eye contact: unknown photographer, Helen Keller with her teacher Anne Sullivan, USA, *c*.1913

Black and white: Edward Slyfield, *Untitled*, Mexico, 2010

Ana Soriano, *Untitled*, Mexico, 2010

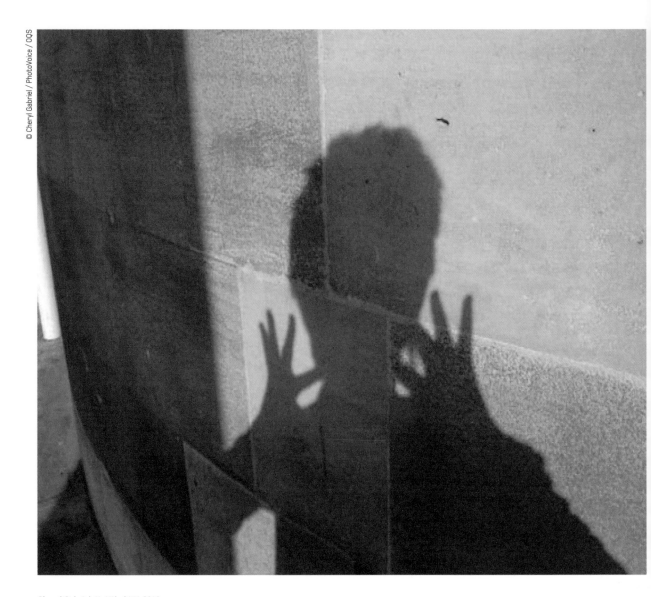

Cheryl Gabriel, *Untitled*, UK, 2010

To understand, put yourself in the shoes of others: Marco Antonio Martinez, *Empathy*, Mexico, *c.*2005

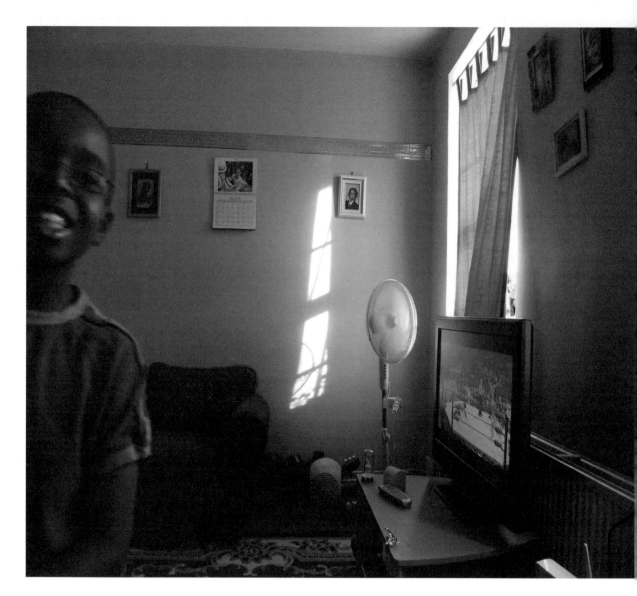

Hot; I hear your smile; the fan is on: untitled photograph by unknown blind artist, UK, 2010

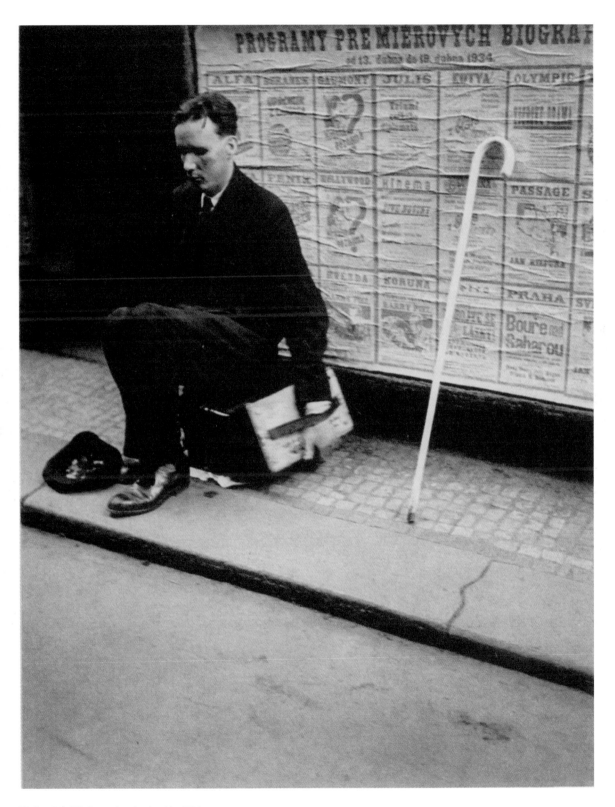

Václav Jírů, *Blind man*, Czechoslovakia, 1934

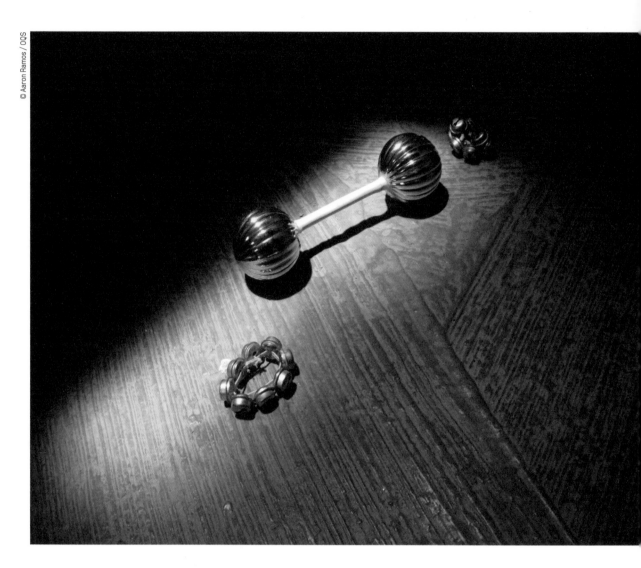

His children's rattles, still and silent in an empty house: Aaron Ramos, *Silence in solitude*, Mexico, *c.*2005

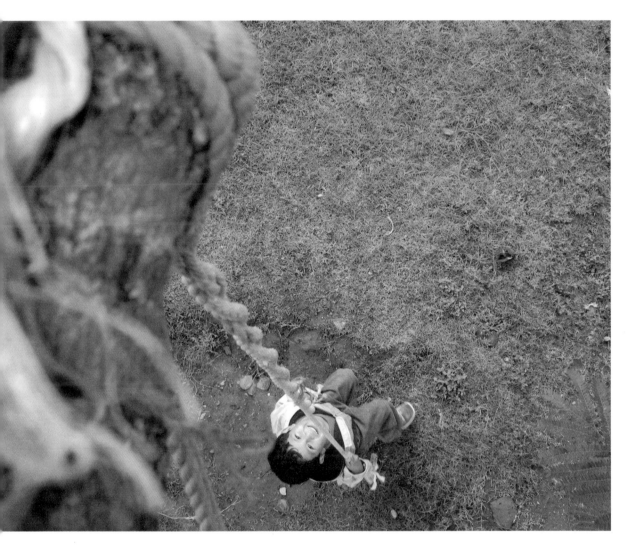

Unable to see and fearful, he makes an image of umbilical connection to signify his continuing love for his son, and confidence in his child's future: Aaron Ramos, *The power of transmitting*, Mexico, c.2005

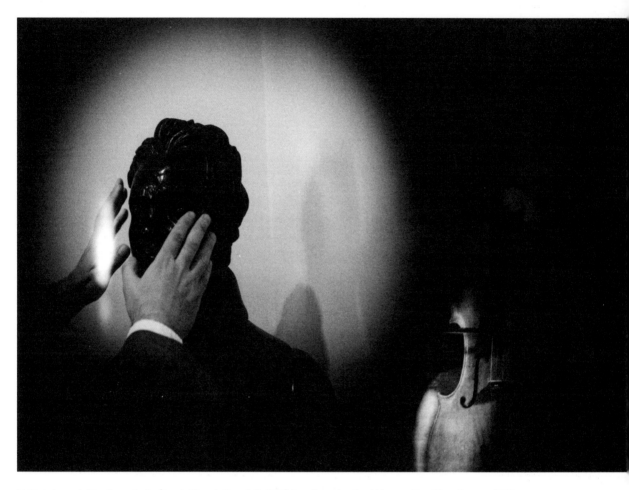

Light, dark, proximities: Evgen Bavčar (born in Slovenia, Yugoslavia, 1946), from the series *Touch Views or Close Views*, France, *c.*2000

DE L'IMPRESSION EN NOIR.

Il est inutile de colorer les impressions à l'usage des aveugles, puisqu'ils ne peuvent les lire que par le relief ; cependant lorsqu'on veut imprimer en noir et en relief à-la-fois, on ajoute un tympan enduit d'encre, et en le laissant retomber légèrement sur la feuille qui se trouve pressée entre la forme et le tympan, les lettres paraissent noires comme dans cette page, que nous donnons pour servir d'exemple.

A page in embossed typography explaining that there is no point in printing in colour for the blind. From *Notice historique sur l'instruction des jeunes aveugles*, Sebastian Guillie, France, 1820

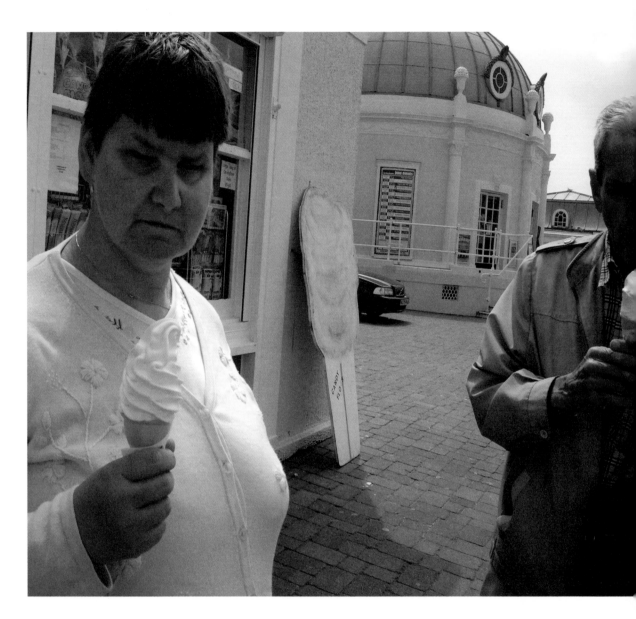

A hot summer's day on Worthing promenade; Jane takes a photograph of Eunice, while Eunice holds Jane's ice cream: Jane Sellers, *Beachconing*, UK, 2007

'…my friend said, that is empty you won't like it, and I said this is exactly what I was looking for, something that once had something that was a life inside them and now is empty': Aaron Ramos, *Process Interrupted*, Mexico, c.2005

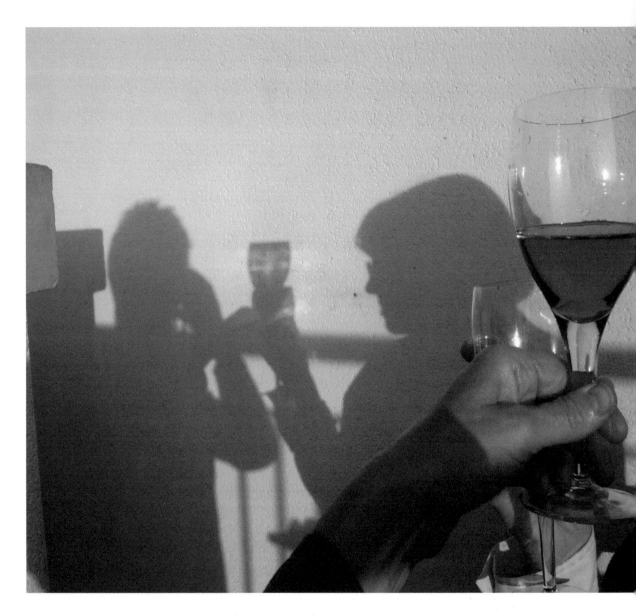

A glass of rosé; between light and shadow: Cheryl Gabriel, *The Best Part of the Day*, UK, c.2005

FOR THE
CHILD'S EYE

Through the '20s and early '30s, in the hard years of the early Soviet Union, there flowered briefly a golden age of children's books. Brilliant artists and writers, often prohibited from other kinds of work, created a benign and fabulous alternative world. It was a world made for children, where learning was play and where enchantment had many uses.

It was the genius of those poets and artists to realise that the transition from early childhood's state of grace entailed a prolonged and playful engagement with the creatures, the objects and the situations of the world as given. They knew that the very idea of 'grasping' reality has its beginnings in the infant's outstretched hand. Child's play is child's work. It is the vital extension of the infant's wonder, inextricably bound up with the growing child's pleasure at increasing mastery of the whatness, whereness and whyness of things. *'Moments of learning'*, said the wise teacher, *'are moments of joy.'*

What makes these images moving as well as funny and beautiful is that they offer pictures of things as they are, and as they might be in a world fit for children to inherit.

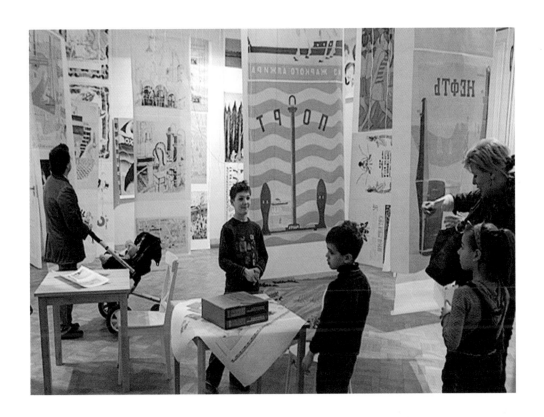

The book launch in Moscow for *A Book for Children: Illustrated Children's Books in the History of Russia, 1881-1939*, Moscow, 2009

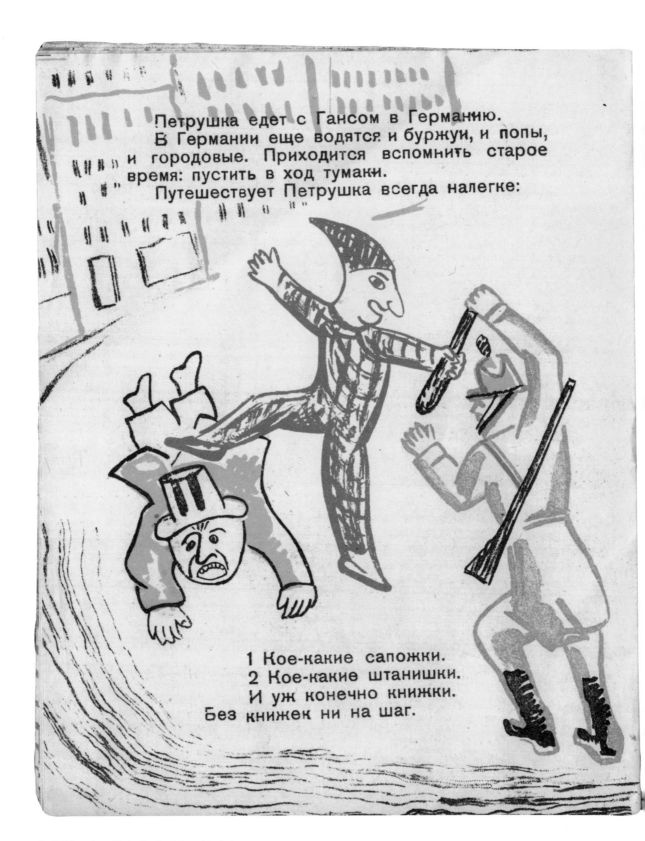

Петрушка едет с Гансом в Германию.

В Германии еще водятся и буржуи, и попы, и городовые. Приходится вспомнить старое время: пустить в ход тумаки.

Путешествует Петрушка всегда налегке:

1 Кое-какие сапожки.
2 Кое-какие штанишки.
И уж конечно книжки.
Без книжек ни на шаг.

David Shterenberg, illustration for *Dolls and Books* by Nina Sakonskaya, USSR, 1932

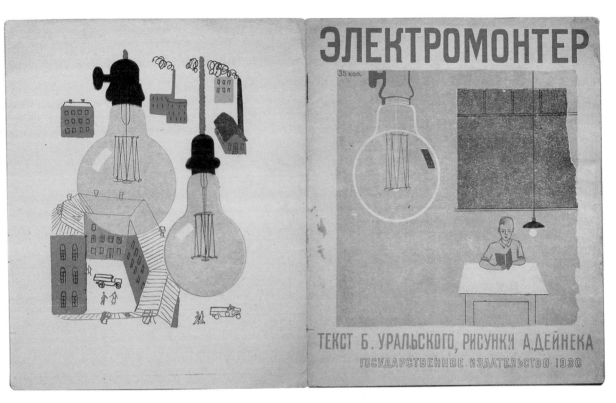

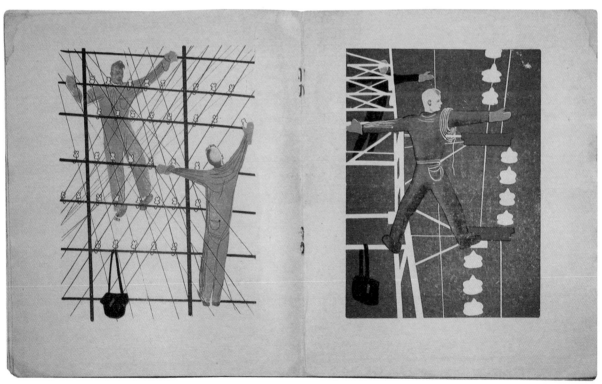

Alexander Deineka, illustration for *Electricity* by B. Uralsky, USSR, 1931

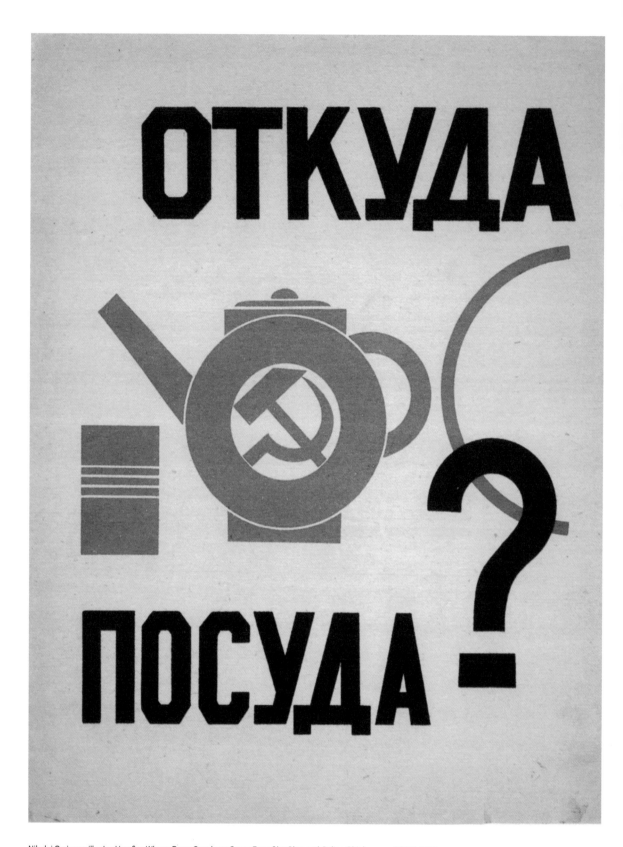

Nikolai Smirnov, illustration for *Where Does Crockery Come From?* by Olga and Galina Chichagova, USSR, 1924

G. Yablonovsky, designs for *What is This?* by V. Gryuntal, USSR, 1932

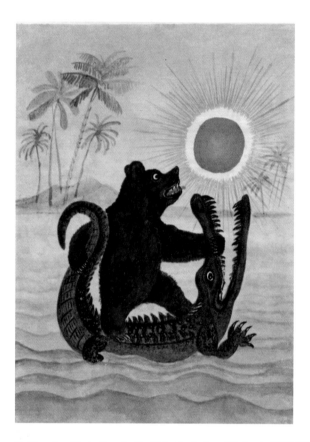 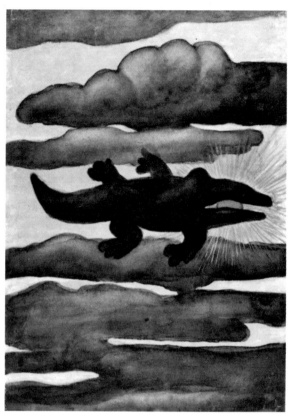

Yuri Vasnetsov, illustrations for *The Stolen Sun* by Kornei Chukovsky, USSR, 1935

ЗВЕРЯТА

Yevgeny Charushin, cover for *Little Animals,* USSR, *c.*1940

Я РЫБНОЙ ЛОВЛЕЙ ЗАНЯЛСЯ:

ПОЙМАЛ В ОРКЕСТРЕ КАРАСЯ.

Vladimir Lebedev, illustration for *The Circus* by Samuil Marshak, USSR, 1928

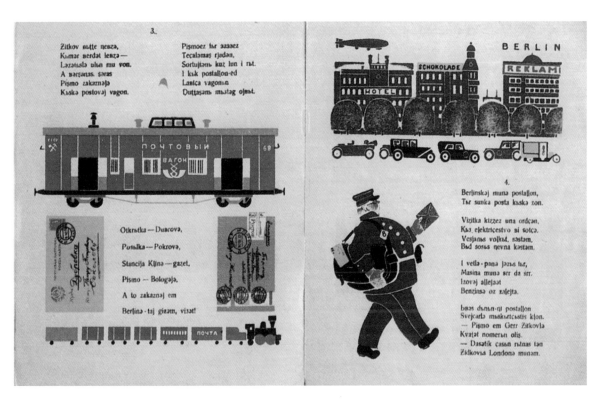

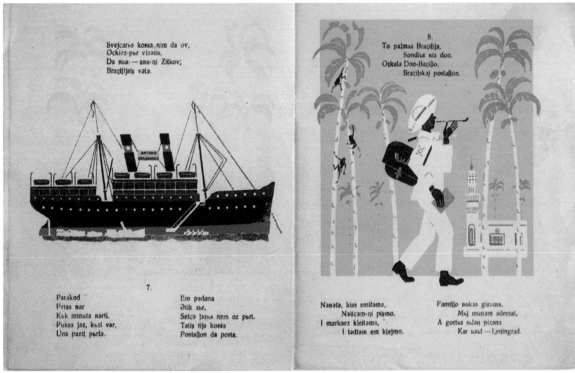

Milhail Tsekhanovsky, illustration for *Post* by Samuil Marshak, USSR, 1934

КОНЬ-ОГОНЬ

ОТЦУ твердил раз триста,
за покупкою гоня:
— Я расту кавалеристом,
подавай, отец, коня. —
О чем же долго думать тут?

Lidia Popova, illustration for *The Fire Horse* by Vladimir Mayakovsky, USSR, 1928

THE EROTIC EYE

The eye is an organ of desire. It does not merely register the desirable, it projects on to the most innocent of objects an aura of sexual mystery or a lascivious intimation of arresting resemblance. Along with touch, smell, taste and hearing, sight is of course integral to the experience of love. But the eye goes further, seeks pleasures and satisfactions beyond the immediately amorous: it loves to look, and the direct satisfactions of the glance, glimpse, peep and gaze are complemented by the indirect pleasures of the voyeur – the seer who overlooks, or experiences sex at second hand, so to speak.

As for those 'innocent' objects' so alluring and suggestive to the eye: erotic fetishism may be said to have a number of distinctive characteristics. The first is desire in excess of its object. The second is a tendency in the viewer/participant to isolate the object of desire from its function in the totality of things; this is an aspect of all sexuality, including so-called 'normal'. A third element is the transposition or displacement of objects from one sphere of activity to another. This may happen in the world itself (the object is taken from the kitchen or the dining room into the bedroom or vice versa) or be effected through photography or painting. Dietrich's shoe may be merely a shoe; but what a shoe! Take a good look.

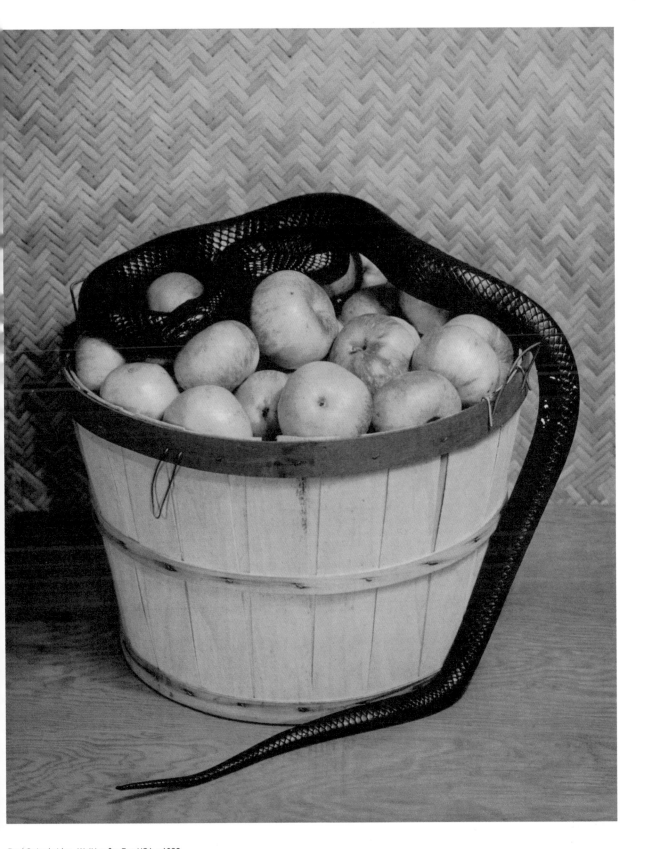

Paul Outerbridge, *Waiting for Eve*, USA, c.1938

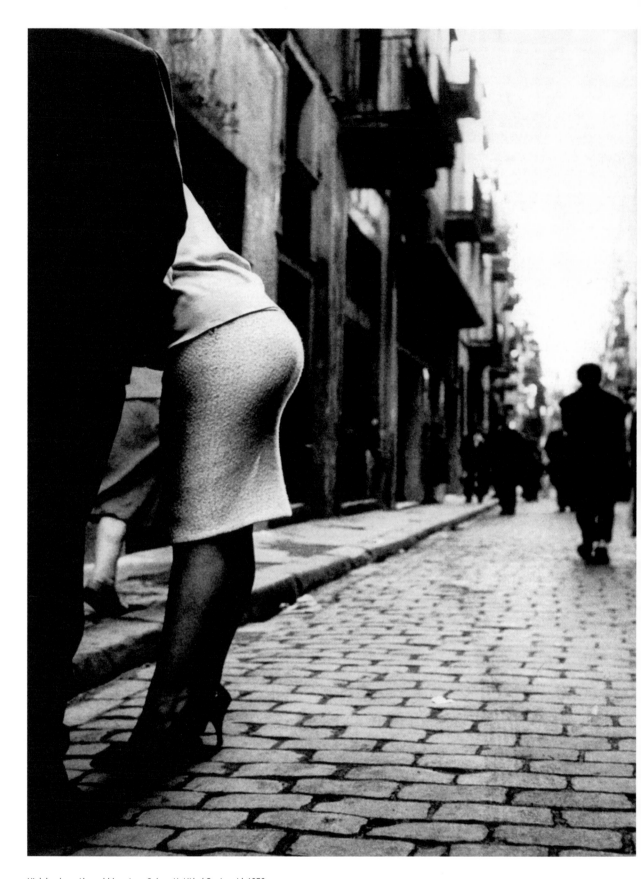

High heels on the cobbles: Joan Colom, *Untitled,* Spain, mid-1950s

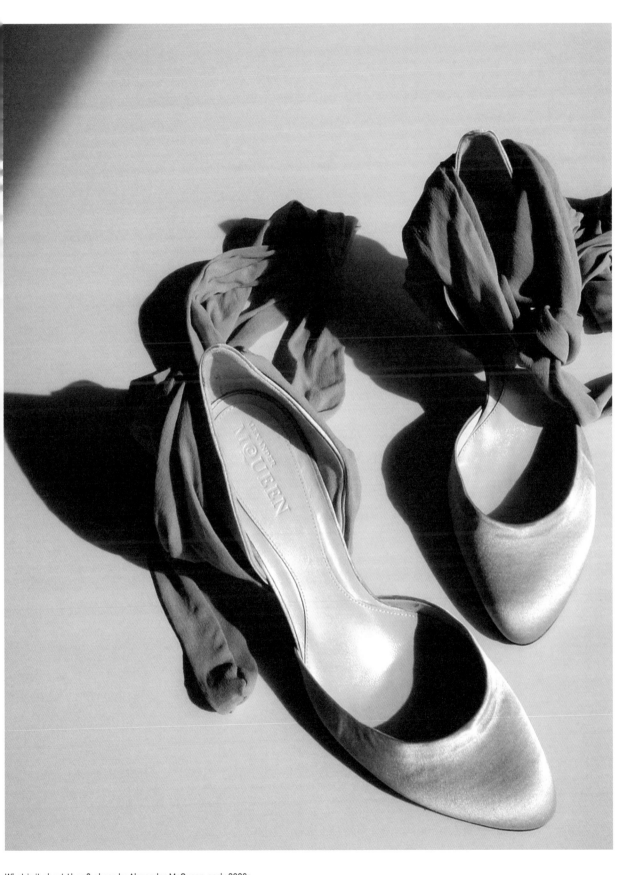

What is it about them?: shoes by Alexander McQueen, early 2000s

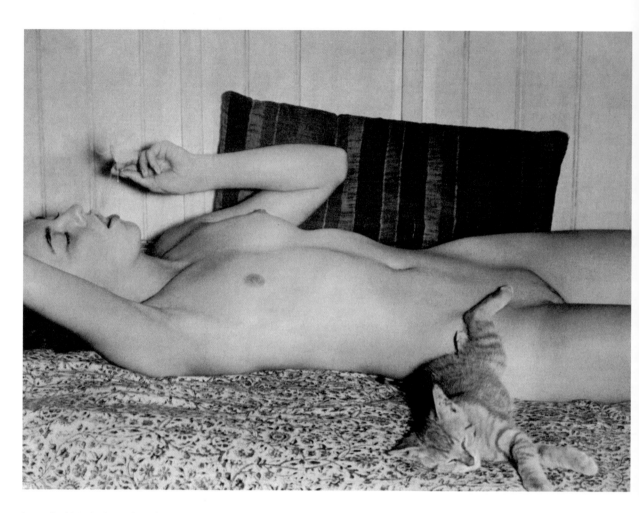

Luxury: Paul Outerbridge, *Nude with Cat*, USA, 1939

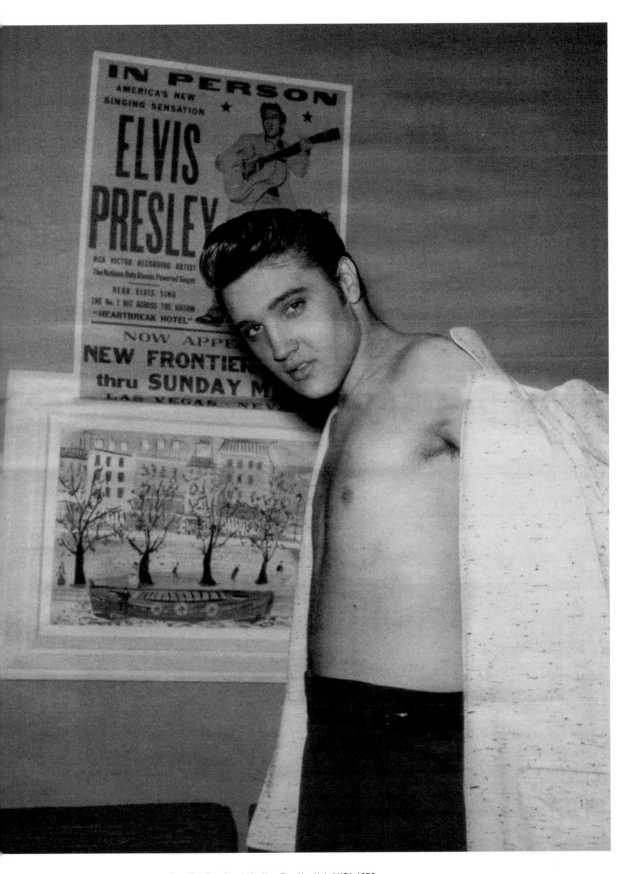

The young king enrobes: unknown photographer, *Elvis Presley at the New Frontier Hotel*, USA, 1956

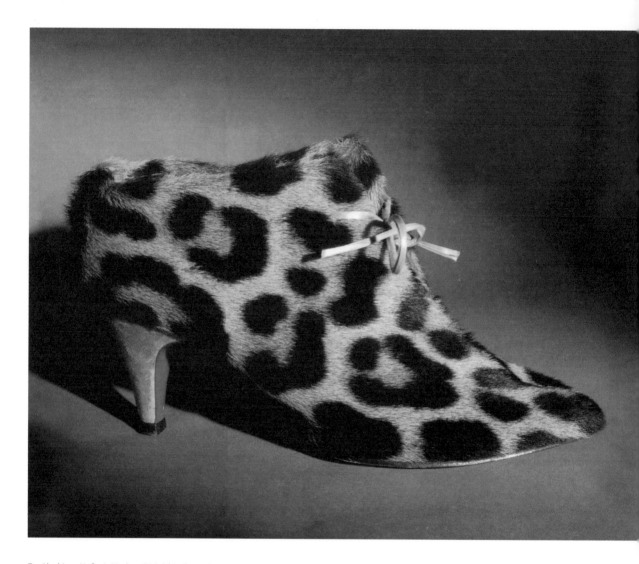

For the big cat's foot: Marlene Dietrich's shoe, USA, 1940s

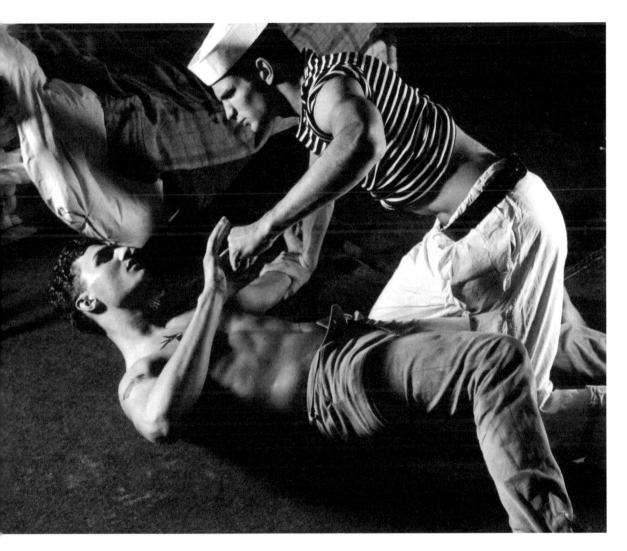

Matelot beware! Untitled photograph by unknown photographer, France, no date

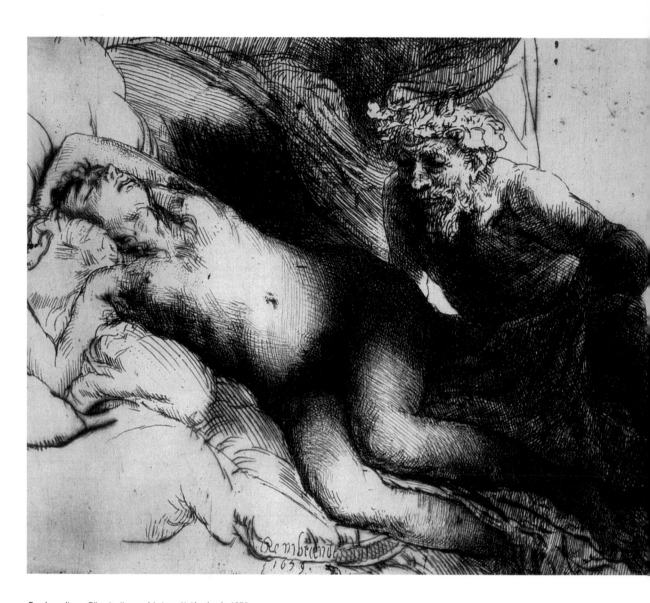

Rembrandt van Rijn, *Jupiter and Antope*, Netherlands, 1659

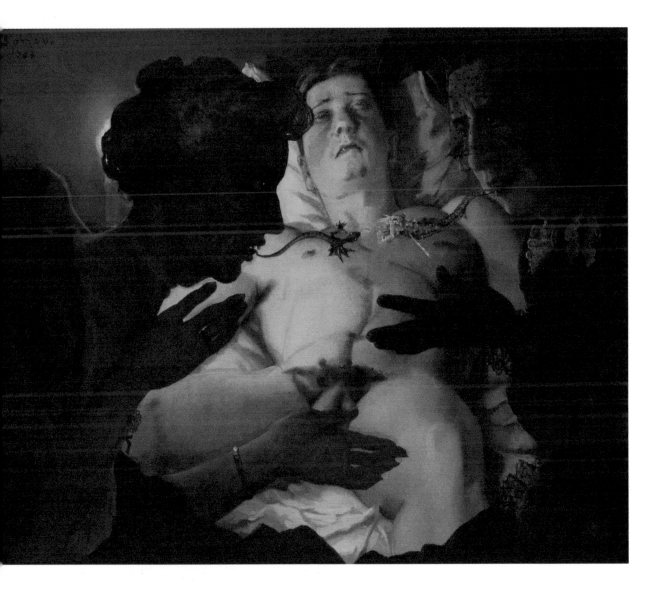

next?: K.A. Somov, *Nightmare in a Burning Fever*, USSR, 1937

Bravo!: Manuel Alvarez Bravo, *Tree Study*, Mexico, 1931

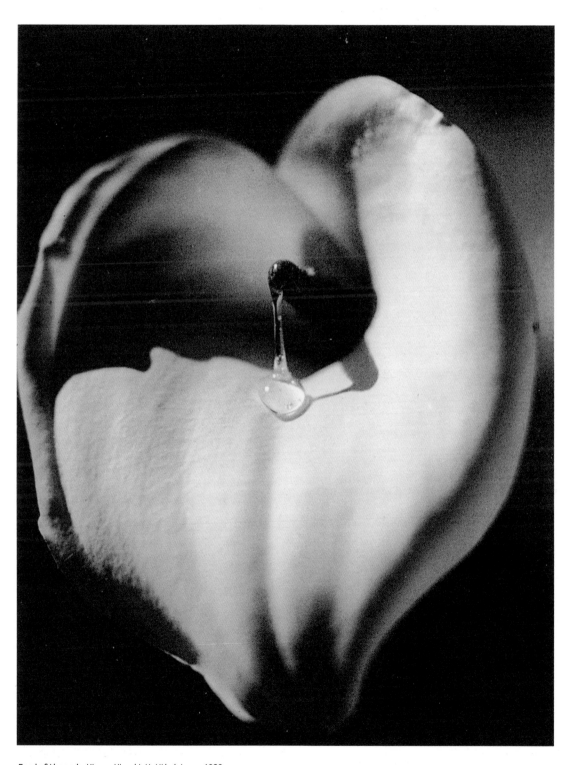

Food of the gods: Hisano Hisashi, *Untitled*, Japan, 1930s

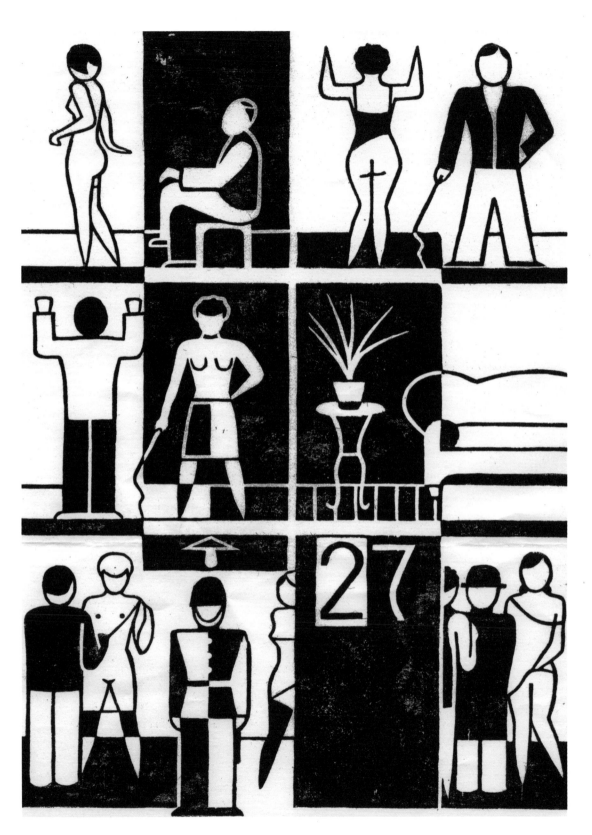

What goes on at No.27: Gerd Arntz, *The Brothel*, from *The Twelve Houses of Today*, Germany, 1927

Optical illusions fascinate us: they indicate with disconcerting effect that what the eye 'sees' physiologically may be quite different from what the brain makes of that sensory perception. We see the images of figures appear where there are none, we detect movement in still images, we are aware of flashing dots in the interstices of grids or white discs where there are only black ones, we enjoy the illusion of recession into space, we misjudge dimensions, etc. Artists have used many of these illusions to create dramatic effects: perspective in representational art, for instance, and optical disturbance for emotive effect in abstraction.

Entertainers and artists can do this because what we 'see' is what we select, construct or construe from what is actually in our field of vision. Optical illusions of various kinds are of great value to the work of experimental psychologists concerned with the complex relations of seeing and knowing. This strictly scientific branch of psychology is concerned with the working of the mind – that problematic and complex abstraction – with the operations of the organs of attention, perception and action – the senses, in short – and their interaction with the most complicated and elaborate organ of all, the brain. Optical tricks are a clue to what the mind can do with what the brain receives from the perceptible world.

TRICKS OF THE EYE

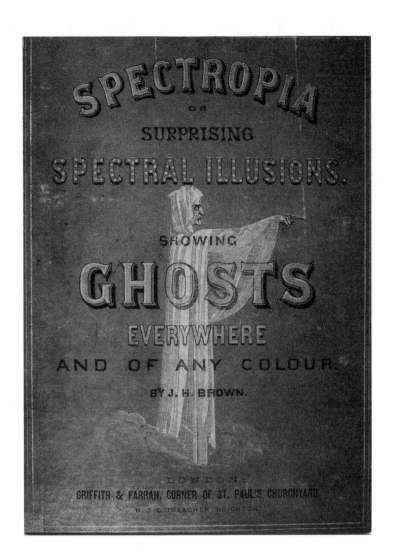

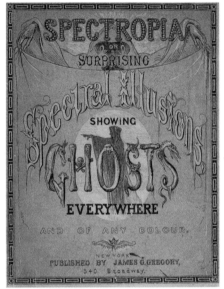

Covers of English and American versions of *Spectropia* (London, New York, 1864) by J.H. Brown, and illustrations of ghost types. Focus intently on the image and then look at a blank white wall: the spectre will reappear and vanish several times, its colours 'spectrally' reversed

J.H. Brown, from *Spectropia, or Surprising Spectral Illusions: Showing Ghosts Everywhere and of any Colour*, UK, 1864

Hans Christian Andersen, anamorphic signature, Denmark, *c.*1870

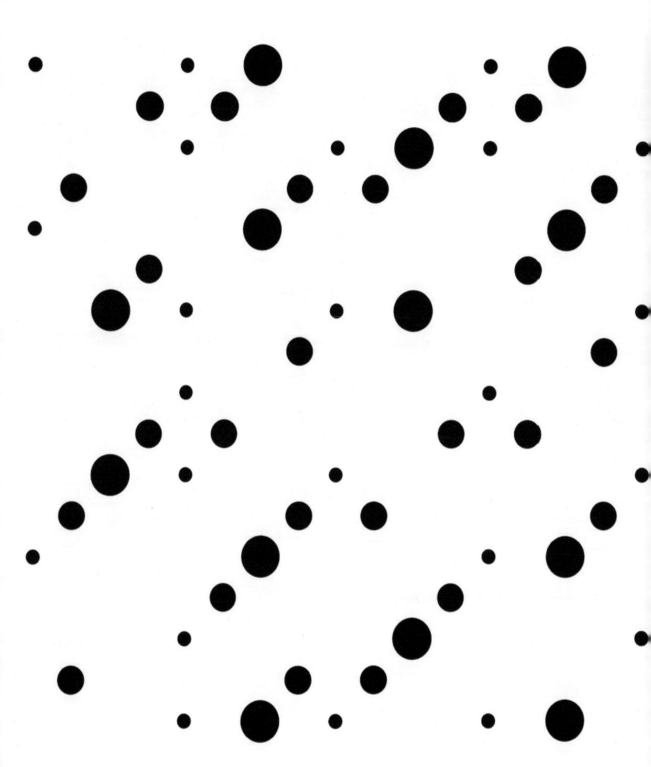

Bridget Riley, *White Discs 2*, UK, 1964

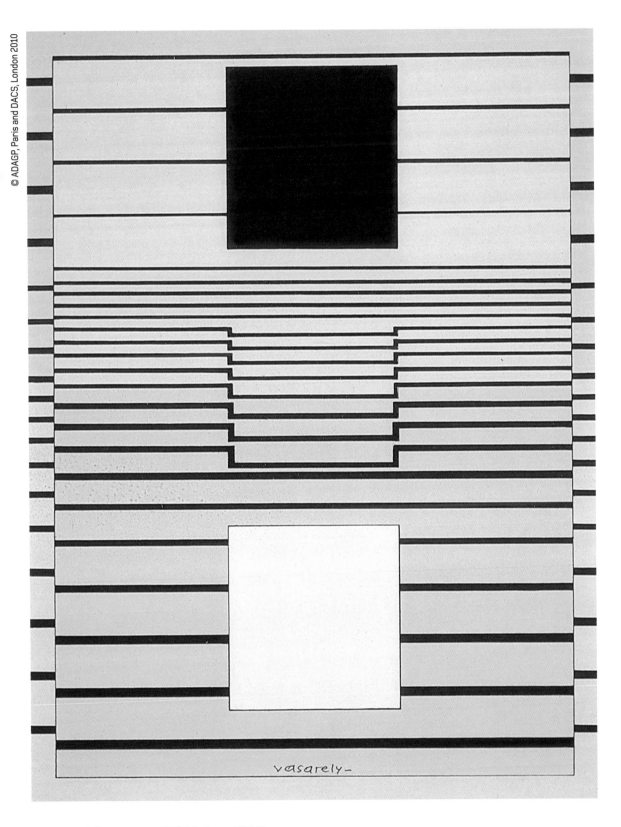

Victor Vasarely (born in Hungary, 1906), *Teke*, France, 1956-60

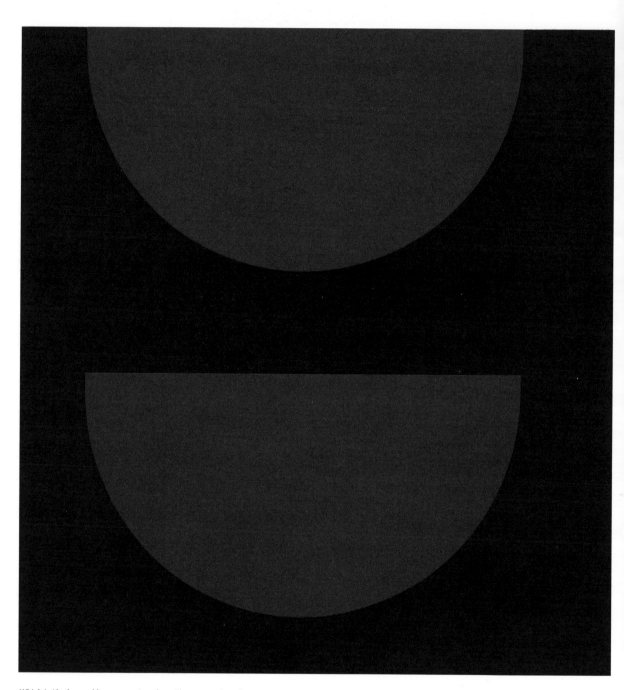

Which is the larger blue segment, and are they same shape?

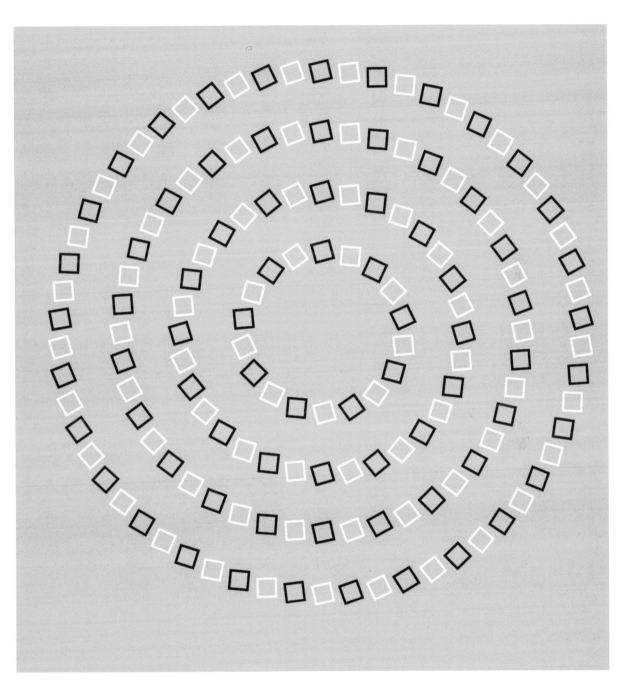

Circles or spirals?

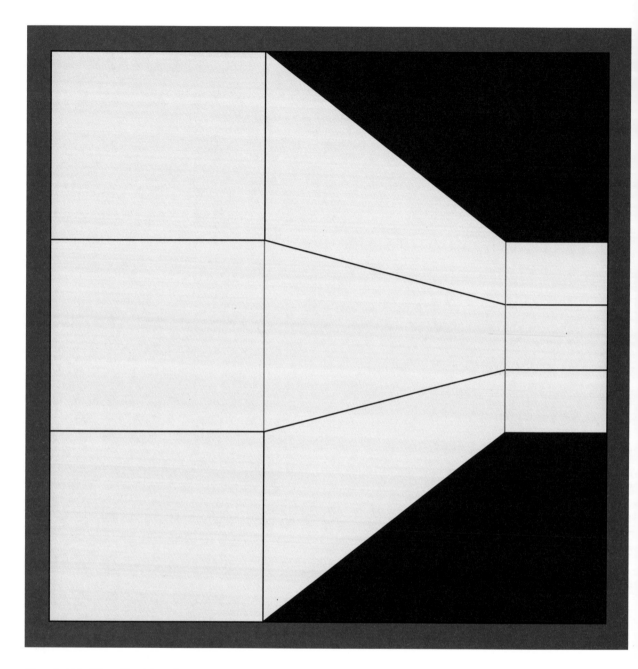

The wall: which of the red lines is longer?

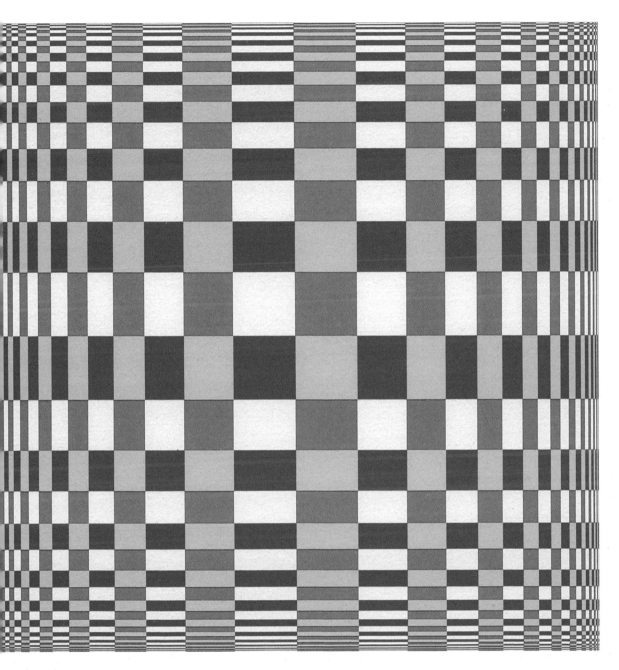

e cushion illusion

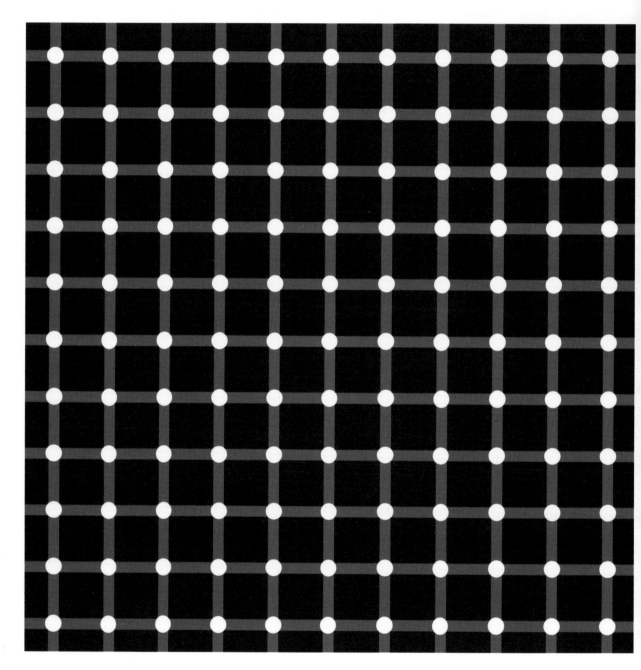

Scintillation effect: black spots flash randomly in the white discs

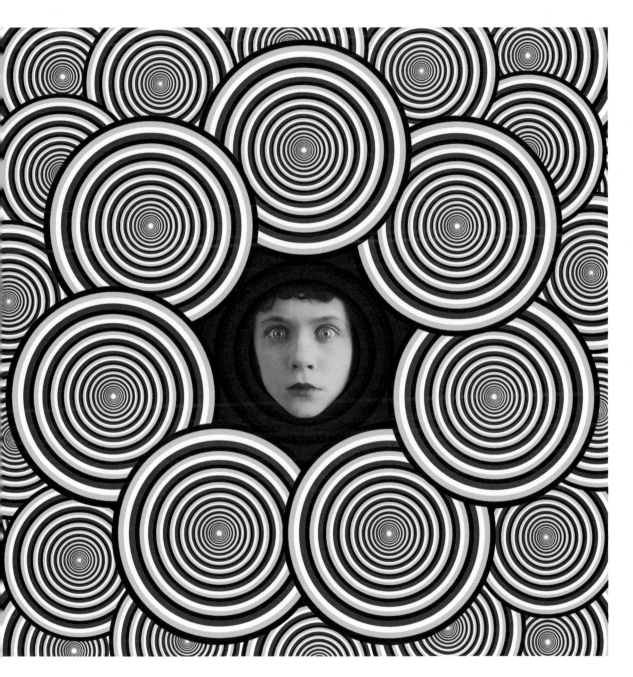

Gianni A. Sarcone, *Look into my eyes, look into my eyes*, Italy, 2008

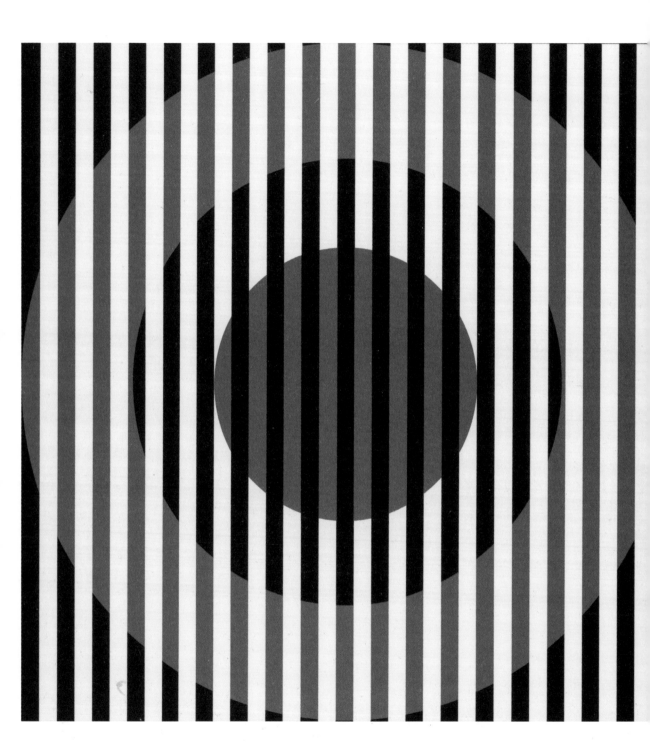

Three illusions in one: a central blue disc that is translucent (the black background to the whole image is behind it); the blue of the inner disc appears darker than the bl[ue] of the outer blue ring (it isn't); in the circular area between the blue ring and inner blue disc, the white stripes appear to be yellower than the rest of the white stripes (they aren't)

THE CHILD'S EYE

'*When the results were read over the next morning, my name headed the list. Later that morning the headmaster came to my desk with my painting in his hand. He was a little surprised at my sudden progression, as in a country dance, from the very bottom of the set to the very top... "It's a funny thing," he said to me, "but I have always thought you ought to be able to do art. Why have you not produced this sort of thing before?" There was only one answer, the same which so many, many children could still give to their teachers even in these art-conscious days... "No one ever asked me to," I said.*' (Sybil Marshall: *An Experiment in Education*)

There are so many things children can do, if only someone asks them to. What we know, as Sybil Marshall discovered as a young teacher, is that circumstance and stimulus will produce from them the most amazingly beautiful and thrilling works of art. Contrary to popular and sentimental belief, children do not paint what they see, but (like artists) they invent the world they depict; soon they will see the world as they have invented it, new every morning. As we all do, when the scales of use and habit fall from our eyes. Give children a camera, and the same fresh intensity of desire, imagination and invention will inform what they do with it in order to possess the world. Children know there is no such thing as 'a good photograph', there is only interesting photography, which reveals what is unseen to the living eye. What is interesting is, of course, a matter of subjective purpose.

...uts beyond the trees: unknown child's painting, South Africa, 1943

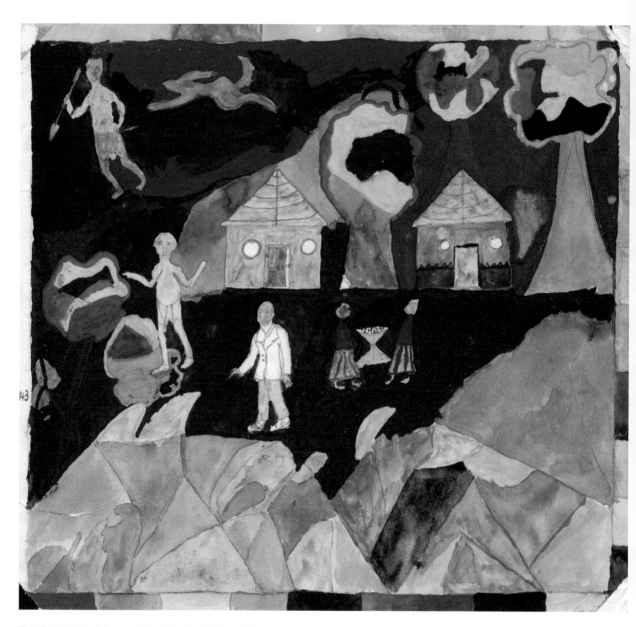

The village at night: unknown child's painting, South Africa, 1945

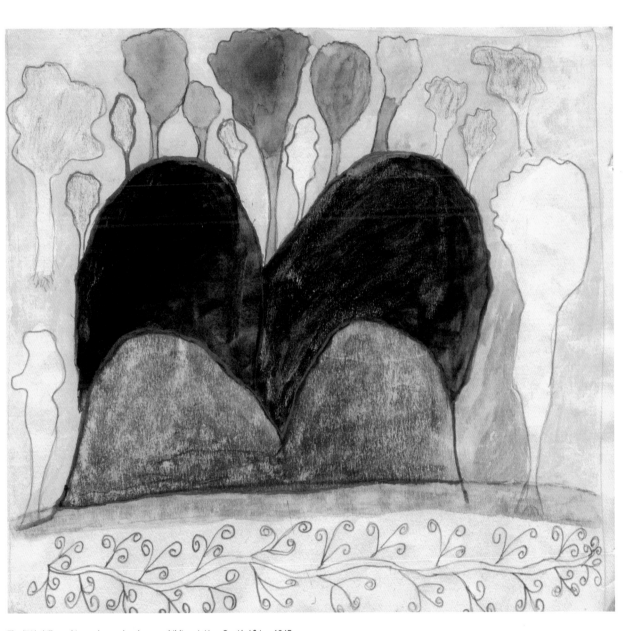

The little hills and trees beyond: unknown child's painting, South Africa, 1945

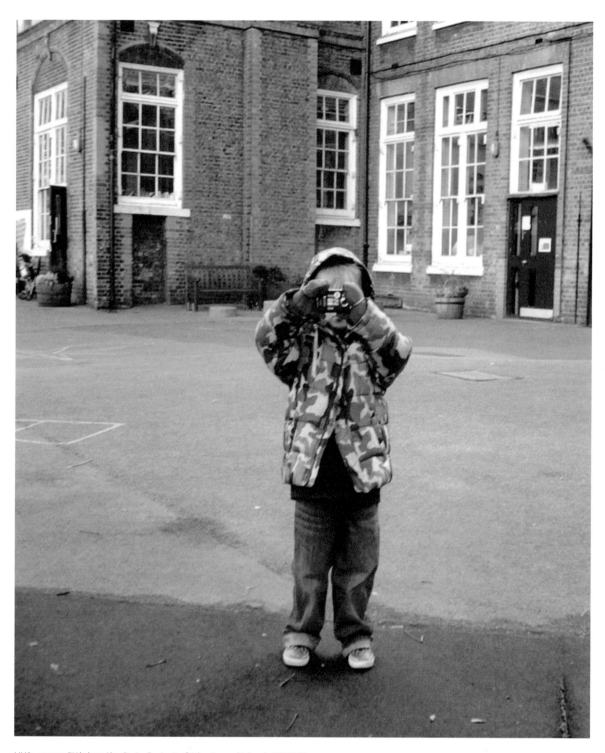

Little camera, little boy: Alex Gavin, *Portrait of Aden Noury-Richards*, UK, 2007

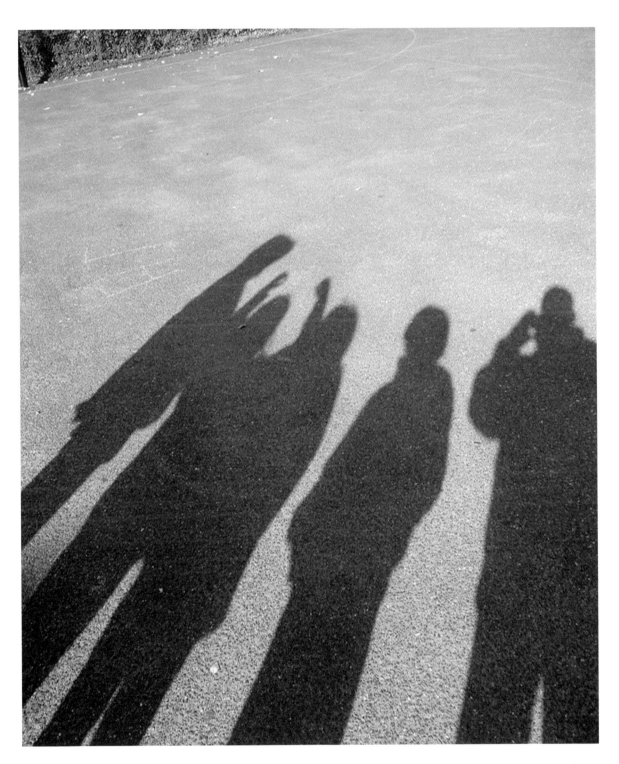

Aaron Eyoma, *Group Portrait*, UK, 2008 OVERLEAF: Photograph by Sally, UK, 2010

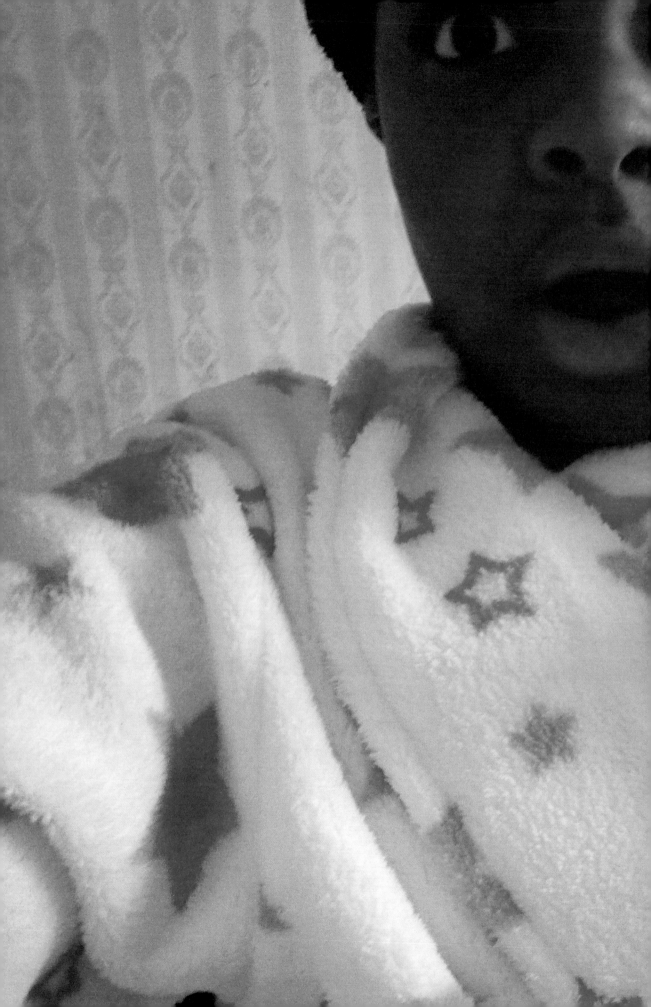

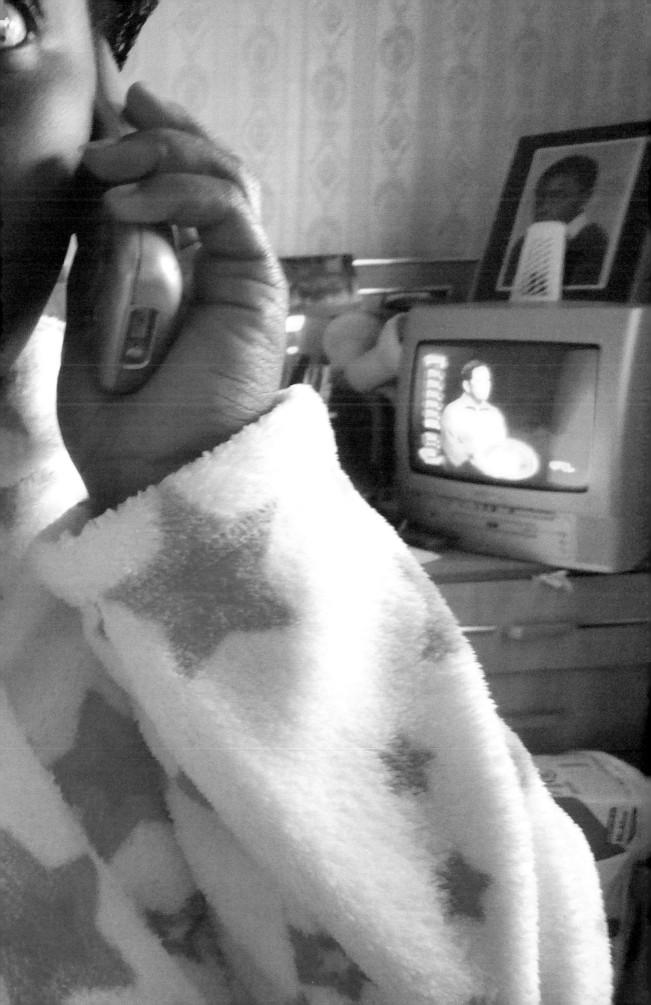

Freddie Goggin, *The Playground*, UK, 2007 RIGHT: Mae Lee, *Portrait of Jessica Kappy*, UK, 2007

OVERLEAF: transported to the field of dreams, photograph by Sarah, UK, 2010

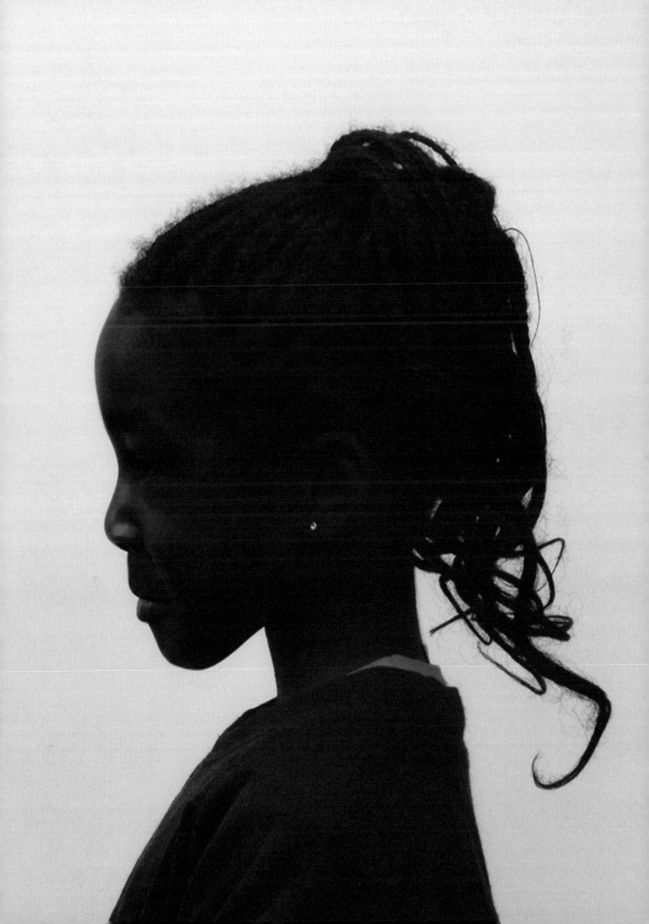

Satire works by measuring the distance between what is accepted to be the truth when spoken by politicians and others in authority, and what is perceived to be the truth when their behaviour and actions are held up to the light. This means of course that although we often think of satire as the prerogative of the left, it can be equally excoriating when it comes from the right: for it is a condition of all critical commentary on the world that its perpetrators believe their perception to be true.

All satirists view the world askance, but from what angle is not a matter of definition but of circumstance. Some satirists see things sub specie aeternitatis, believing with the philosopher Thomas Nagel that *'if there is no reason to believe that anything matters, then that does not matter either, and we can approach our absurd lives with irony instead of heroism or despair.'* Like all the artists and artisans in the world we are bound willy-nilly for Posada's Purgatory. This is a satirical vision at once true and apolitical, but it shares with all other satire an aspect of the extreme. In fact, to see the skull beneath the skin is a familiar satirical device, which may have diverse purposes, and can refer to those who bring death and destruction with their actions in life as well as to the fact of our common mortality.

THE

SATIRICAL EYE

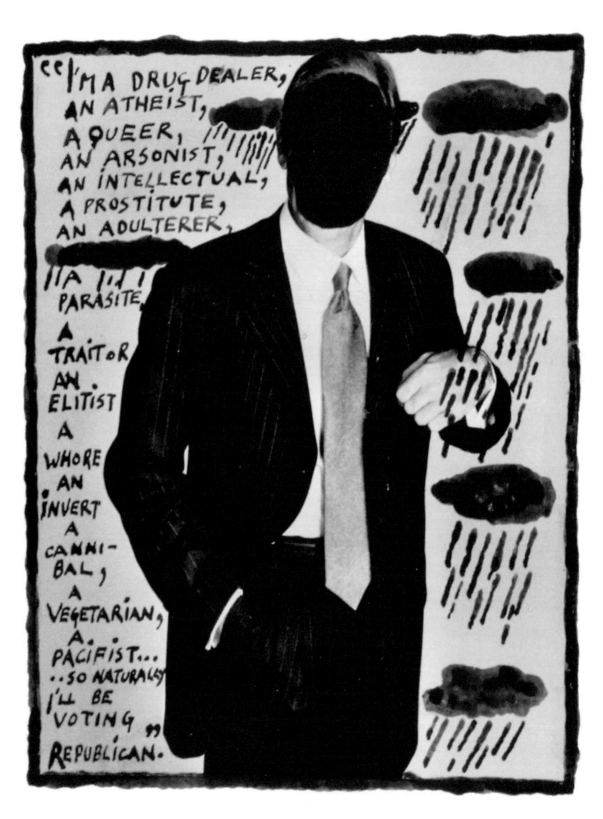

Derek Boshier, *Voting Republican*, UK, 2004

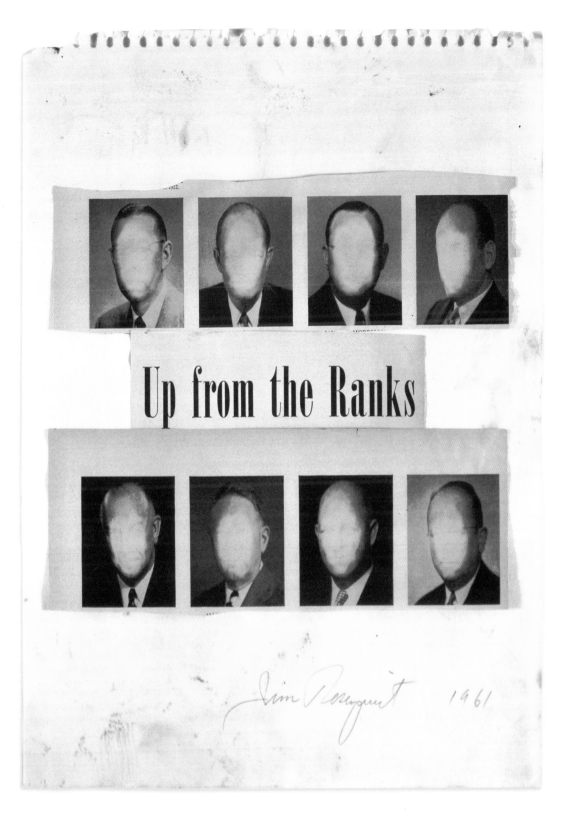

James Rosenquist, *Up from the Ranks*, USA, 1961

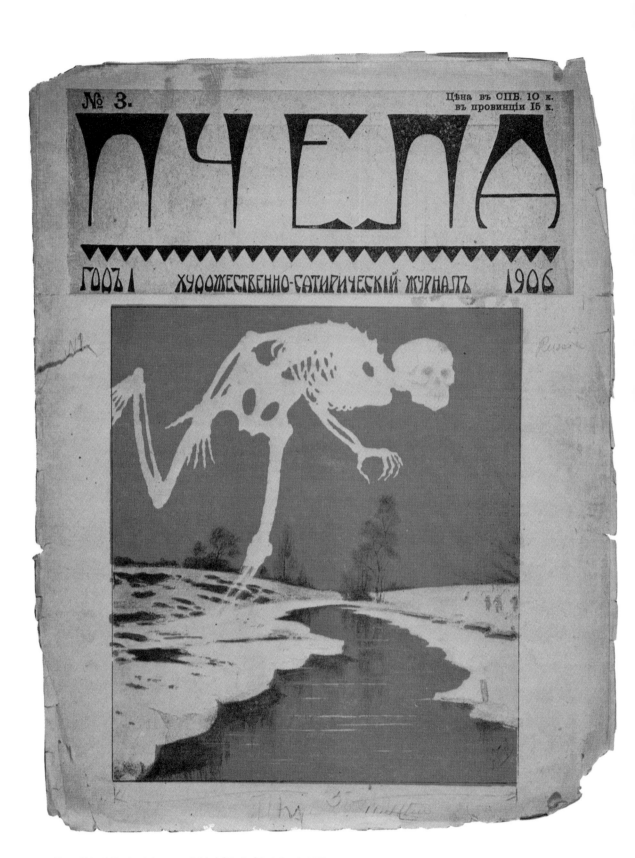

River of blood, blood red sky: cover of *Pchele* (*The Bee*) No.3, Russia, 1906

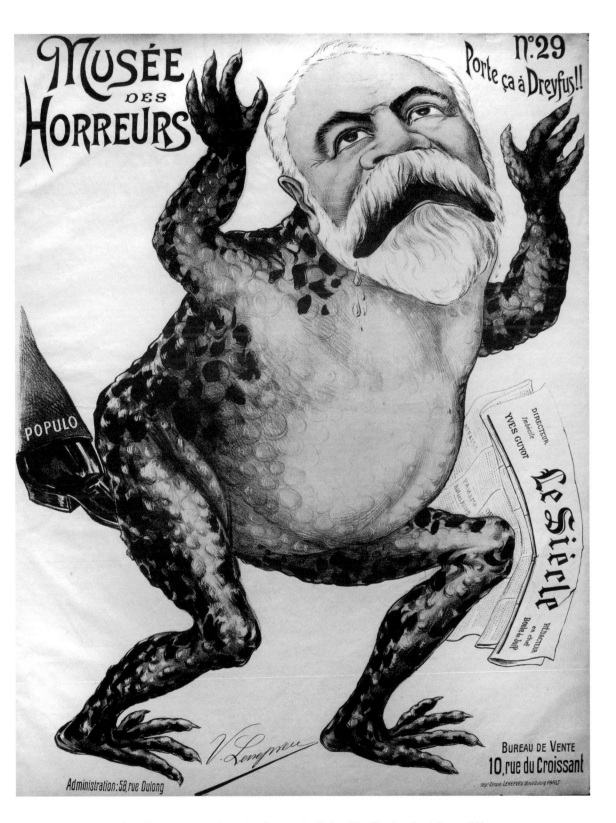

Anti-Dreyfus, anti-Semitic broadsheet lampooning the pro-Dreyfus paper *Le Siècle* and its editor, Yves Guyot, France, 1890s

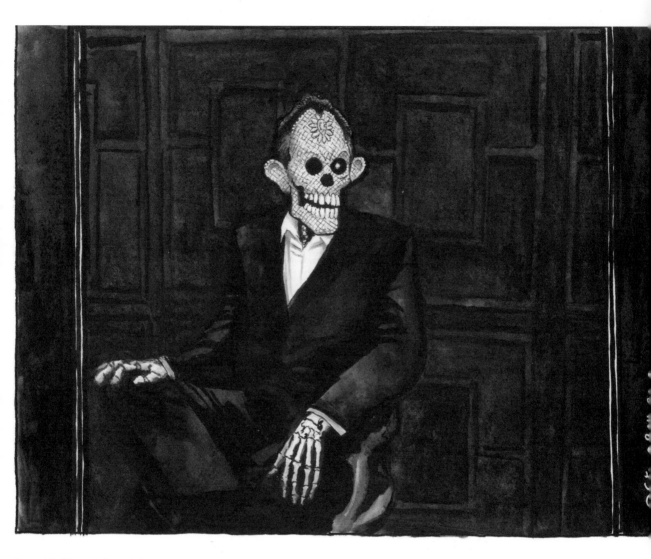

Diamond Skull: Steve Bell, *Untitled*, UK, 2008

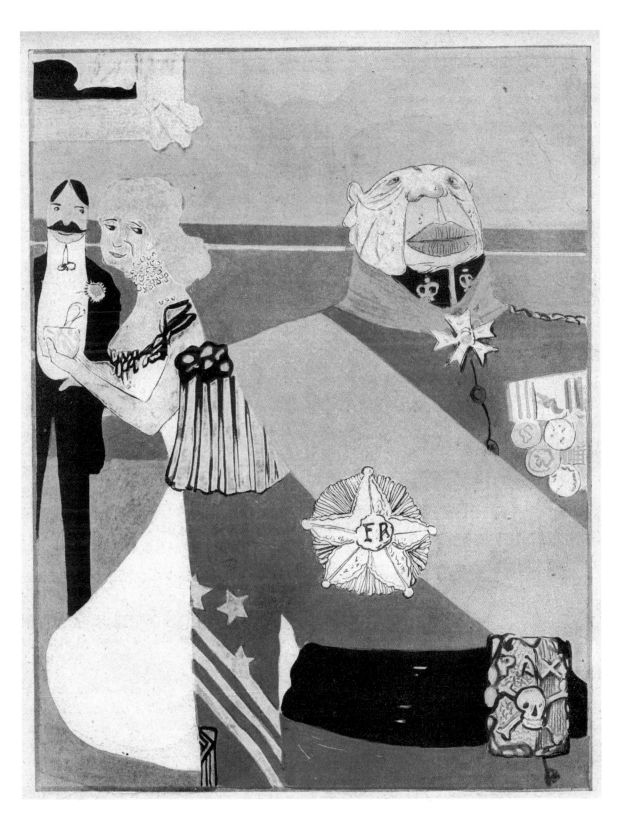

Paul Iribe, from the radical magazine *L'Assiette du Beurre*, No 108, France, 1903

PADILLA,
EN LUCHA ELECTORAL

PADILLA,
TAL COMO ES

From the magazine *1946 (In Defence of Social Progress in Mexico)*, the pro-American presidential candidate Ezequiel Padilla, shown as he presents himself in the election, and as he really is, Mexico, 1946

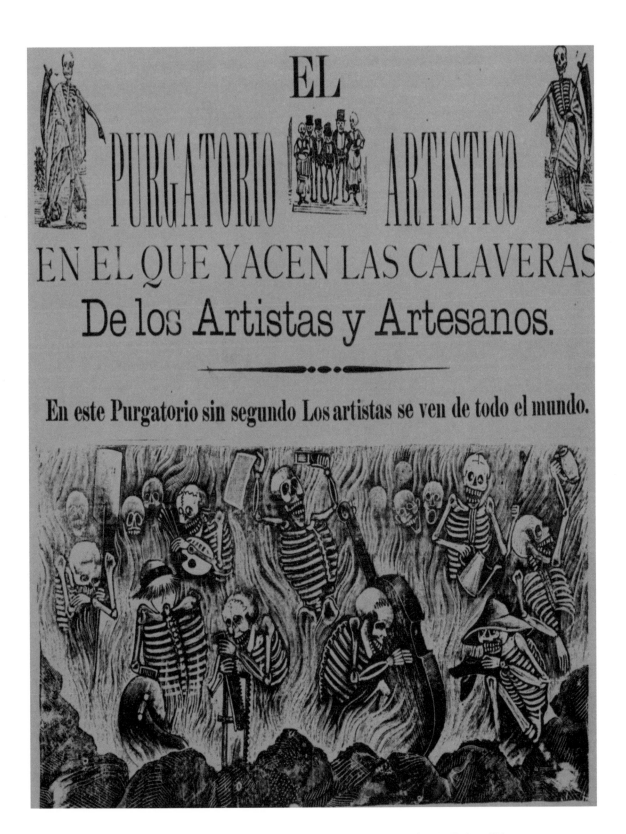

José Guadalupe Posada, *The Artists' Purgatory wherein lie the skeletons of artists and artisans*, popular print, Mexico, c.1890

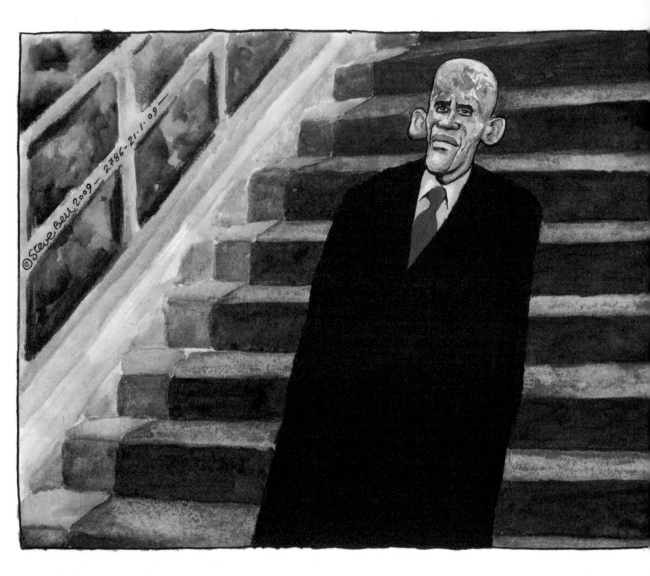

Steve Bell, *Untitled*, UK, 2008

THE
CAMERA EYE

In truth, the camera has no eye, and the common expression is based on a misconception of the machine. The eye as we know is part of the mind, and the camera has no mind, working purely by the chemical reactions following the exposure of the plate to light. The camera never lies because no camera can tell the truth.

Of course photographers and those who pay them can use the camera and the manipulation of chemical processes to offer visions that are a form of lie, trusting to the innocence of those who believe in their fictions. We all collude in this, happily misled by the images that assail us from newspapers, magazines, advertisements. The universal ubiquity of the camera/phone has finally democratised the virtually instantaneous dissemination of what is purportedly 'seen' by the camera eye. But it has not ensured the distribution of truth.

We are moved and thrilled by what we see as the truth of what has been 'caught in the lens' of a great photographer; and we know that many artists have used photography to invent their own visions of reality. They have found poetry in the light reversal of the negative, in the translucency of the X-ray, in the ambiguities and poignancies of an angle of view, in double exposure and montage; they have understood the potency of the *mise-en-scène* and the instantaneity of a moment of light. The truth of art can be served by the artifice of photography.

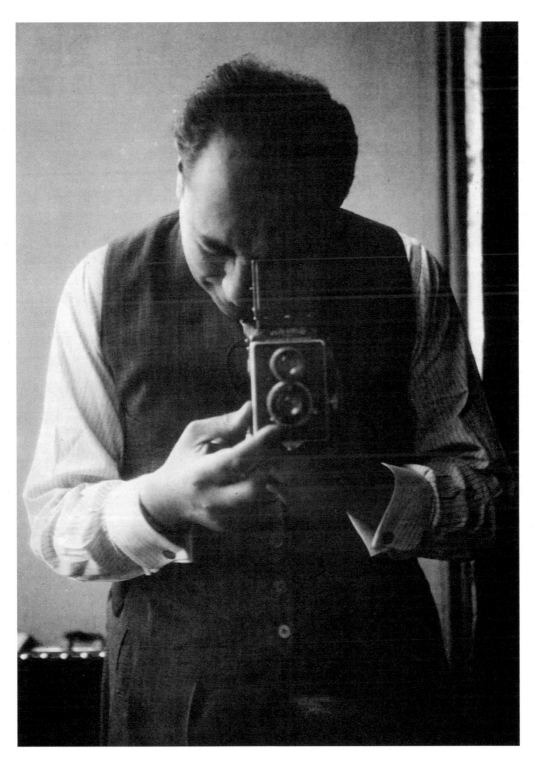

Hans Casparius, *Self-portrait*, Germany, *c.*1950

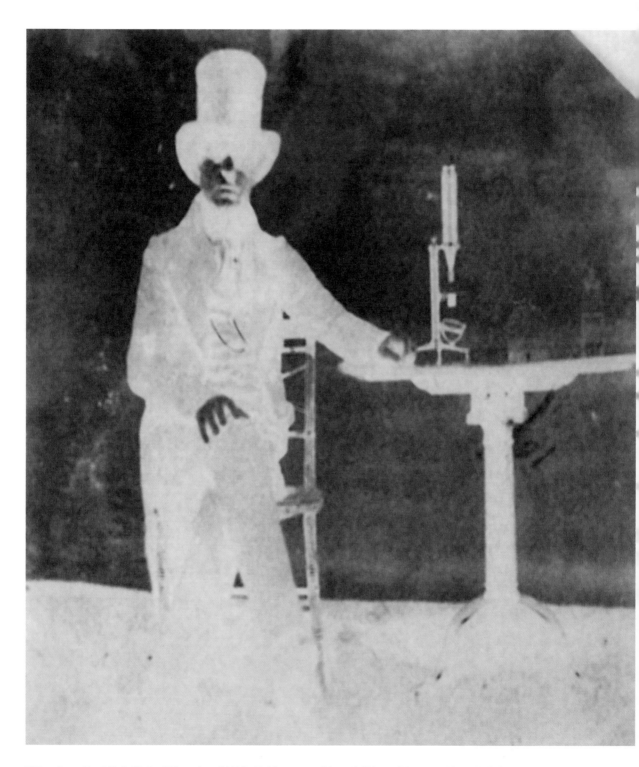

William Henry Fox Talbot, *Sir David Brewster with Talbot's Microscope at Lacock Abbey*, calotype negative, UK, 1842

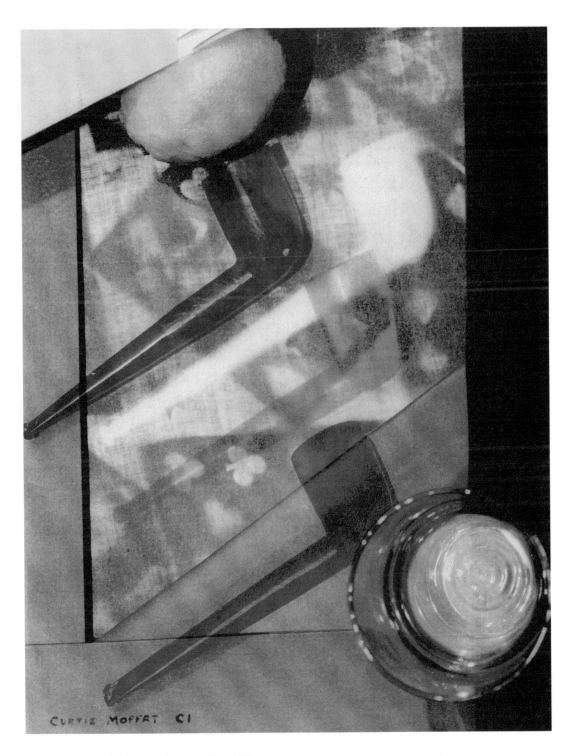

Curtis Moffatt, untitled colour photogram, UK, c.1935

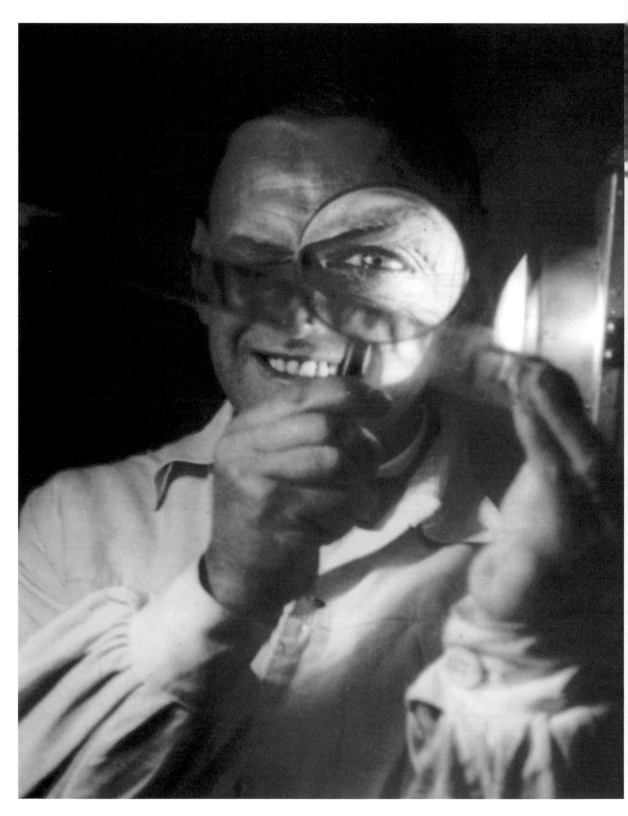

Dr. Paul Wolff, *Magnifying Glass and Eye (Die Lupe)*, Germany, 1931

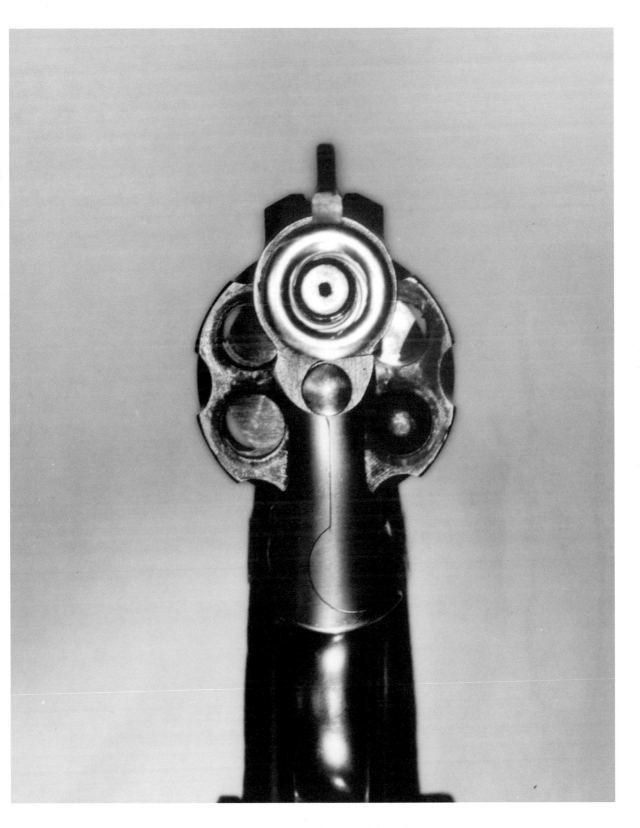

'An eye can threaten like a loaded and levelled gun': anonymous photograph, origin and date unknown

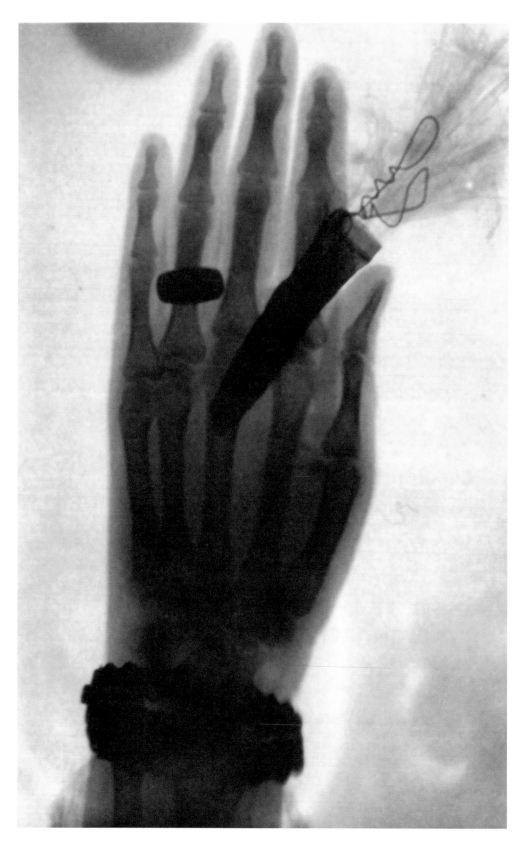

The bone beneath the skin: Walter König, X-ray of woman's gloved hand with bracelet and bouquet, Austria, 1896

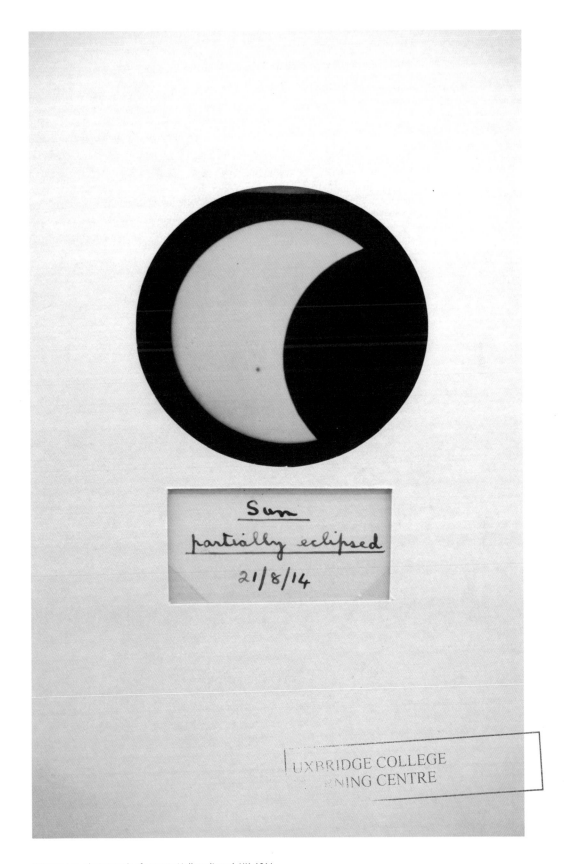

Anonymous, photograph of sun partially eclipsed, UK, 1914

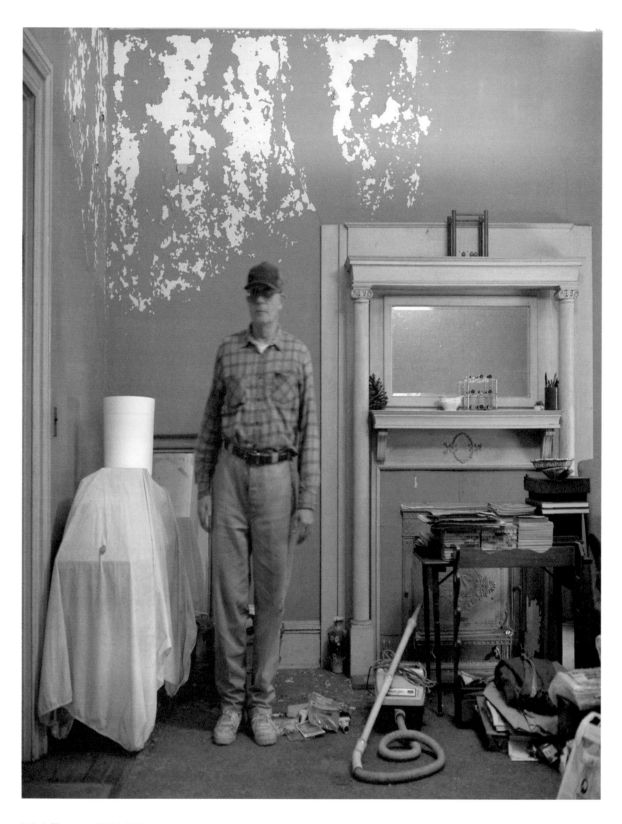

Dale Goffigon, *Arnold*, USA, 2009

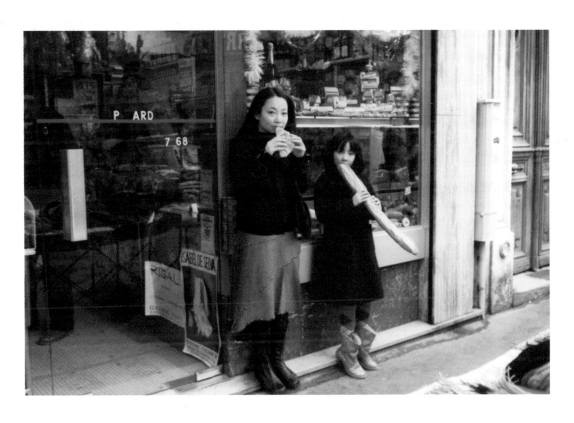

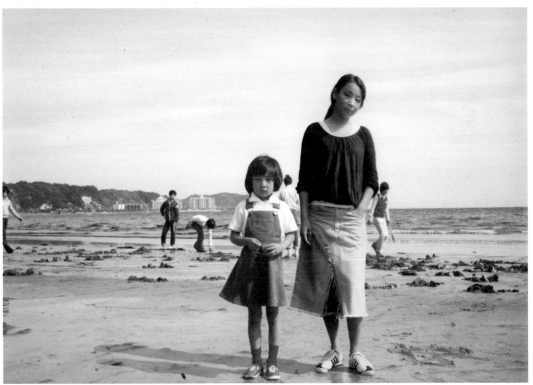

Chino Otsuka, *Imagine Finding Me,* ABOVE: Paris, 1982 and 2005; BELOW: Kamakura, 1976 and 2006, double self-portraits, Japan, 2006

Roger Parry, illustration for *Banalité* by Léon-Paul Fargue (surrealist texts), France, 1930

WORK FOR THE EYE

Work for the eye is work for the mind. '*One picture is worth a thousand words*' is an old saying: it affirms the potency of the eye as a receptor of data for the mind to transform into information. As the word suggests, information is that which informs – gives shape to – various kinds of action: we can do things when and because we know things. From the moment of its formation and the aeons of its development into the most subtle and complex organ of perception, the eye has played no small part in the astonishing growth of the mind, considered as a complex system of connections and insights. The mind makes the world comprehensible to sighted organisms, and the human organism is the most wonderfully adaptable.

In the simplest sign of warning and reminding (another use of the skull as signifier); from the simplest to the most comprehensive map of where we are on earth (*'that way water'* to *'this is the whole world'*); from the mechanisms of optics to the artistic uses of colour; from the number of hospital beds in use to the proportion of those in work; from the fecundity of rabbits to the wonder of the Peaceable Kingdom; from the inventories of emperors to the names of Aztec places: graphic forms for the eye to read have played a major role in the practical dissemination of required knowledge. These visual arrays and demonstrations not only inform the mind, but surprise and pleasure the eye.

You never know: human beings metamorphosing into insects, worms and other beasts, popular print, China, 1940

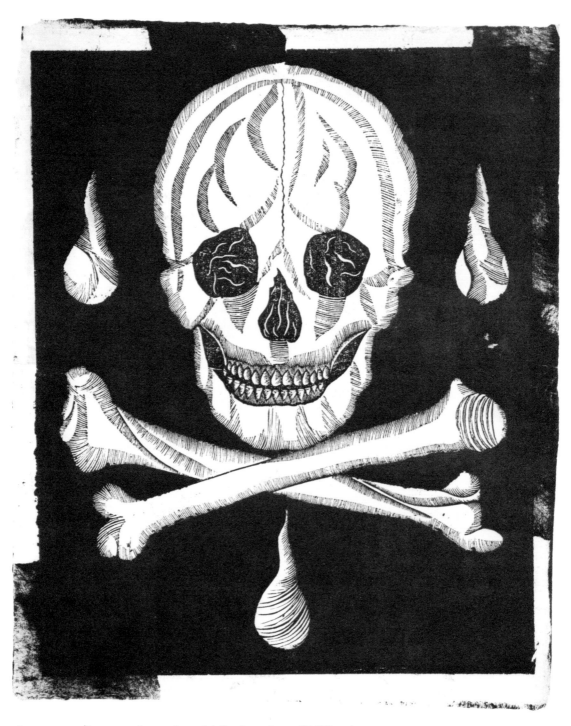

'As you are now/Even so was I': memento mori skull and crossbones, UK, 19th century

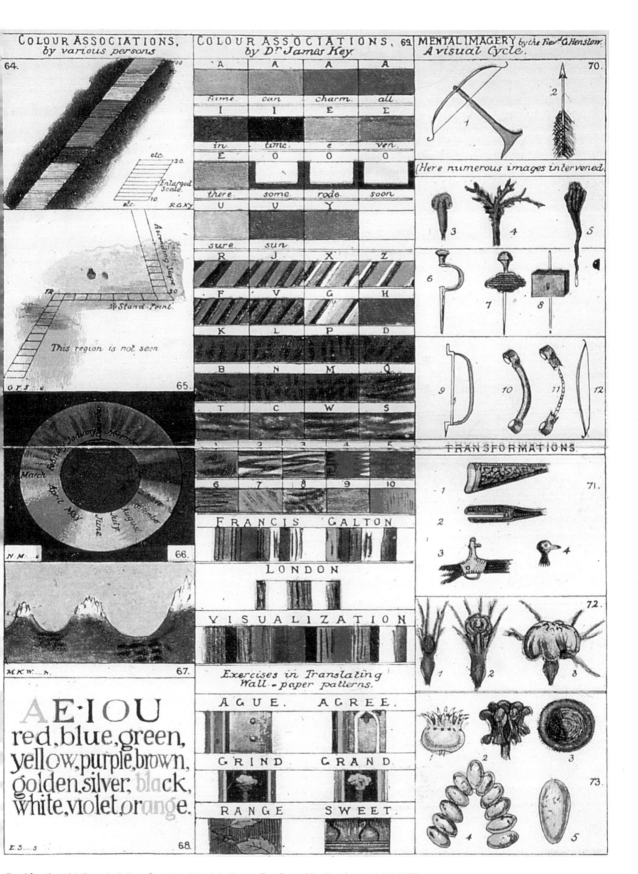

Food for thought: Francis Galton, from *Inquiries into Human Faculty and its Development*, UK, 1907

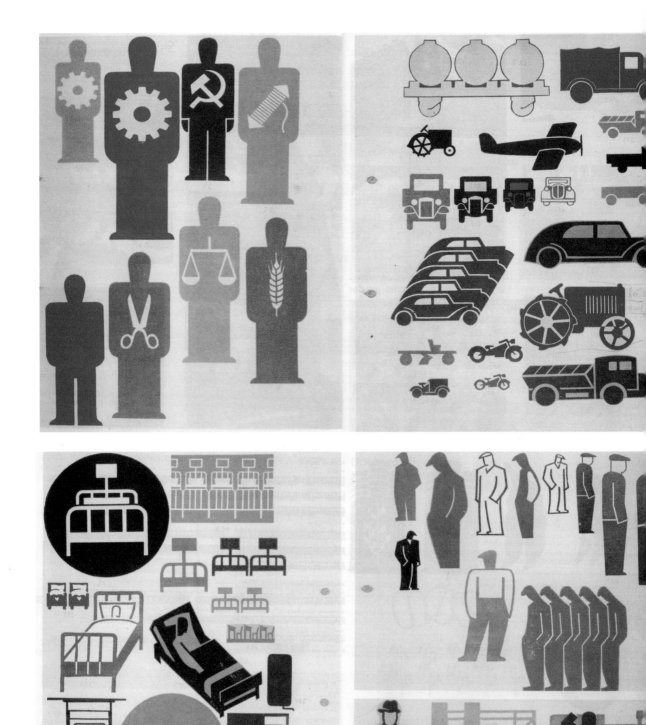

Statistics for the eye: examples of 'Isotype' information graphics devised by Otto Neurath, Gemany, 1930

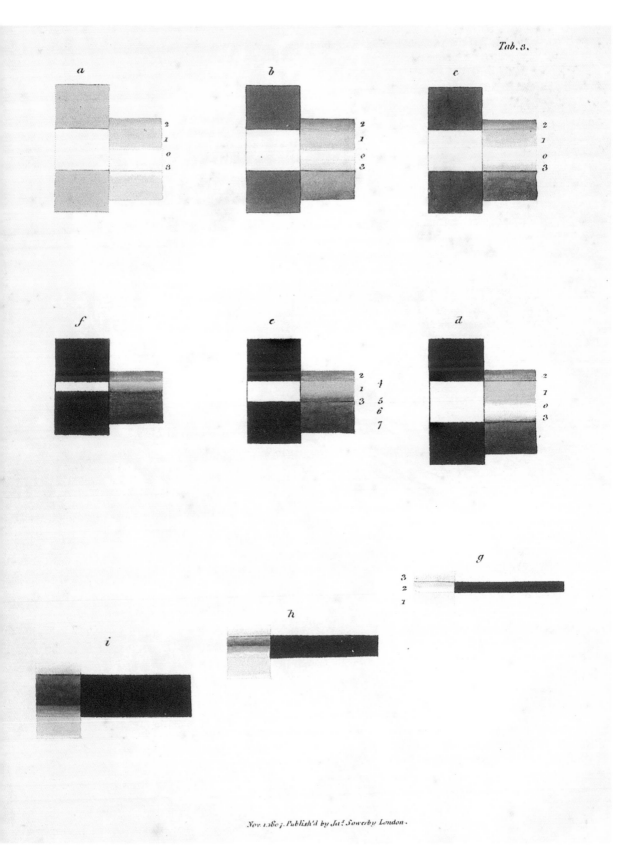

Colour science for artists: M.E. Chevreul, from *The Laws of Contrast of Colour and their Application in the Arts*, France, 1789

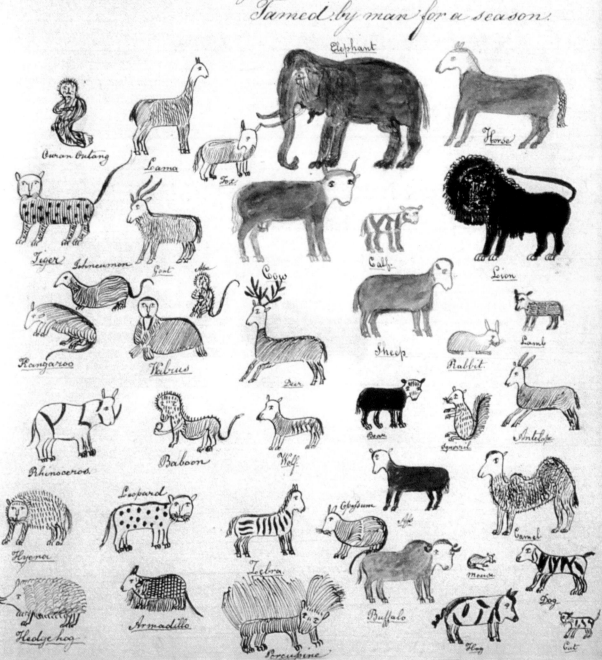

The Beasts of the Fields and Forests, both tame and wild will be driven together and will bear peace with each other, because of the destruction that will come on the Earth; for it will come in the latter days; and they will murmer and rebel against mankind; and shall not be Tamed by man for a season.

Solidarity of the beasts: Shaker 'gift drawings' by Miranda Barber, in *The Book of Prophetic Signs* written by Prophet Isaiah, USA, 1843

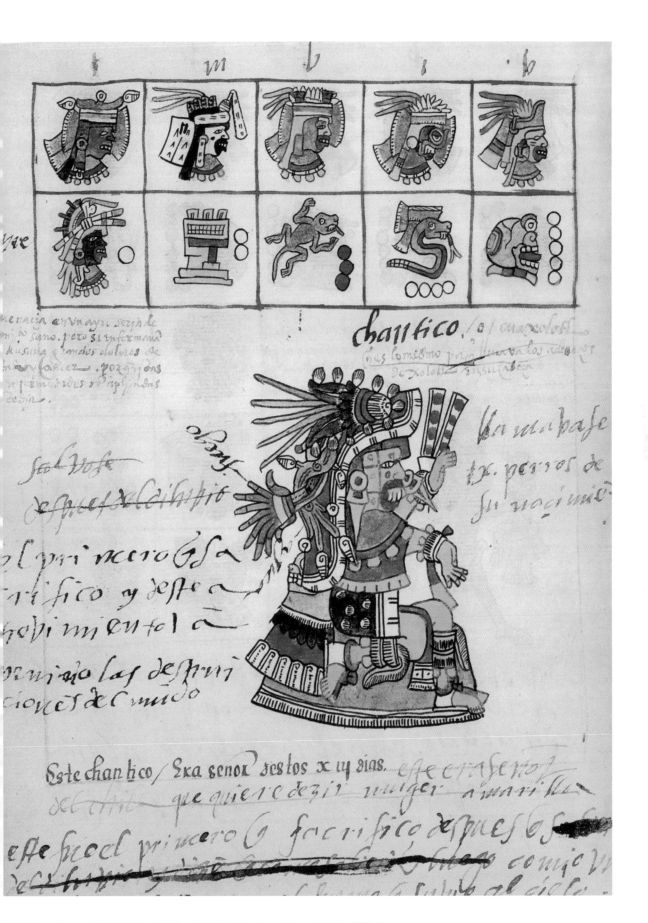

Head-dresses for a god: the deity Tepoyolotl, from the *Codex Terrerianus-Pemensis,* Mexico, 1562-3

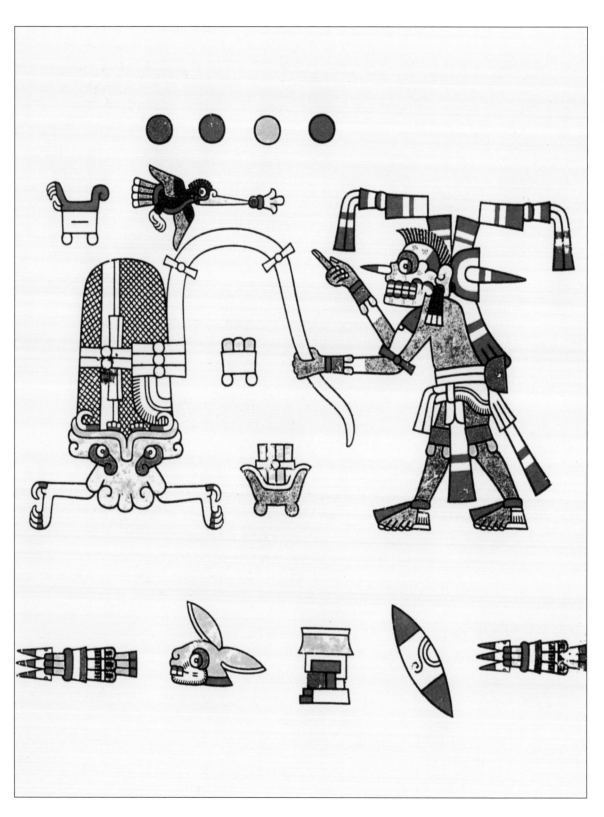

Portents of a good birth: from the *Laud Codex*, Mexico 16th century

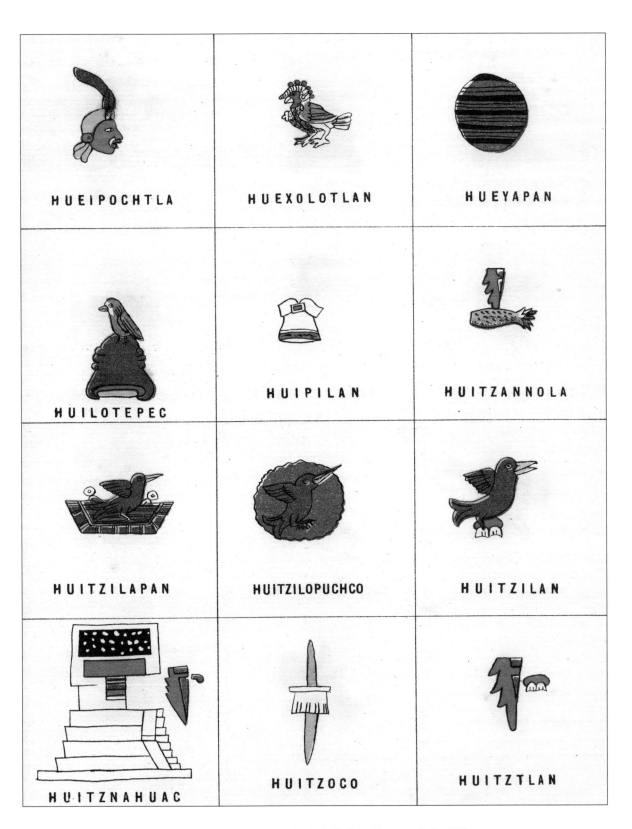

HUEIPOCHTLA	HUEXOLOTLAN	HUEYAPAN
HUILOTEPEC	HUIPILAN	HUITZANNOLA
HUITZILAPAN	HUITZILOPUCHCO	HUITZILAN
HUITZNAHUAC	HUITZOCO	HUITZTLAN

Antonio Penafiel, from *The Alphabetic Catalogue of the Place Names Belonging to the Nahuatl Language*, Mexico, 1885

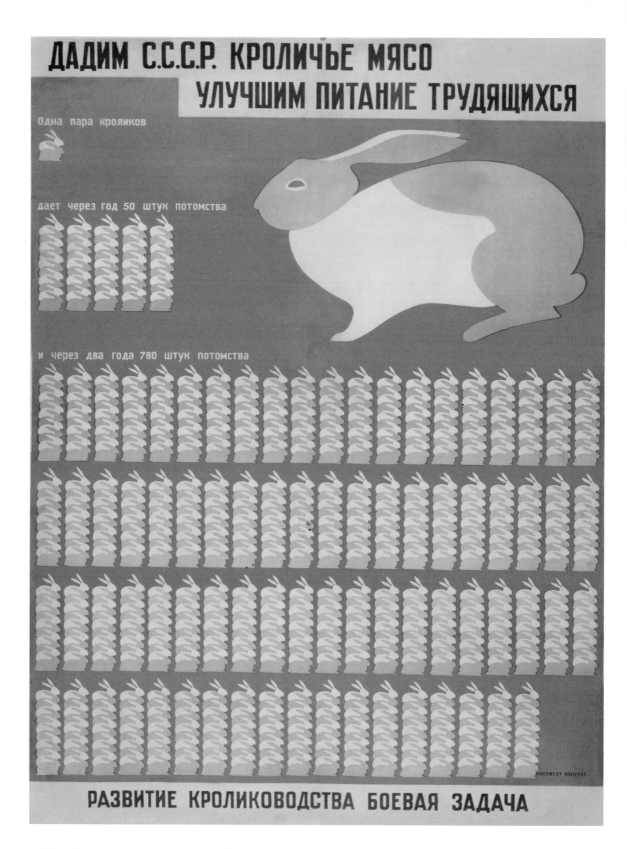

Rabbits, rabbits: anonymous, *Building the Collective* (Institute for the Representation of Statistics), Russia, *c.*1930

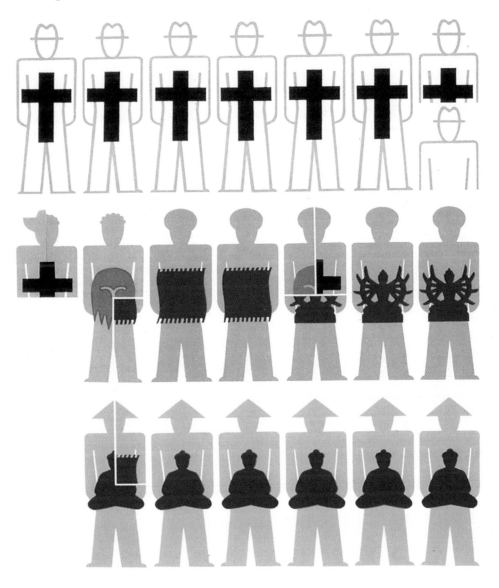

Religions of the world in relation to populations of Europe, India and China: Isotype chart by Gerd Arntz, Germany, 1930

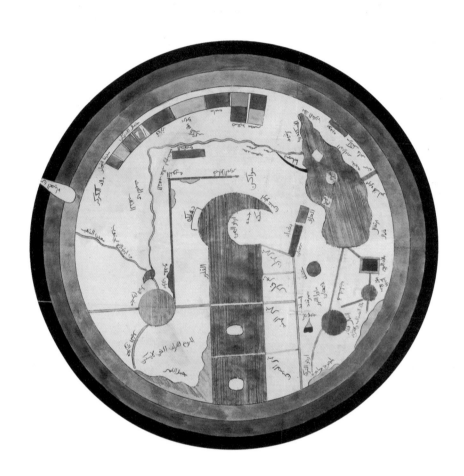

Map of Islamic world: date and source unknown

ACKNOWLEDGEMENTS

Special thanks to these three remarkable projects:

for the work by blind photographers
Gina Badenoch (www.ojosquesienten.org or www.sightofemotion.org)

for the photographs by children
Daniel Baker (www.cubittartists.org.uk) and Gideon Mendel (www.3EyesOn.org)

THANKS ALSO TO: Natasha Arendt, David Batterham, Lutz Becker, Steve Bell, Merrill Berman, Sian Bonnell, Derek Boshier, Olga Budashevskaya, Pablo Butcher, Anne Clarke, Chris Corr, Wim Delvoye, Dale Goffigon, Pam Griffin, librarian/Hayward Gallery, Rhiannon Gooding, Steve Henderson, Will Hobson, Michael Hoppen/Michael Hoppen Gallery, Karen Lipman, librarian/Royal National Institute for the Blind, Adam Lowe, Otis Marchbank, Bill McAlister, Bobbie Oliver, Tom Phillips, Jim Rosenquist, Martha Rosler, Ella Rothenstein, Ed Ruscha, Ivan Samarine, Nicola Schwartz, Stephen Shore, David Shrigley, Elena Spitsina, Mimi Thompson.

And special thanks to: Rosemary Davidson and Simon Rhodes of Square Peg, Matthew Hamilton of Aitken Alexander Associates.

SOURCES OF ILLUSTRATIONS

(Ipswich, UK), courtesy Steve Henderson 115: reproduced courtesy the Museum of London 116: © Colette Urbajtel/Asociación Manuel Álvarez Bravo 117: © Martha Rosler. All rights reserved 118: © Stephen Shore, courtesy Pocko/www.pocko.com 123: © Wim Delvoye, courtesy Studio Wim Delvoye 124: Redstone Press collection/courtesy Nasreen Kabir, Hyphen Films 125: Redstone Press collection 126: © Wim Delvoye, courtesy Studio Wim Delvoye 127: © Erwin Wurm, courtesy Atelier Erwin Wurm, Austria 128: © David Shrigley, from *Why We Got the Sack From the Museum*, Redstone Press, 1998 129: © David Shrigley, from *The Book of Shrigley*, edited by Mel Gooding and Julian Rothenstein, Redstone Press, 2005 130: Redstone Press collection 131: © Alicia Melendez, courtesy Ojos que Sienten A.C. 132: © Chema Madoz, DACS, London, 2010. Provenance of the image, Image Bank / VEGAP 133: © Sian Bonnell, courtesy the artist. All rights reserved 134: Redstone Press collection 135: Maurizio Cattelan, courtesy Marian Goodman Gallery, New York, courtesy the artist 136: Redstone Press collection 137: © Friedrich Kunath, courtesy BQ, Boetnagel & Quirmbach, Berlin 138-9: © Sian Bonnell, courtesy the artist. All rights reserved 140: © Harland Miller, photo Stephen White, courtesy White Cube 145-7 Redstone Press collection 148: from *The Indian Diary*, edited by Julian Rothenstein and Dhruva Mistry, Redstone Press, 1994, courtesy Chris Corr collection 149: Private collection 150: © Donald Baechler, courtesy Baechler Studio, New York 151: © Johnny Warangkula Tjupurrula, courtesy Aboriginal Artists Agency Ltd., Australia 152: courtesy David Batterham 153: from *The Redstone Diary 1997: True Places*, edited by Julian Rothenstein and Adam Lowe, Redstone Press, 1997 154-5: from *The Redstone Inkblot Test*, Redstone Press, 2010 156: from *The Redstone Diary 1997: True Places*, edited by Julian Rothenstein and Adam Lowe, Redstone Press, 1997 157: Redstone Press collection 158-9: courtesy The Western Reserve Historical Society, Ohio 160: © the Estate of Feodor Rojanovsky 165: © Verenice Hernandez, courtesy Ojos que Sienten A.C. 167: Private Collection 168: © Edward Slyfield, courtesy Ojos que Sienten A.C. 169: © Ana Soriano, courtesy Ojos que Sienten A.C. 170 :© Cheryl Gabriel, courtesy PhotoVoice / OQS 171: © Marco Antonio Martinez, courtesy Ojos que Sienten A.C. 172: unknown photographer, courtesy Ojos que Sienten A.C. 173: from *Avant-garde Czech Photography, 1918-1948* by Vladimir Burgis et al., Kant, 2002 174, 175: © Aaron Ramos, courtesy Ojos que Sienten A.C. 176: © Evgen Bavčar. All rights reserved 177: courtesy Adam Lowe, Factum-Arte, Madrid 178: © Jane Sellers, courtesy Ojos que Sienten A.C. 179: © Aaron Ramos, courtesy Ojos que Sienten A.C. 180: © Cheryl Gabriel, PhotoVoice / OQS 185: unknown photographer: the book launch in Moscow for *A Book for Children: Illustrated Children's Books in the History of Russia*. From the collection of Alexander Lurye, editor in chief, N. Verlinskaya, Moscow, 2009 186: from *The Redstone Diary 2010: A Russian Diary*, edited by Julian Rothenstein, Redstone Press, 2009. Courtesy International Institute of Social History, Amsterdam 187: courtesy Sasha Lurye collection 188: from *The Redstone Diary 2010: A Russian Diary*, edited by Julian Rothenstein, Redstone Press, 2009 189: courtesy Sasha Lurye collection 190: from *The Stolen Sun*, Kornei Chukovsky, Progress Publishers, Moscow, 1983 191: courtesy Olga Budashevskaya 192: Alexander Lebedev © DACS, 2010 193-4: from *The Russian Diary 2010*, edited by Julian Rothenstein, Redstone Press, 2009. Courtesy International Institute of Social History, Amsterdam 197: Private collection 199: © Paul Outerbridge Estate, c/o G. Ray Hawkins, Santa Monica 200: © Joan Colom c/o Agrupacio Fotografica de Catalunya 201: courtesy Alexander McQueen 202: © Paul Outerbridge Estate, c/o G. Ray Hawkins, Santa Monica 203: Private collection 204: Private collection 205: Private collection 206: Private collection 207: © the Estate of K. A. Somov, courtesy Ivan Samarine 208: © Colette Urbajtel/Asociación Manuel Álvarez Bravo 209: © the Estate of Hisano Hisashi, private collection 210: courtesy the Isotype collection at the Department of Typography and Graphic Communication at the University of Reading, Middlesex 214-16: from *The Paradox Box*, edited by Mel Gooding, Redstone Press, 1994 217: Private collection 218: © Bridget Riley, 2010. All rights reserved. Courtesy Karsten Schubert, London 219: © Victor Vasarely ADAGP, Paris and DACS, London, 2010 220: Redstone Press collection 221-2: from *Psychobox*, edited by Mel Gooding, Redstone Press, 2004 223: Private collection 224: from *Psychobox*, edited by Mel Gooding, Redstone Press, 2004 225: © Gianni A. Sarcone, www. archimedes-lab.org 226: from *Psychobox*, edited by Mel Gooding, Redstone Press, 2004 231-3: Redstone Press collection 234: courtesy Alex/Cubitt artists 235: courtesy Aaron Eyoma/Cubitt artists 236-7 © Sally, courtesy Kingsmead Primary School and Gideon Mendel 238: courtesy Freddie Goggin/Cubitt artists 239: courtesy Mae Lee/Cubitt artists 240-1: © Sarah, courtesy St Aidan's C of E Primary School and Gideon Mendel 244: © Derek Boshier. Courtesy the artist 245: © James Rosenquist. Courtesy the artist 246: from *Blood and Laughter: Caricatures from the 1905 Revolution*, by David King and Cathy Porter, Jonathan Cape Ltd, 1983, courtesy David King 247: courtesy David Batterham 248: © Steve Bell, courtesy the artist 249: courtesy David Batterham 250: Redstone Press collection 251: from *Calaveras: Mexican Prints for the Day of the Dead*, Redstone Press, 2009 252: © Steve Bell, courtesy the artist 257: © the Estate of Hans Casparius 258: Private collection 259: © the Estate of Curtis Moffatt 260-3: courtesy the Michael Hoppen Gallery, London 264: © Dale Goffigon. All rights reserved 265: © Chino Otsuka. All rights reserved. www.chino.co.uk 266: © the Estate of Roger Parry 271-2: Redstone Press collection 273: courtesy the Royal College of Art (Colour Library), photograph by Dominic Sweeney 274: Isotype symbols from *Arbeiterbildung in Der Zwischenkriegsziet*, Otto Neurath & Gerd Arntz, Locker Verlag, Germany, 1982 275: courtesy the Royal College of Art (Colour Library), photograph by Dominic Sweeney 276: courtesy The Western Reserve Historical Society, Ohio 277-8: from *The Redstone Diary 1993: Aztec*, edited by Julian Rothenstein, Redstone Press, 1992 279: courtesy Pablo Butcher collection 280: Merrill Berman collection, photo Jim Frank 281: courtesy the Isotype collection at the Department of Typography and Graphic Communication at the University of Reading, Middlesex 282: Private collection

Every effort has been made to contact copyright holders. Any copyright holders we have been unable to reach or to whom innacurate acknowledgement has been made are invited to contact the publisher so that corrections can be made to future editions.